# *Draw Like*
# THE MASTERS

# *Draw Like* THE MASTERS

## Practical steps to classic skills

**Barrington Barber**

ARCTURUS

ARCTURUS

This edition published in 2008 by Arcturus Publishing Limited
26/27 Bickels Yard, 151–153 Bermondsey Street,
London SE1 3HA

Book design by Alex Ingr at www.typeandimage.com, London N1

ISBN: 978-1-84858-004-6

Printed in China

# Contents

# Introduction

Draw Like the Masters is about the age-old method of copying from a master drawing in order to learn how to draw well. In previous ages, in a studio run by a master artist, there would have been regular periods when the assistants, or apprentices, would carefully copy drawings done by the master or by his best assistant. These would have to be as exact as possible, in order to help the young student to learn the art of drawing. This was unlike the later idea that all artists have to be original and, in fact, originality was not considered of any import. The student artist was expected to try to be as similar to his master in style and quality as possible. When he was accomplished in the art of copying, he would be entrusted with drawing up certain parts of the works produced by the master and his studio. In this way, he would gradually become a major worker on the pictures produced by that studio and, when he had mastered all the techniques, would be allowed to initiate works of his own. From there he would perhaps start his own studio, and in time employ other young hopefuls, who would go through a similar process. By this system, in quite a short time, many competent artists were produced who could handle a wide range of artworks. Even the studio drawings, which were kept for reference purposes, would all be drawn in common sketch books that held works by several of the artists working there. It was very much a corporate effort. After a while, the system would be rejuvenated by a new artist of sufficient stature to add new ideas to the regular canon of art examples. But the normal working procedure was always based on the student learning directly from the master, by copying his drawings and methods.

When you embark on this way of learning to draw, you will find how difficult it is to copy accurately. But gradually, you will begin to see and understand the subtleties of the drawing methods. Once you have discovered how the original drawing was done in some detail, you won't forget easily how to do it yourself. And once this degree of expertise is achieved, your drawing, although derived from a particular master source, begins to take on its own character, which is when your own style starts to make itself apparent.

So copying, as a tried and tested method, is really quite an efficient way to improve your artistic endeavours, and as long as you stick to the best master works that you can find, you should have no problem in improving your drawing skills.

# Line drawing

D rawing at its most basic may be described as the making of marks on a surface and, more particularly, as the arrangement of lines drawn in pencil, ink, charcoal or chalk. This section features copies of works by master draughtsmen, which rely for their effectiveness on nothing but the quality of their linework to describe the subject. I cannot show the entire chronological development of line drawing, prehistoric examples of which are to be found on the walls of caves in France and the Sahara; so, apart from one instance from Classical Greece, I have selected attributed works – from the Renaissance to the present day – that I think demonstrate a good variety of approaches to the task, with enlarged details in many cases.

Nor are the following drawings mere outlines – they also show us how a master can convey the feeling of weight and substance by his handling of the medium. The slightest manipulation of a line can be made by him to suggest a three-dimensional shape in motion or at rest. Any aspiring artist does well to emulate the ability of a master to define shapes by simple means. Good drawing does not have to involve complexity.

It becomes clear from these examples that understanding how to draw a line in various and subtle ways enormously enhances the quality of your work. The strength of the line, its sensitivity, its ability to change in intensity, and other variations of method, all help the artist to suggest a range of effects with very little complexity.

## Michelangelo Buonarroti (1475–1564)

Michelangelo is arguably the most influential figure in the history of art; a good example to start with. Study his drawings and then look at the work of his contemporaries and the artists who followed him and you will see how great was his influence. The copies shown here incorporate the original techniques he introduced. In the pen and ink drawing the style is very free and the shapes very basic, suggesting figures in motion; Michelangelo's deep knowledge of anatomy enabled him to produce an almost tactile effect in his life drawing. He shows clearly that there are no real hollows in the human form, merely dips between the mounds of muscles. This is worth noting by any student drawing from life and will give more conviction to your drawing.

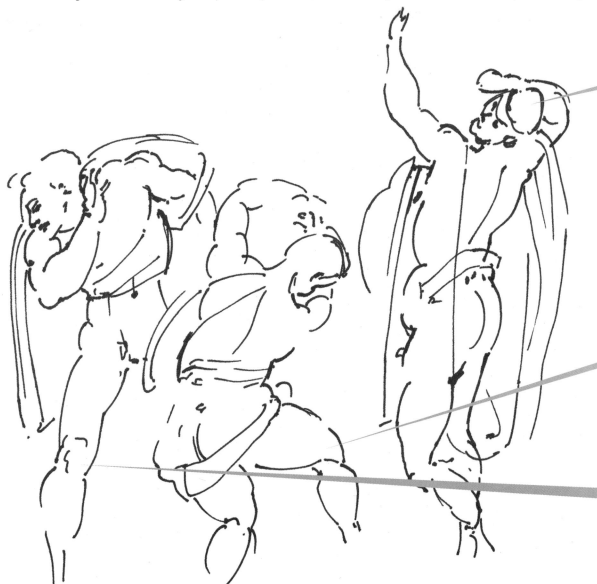

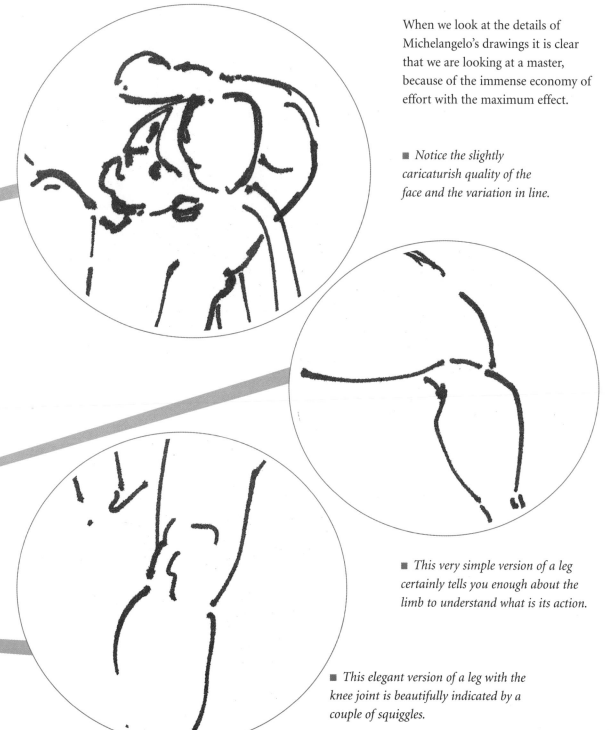

When we look at the details of Michelangelo's drawings it is clear that we are looking at a master, because of the immense economy of effort with the maximum effect.

■ *Notice the slightly caricaturish quality of the face and the variation in line.*

■ *This very simple version of a leg certainly tells you enough about the limb to understand what is its action.*

■ *This elegant version of a leg with the knee joint is beautifully indicated by a couple of squiggles.*

11

## Guercino (1591–1666)

Rarely have I seen such brilliant line drawings in ink of the human figure as those of the painter Guercino. In this example the line is extremely economical and looks as though it has been drawn from life very rapidly. The flowing lines seem to produce the effect of a solid body in space, but they also have a marvellous lyrical quality of their own. Try drawing like this, quickly, without worrying about anything except the most significant details, but getting the feel of the subject in as few lines as possible. You will have to draw something directly from life in order to get an understanding of how this technique works.

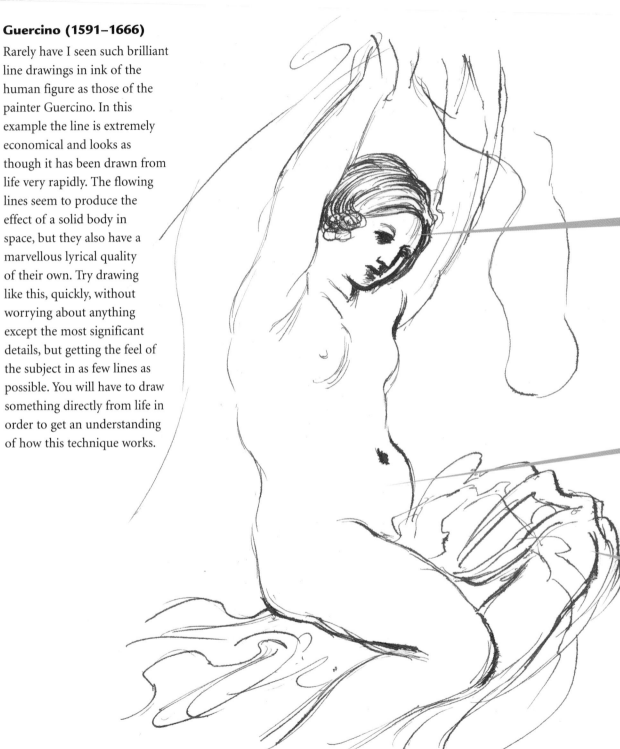

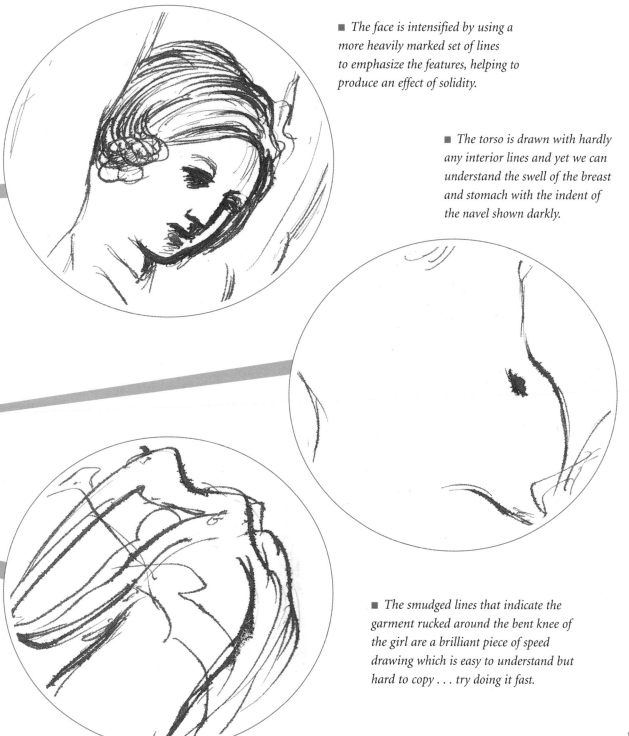

■ The face is intensified by using a more heavily marked set of lines to emphasize the features, helping to produce an effect of solidity.

■ The torso is drawn with hardly any interior lines and yet we can understand the swell of the breast and stomach with the indent of the navel shown darkly.

■ The smudged lines that indicate the garment rucked around the bent knee of the girl are a brilliant piece of speed drawing which is easy to understand but hard to copy . . . try doing it fast.

## Joseph Mallord William Turner (1775–1851)

Turner started his career as a topographical painter and draughtsman and made his living producing precise and recognizable drawings of places of interest. He learnt to draw everything in the landscape, including all the information that gives the onlooker back the memory of the place he has seen. This ability stayed with him, even after he began to paint looser and more imaginative and elemental landscapes. Although the detail is not so evident in these canvases, which the Impressionists considered the source of their investigations into the breaking up of the surface of the picture, the underlying knowledge of place and appearance remains and contributes to their great power. The outline drawing of this abbey is an early piece, and amply illustrates the topographic exactitude for which the artist was famous in his early years.

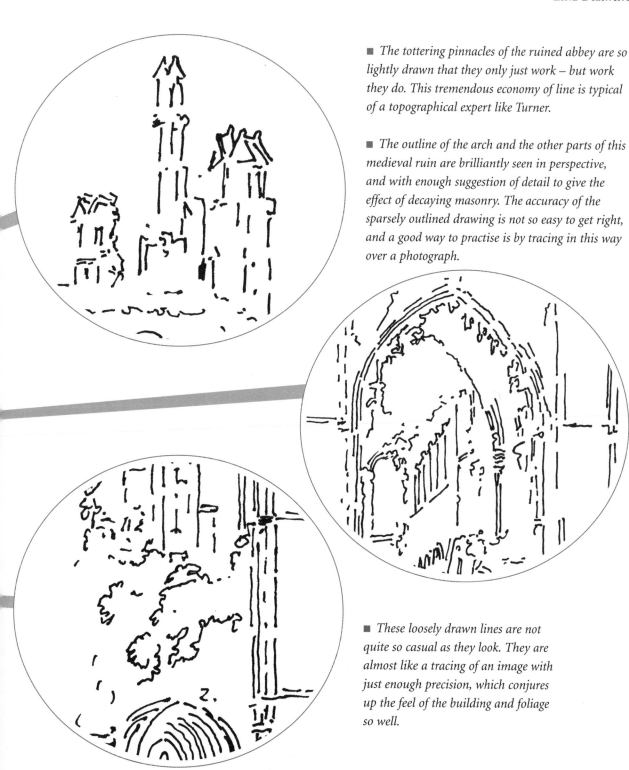

■ The tottering pinnacles of the ruined abbey are so lightly drawn that they only just work – but work they do. This tremendous economy of line is typical of a topographical expert like Turner.

■ The outline of the arch and the other parts of this medieval ruin are brilliantly seen in perspective, and with enough suggestion of detail to give the effect of decaying masonry. The accuracy of the sparsely outlined drawing is not so easy to get right, and a good way to practise is by tracing in this way over a photograph.

■ These loosely drawn lines are not quite so casual as they look. They are almost like a tracing of an image with just enough precision, which conjures up the feel of the building and foliage so well.

15

## Eugène Delacroix (1798–1863)

The great French Romantic painter Delacroix could draw brilliantly. He believed that his work should show the essential characteristics of the subject matter he was portraying. This meant that the elemental power and vigour of the scene, people or objects should be transmitted to the viewer in the most immediate way possible. His vigorous, lively drawings are more concerned with capturing life than including minuscule details for the sake of it. He would only include as much detail as was necessary to convince the viewer of the verisimilitude of his subject. As you can see from these examples, his loose, powerful lines pulsate with life.

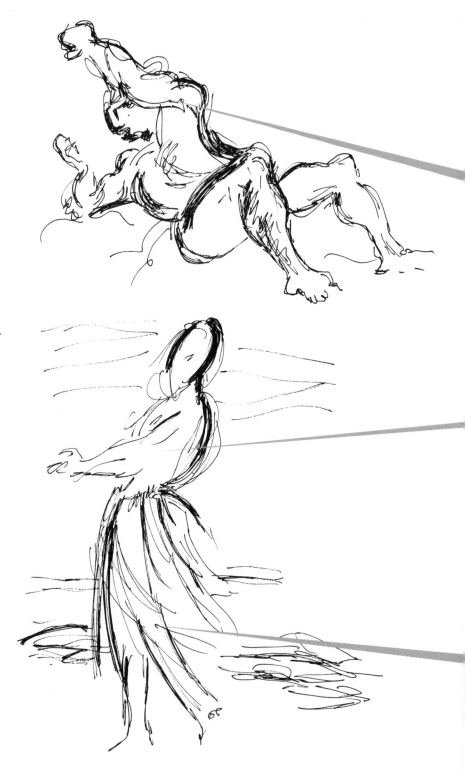

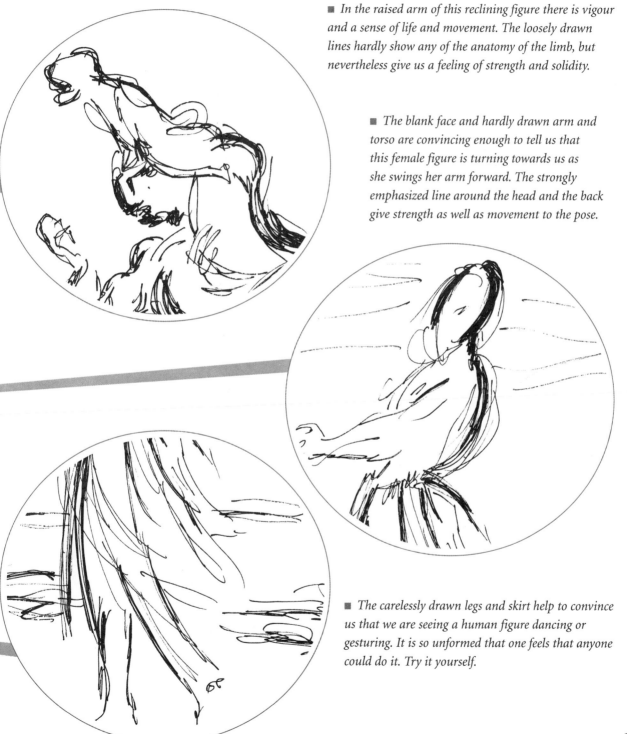

■ In the raised arm of this reclining figure there is vigour and a sense of life and movement. The loosely drawn lines hardly show any of the anatomy of the limb, but nevertheless give us a feeling of strength and solidity.

■ The blank face and hardly drawn arm and torso are convincing enough to tell us that this female figure is turning towards us as she swings her arm forward. The strongly emphasized line around the head and the back give strength as well as movement to the pose.

■ The carelessly drawn legs and skirt help to convince us that we are seeing a human figure dancing or gesturing. It is so unformed that one feels that anyone could do it. Try it yourself.

### Aristide Maillol (1861–1946)

This beautiful line drawing of a crouching girl by the great French sculptor Aristide Maillol, drawn at the beginning of the 20th century, shows how the soft smoky texture of the chalk line gives a feeling of the roundness of the limbs and the soft quality of the flesh. A line drawing like this is quite difficult to achieve with any degree of quality because you need to get it more or less right first time. However, it is worth trying because of the discipline that it imposes on the artist not to make too many mistakes.

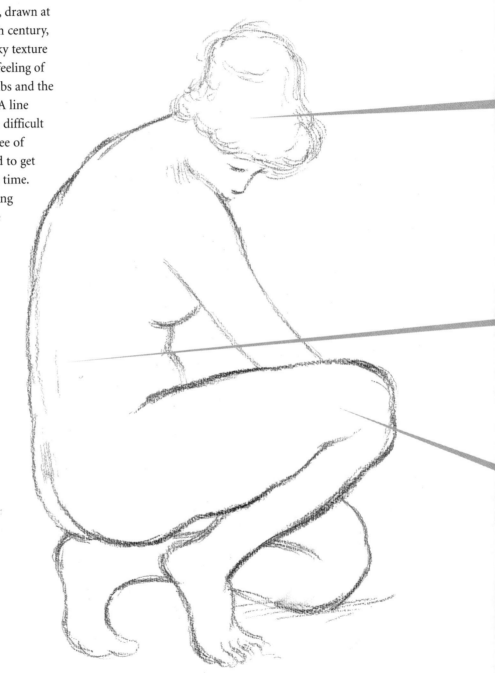

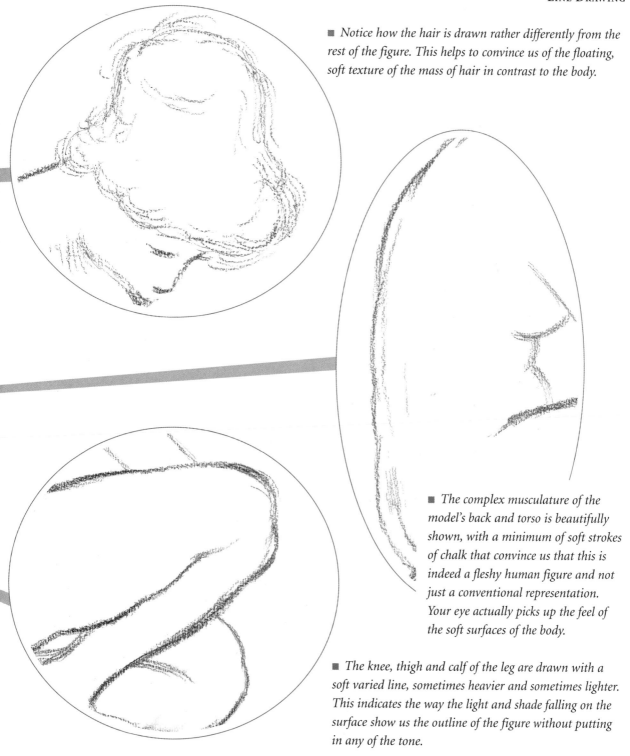

■ *Notice how the hair is drawn rather differently from the rest of the figure. This helps to convince us of the floating, soft texture of the mass of hair in contrast to the body.*

■ *The complex musculature of the model's back and torso is beautifully shown, with a minimum of soft strokes of chalk that convince us that this is indeed a fleshy human figure and not just a conventional representation. Your eye actually picks up the feel of the soft surfaces of the body.*

■ *The knee, thigh and calf of the leg are drawn with a soft varied line, sometimes heavier and sometimes lighter. This indicates the way the light and shade falling on the surface show us the outline of the figure without putting in any of the tone.*

## Henri Matisse (1869–1954)

Even without the aid of bright, rich colours Matisse could invest his work with great sensuality. His drawings are marvellously understated yet graphic, thanks to the fluidity of line. Awkwardness is evident in some of them, but even with these you never doubt that they express exactly what he wanted. There are no extraneous marks to diffuse the image and confuse the eye. As he got older and suffered from arthritis in his hands, Matisse resorted to drawing with charcoal on the end of a long stick. Despite this handicap, the large, simple images he produced by this method possess great power.

■ *Look at the way Matisse draws the bent arm, with what is the outside of the upper arm becoming the inside of the forearm as it bends over. It is an optical illusion, but works very well, creating an amusing point in the drawing. The simplicity of the outline is very deceptive and quite difficult to get right. Try tracing it first and then freehand copying.*

■ *Looking at* Nude in the Studio *you will probably think, 'I could do that.' Certainly, on the face of it, there appears to be very little to this drawing and some parts look to be crudely drawn.*

*When you've tried to draw in this way, you'll know how difficult it is. It is so easy to do too much and in the process lose the truth of what you are trying to portray.*

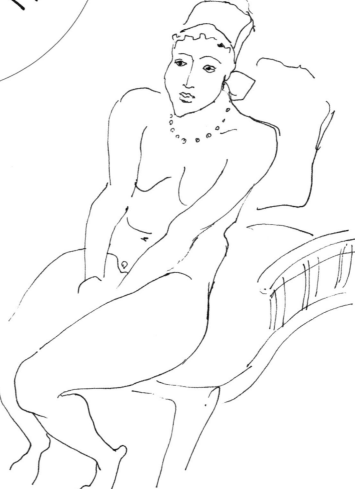

## Pablo Picasso (1881–1973)

Picasso is famous for his ease of drawing and these line drawings of his are no exception. The ability to describe the shape of a figure in its simplest form is reminiscent of the Greek vase drawings of over two thousand years ago. Drawing like this is a great test for the artist as nine times out of ten it may not work. But it is worth persevering for that tenth time when the line does exactly what you want it to.

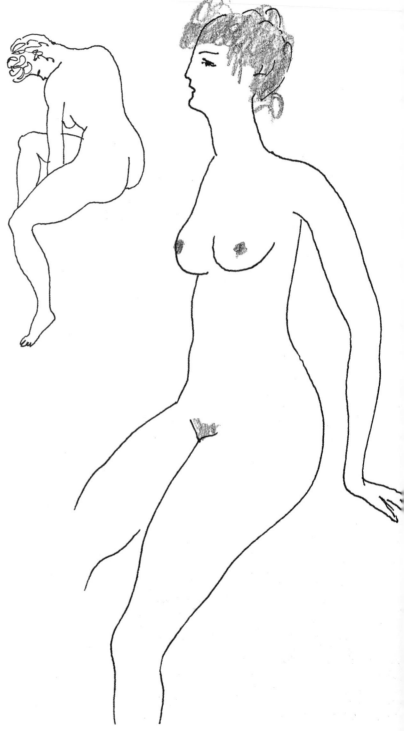

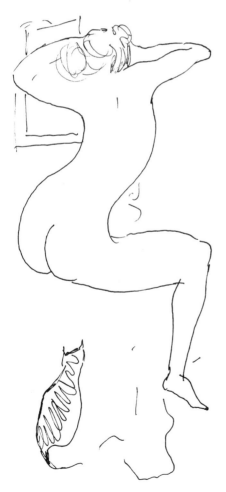

*Here the outline form is an amazing example of a line doing a lot of work to show movement, emotion and spatial dimension. The particular distortions of the forms convey a feeling of substance in a vivid, almost rubbery way. The outline is not formal but wiry and energetic and gives a strong impression of drama and emotion.*

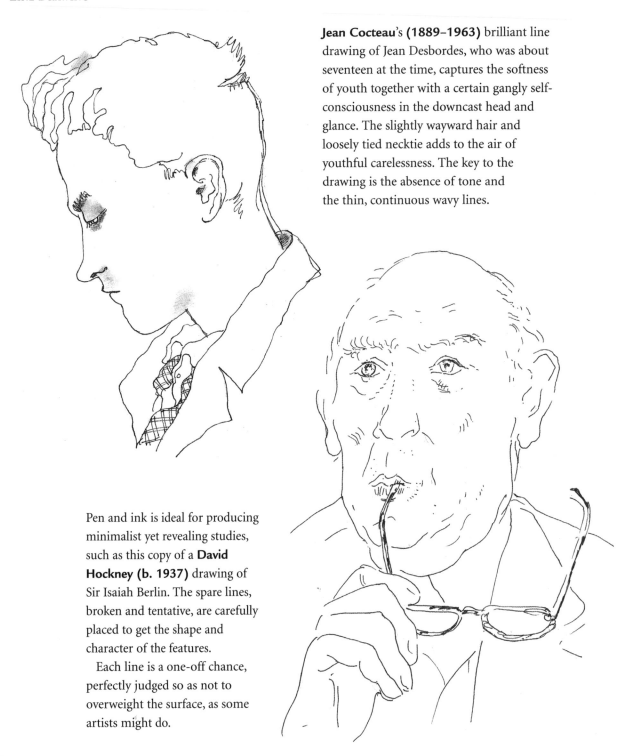

Jean Cocteau's **(1889–1963)** brilliant line drawing of Jean Desbordes, who was about seventeen at the time, captures the softness of youth together with a certain gangly self-consciousness in the downcast head and glance. The slightly wayward hair and loosely tied necktie adds to the air of youthful carelessness. The key to the drawing is the absence of tone and the thin, continuous wavy lines.

Pen and ink is ideal for producing minimalist yet revealing studies, such as this copy of a **David Hockney (b. 1937)** drawing of Sir Isaiah Berlin. The spare lines, broken and tentative, are carefully placed to get the shape and character of the features.

Each line is a one-off chance, perfectly judged so as not to overweight the surface, as some artists might do.

This Greek vase outline drawing dating from 510 B.C. shows how effective the simple use of line can be to produce a convincing feeling of form and substance. The use of the fine wavy lines to express the material of the dress covering the curves of the female body show how accurate the artist's knowledge of anatomy was. The drawings of Picasso and Matisse come somewhere near this in expertise in line.

# Tone

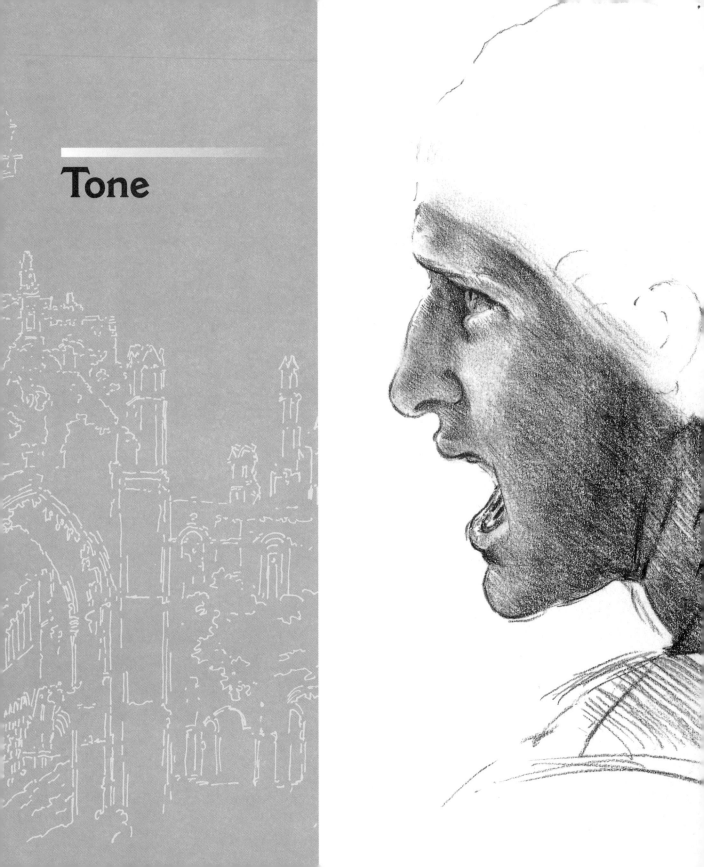

Creating tone, with areas of shade softly merging into one another, is the next step after line to making a drawing appear more convincing. The use of tone probably arose some time after the use of line; certainly the frescoes at Pompeii had tonal areas to give substance and form to the figures they portray.

Tone allows us new ways to express form. The following examples help to convince the viewer of the weight of objects, and of the depth of field in a picture. Some examples show how repetition of fine lines can render the same effect as tonal areas, and others dispense with line altogether.

Careful gradation of tone on an object persuades us that it is occupying a volume in space; the more fine the gradation, the more readily the eye is convinced. We are so used to looking at photographs that tonal drawing is equally acceptable as evidence of the reality of the subject. If the tonality is convincing enough, we think it must exist somehow, some-where, even though our reason tells us otherwise.

Nowadays it is not too difficult to reproduce people, objects, architecture and landscapes accurately. But at the start of the Renaissance period it was still a challenge for most artists to encourage the viewer to believe in the depth of field in a picture or the reality of a subject. However, by the mid-1500s, when the Baroque era was under way, artists had learned how to handle graded tonal values as well as anyone did nearly three hundred years later on, with the invention of photography.

The artists shown here are great exponents of tonality, but you can also learn a lot from studying photographs taken in natural light – not shot with a flash, which tends to flatten the tones.

### Vittorre Carpaccio (1472–1526)

Tone, or the relative values between the light falling on an object and the shadow in its varying depths, on and around the same object, help to convince the viewer that it is a three-dimensional thing in space. The earliest attempts at this were effective, but not so effective or dramatic as in later times.

Here the dominant area of tone is that of the paper the drawing has been worked on. With great economy but precise method, Carpaccio uses white and black chalk to give the effect of light and shade, which is convincing enough to produce a three-dimensional-looking head and shoulders, in space, lit by light from the upper left of the head.

The mid-tone of the paper has been used to great effect in this copy of Carpaccio's drawing of a Venetian merchant. Small marks of white chalk pick out the parts of garments, face and hair that catch the light. No attempt has been made to join up these marks. The dark chalk has been used similarly: as little as the artist felt he could get away with. The medium tone of the paper becomes the solid body that registers the bright lights falling on the figure. The darkest tones give the weight and the outline of the head, ensuring that it doesn't just disappear in a host of small marks.

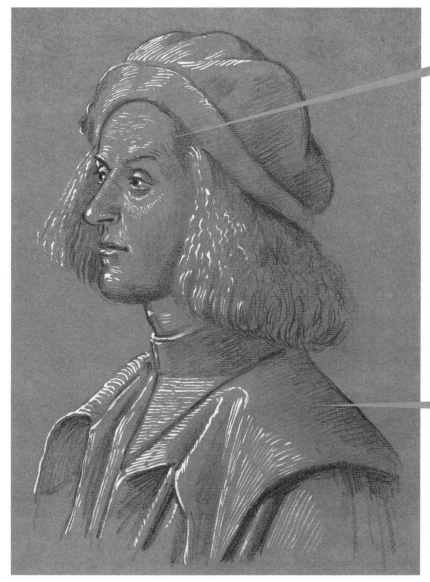

■ Look here at the marks on the cloth hat and the features of the face. With great restraint, the artist puts in enough small strokes of white chalk to give the effect of the brow, eyelids and nose, while the lines on the hat seem to be longer and more even to represent fabric.

■ With the cloth of the coat the marks are even, and build up to give a strong effect of large planes of smooth cloth.

In **Guercino**'s drawing the drama of light and shade is now at its greatest power. Influenced by the tonal variety and drama of artists like Caravaggio, the face of a youth is seen in deep shadow with some small areas where features catch the strong light. Notice the even strokes on the facial surface, building up a texture of dark, darker and darkest tones that evince the look of deep shadows contrasting with strong light striking the head from one side. Notice the larger and coarser texture used for the hair to give a different feel from the smooth skin. Every now and then, he puts in strong marks coming from a different direction, to help emphasize the form. And then, of course, the line of the mouth where it opens, the nostrils and the edges of the eyelids and pupils are drawn in with the strongest, darkest marks. This is an example of the discovery by the Renaissance artists of the power of tone to convince the eye of the reality of the form.

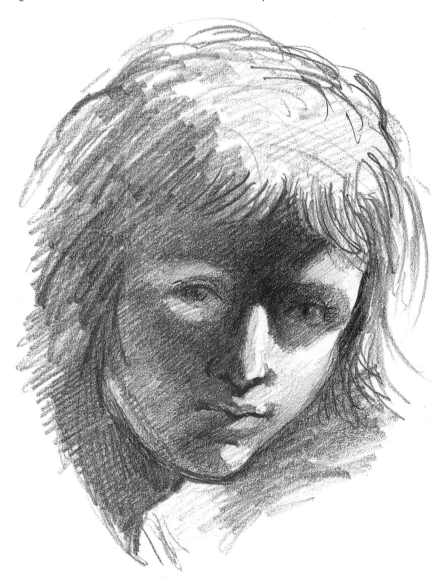

This brush and wash drawing by Danish painter **Peter Ilsted (1861–1933)** shows a lone chair by a desk lit by strong sunlight. The light source is not shown, but comes from an invisible window in the corner of the room – a device very effective in giving some impression of a larger space behind the viewer. The contrasting areas of tone blend together subtly, creating a natural and expansive still life.

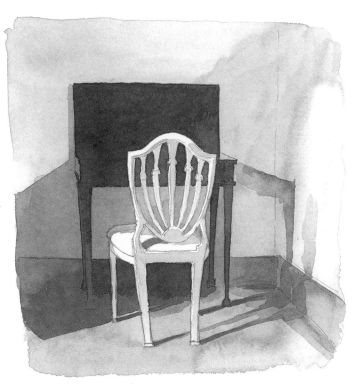

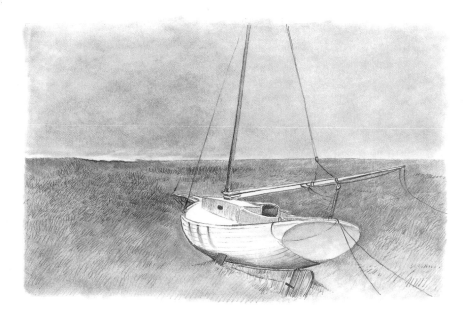

This outdoor scene after **Andrew Wyeth** (b. 1917) is of unlimited space, and the subject is a still life of a larger nature: a sailing boat beached in a field close to the sea. The artist has drawn two large areas of tone to indicate the sea and the sky, leaving a fine line of white along the horizon line which opens up the composition and indicates a much larger world beyond.

### Claude Lorrain (1600–1666)

In this pen and wash drawing of the Roman countryside our vision is by deliberate choice of the artist. We are viewing the scene from down in a hollow or small ravine with rocky outcrops to the left and in front. Up on the rocks in front is an old tower, sharply silhouetted against the sky. Our low viewpoint and the high rocky ridges prevent us from seeing much more of the landscape. Because of the position taken by the artist, our view is restricted to a few metres, forcing us to concentrate on the details in the foreground, both middleground and background being almost non-existent.

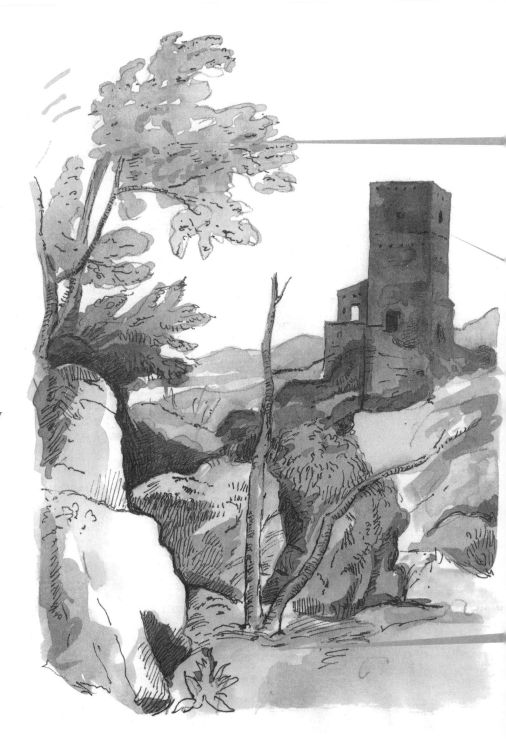

■ *Here, the very light tone of the leafy canopy is helped by the small dark marks that tell us something about the shapes of the leaves and twigs.*

■ *The solid stone structure blocks out all the distant light, and therefore is washed in with a deep tone, with some darker tones within the main shape. This gives a focal point to the picture.*

■ *In this area there are parts completely untouched, to suggest strong light falling on the stone surfaces; some parts in medium tone, with lines of black to indicate textural differences; and then deep shadows in a very dark tone. With just three or four main areas of tone, many convincing types of landscape can be indicated. Of course, Claude Lorrain is one of the greatest landscape painters of the French school, so the lesson is a good one.*

## Canaletto (1697–1768)

It is easy to become confused with the details of texture in a scene such as this, of the Grand Canal in Venice. It exemplifies one of landscape's golden rules: always put the main shapes of buildings in first. The repetition of architectural details must be kept as uniform as possible, otherwise the buildings will look as though they are collapsing. Never try to draw every detail: pick out the most definite and most characteristic, such as the arches of the nearer windows and doors, and the shapes of the gondolas in the foreground. The reflections of the buildings in the water are suggested, with the darkest shadows depicted by horizontal lines under the buildings. Multiple cross-hatching denotes the darker side of the canal. On the lit side, white space has been left and the sky above lightly shaded to enhance the definition and provide greater contrast.

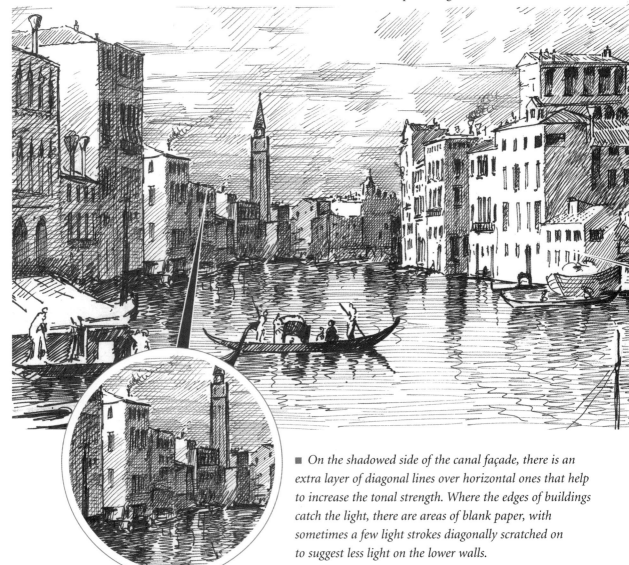

■ *On the shadowed side of the canal façade, there is an extra layer of diagonal lines over horizontal ones that help to increase the tonal strength. Where the edges of buildings catch the light, there are areas of blank paper, with sometimes a few light strokes diagonally scratched on to suggest less light on the lower walls.*

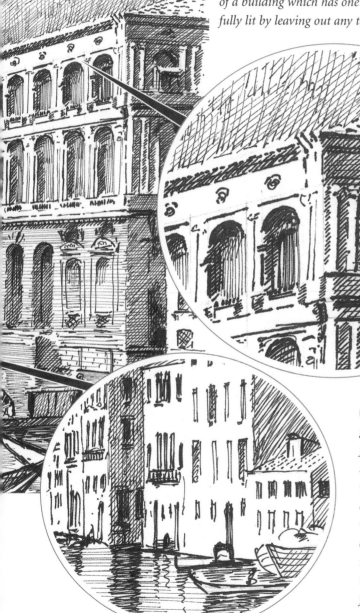

■ A rather different way of showing tone, by using a multiplicity of drawn lines in ink to show variety in light and shade. Canaletto's view of the Venetian Grand Canal shows a corner of a building which has one surface fully lit by leaving out any tonal marks, except in the windows and decorative cornices. The side that is turned away from the light has been covered with diagonal strokes of about the same weight, leaving only small areas of white, again to indicate the indentation of the windows and balconies.

■ This area where the light is greatest is left very blank, except for minimal indications of the slots of the windows. To contrast with the buildings, the water is drawn in with horizontal lines, with extra-strong variations where a shadowed part of the building is reflected. Notice how the stronger reflections get weaker as they move further from the surface contact.

## Henri Le Sidaner (1862–1939)

In this drawing, the placing of a table laid for tea in front of a window, looking out onto a lawn, takes the view out into the open air although the still life is itself in an enclosed area. The flowers on the table link it with the garden beyond.

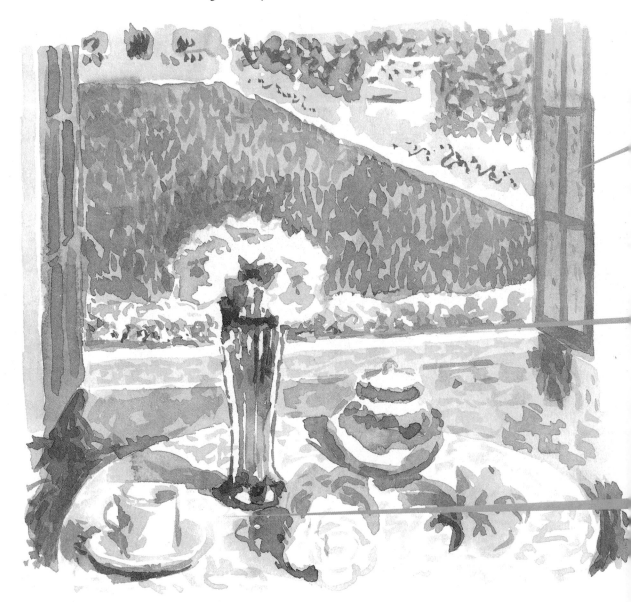

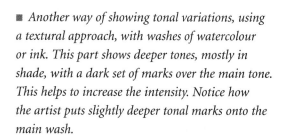

■ Another way of showing tonal variations, using a textural approach, with washes of watercolour or ink. This part shows deeper tones, mostly in shade, with a dark set of marks over the main tone. This helps to increase the intensity. Notice how the artist puts slightly deeper tonal marks onto the main wash.

■ This area is where Henri Le Sidaner shows the focal points of the composition with stronger contrast between the darker and lighter tones. This suggests reflective, shining surfaces like glass and ceramic.

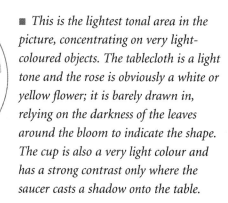

■ This is the lightest tonal area in the picture, concentrating on very light-coloured objects. The tablecloth is a light tone and the rose is obviously a white or yellow flower; it is barely drawn in, relying on the darkness of the leaves around the bloom to indicate the shape. The cup is also a very light colour and has a strong contrast only where the saucer casts a shadow onto the table.

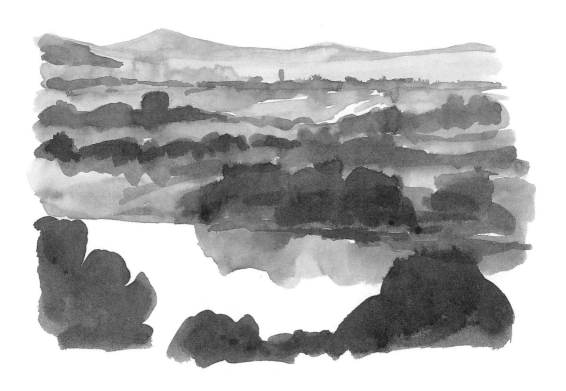

### Claude Lorrain

This wash drawing of the Tiber at Rome after master landscape painter Claude Lorrain has a few small speckles of pen work near the horizon. The tones vary from very pale in the distance, darkening as we approach the foreground, which is darkest of all. The dark tone is relieved by the white patch of the river, reflecting the light sky with an indication of reflection in a softer tone. The tones suggest distance. The actual objects such as trees, buildings, hills and water are not drawn in any detail at all. However, the eye easily picks out the impression of intensely dark trees that are near, contrasting with the bright water, and the fainter tones, which seem to recede until we reach the horizon. Without detail, the effect of a sweeping landscape is convincingly reproduced, just with a variety of tones. A brilliant sketch.

Lorrain gives a real lesson in how to draw nature with this study of a tree. Executed with much feeling but great economy, the whole drawing is done in brushwork.

To try this you need three different sizes of brush (try Nos. 0 or 1, and 6 and 10), all of them with good points. Put in the lightest areas first (very dilute ink), then the medium tones (more ink less water), and then the very darkest (not quite solid ink).

Notice how Lorrain doesn't try to draw each leaf, but makes interesting blobs and scrawls with the tip of the brush to suggest a leafy canopy. With the heavier tones he allows the brush to cover larger areas and in less detail. He blocks in some very dark areas with the darkest tone and returns to the point of the brush to describe branches and some clumps of leaf.

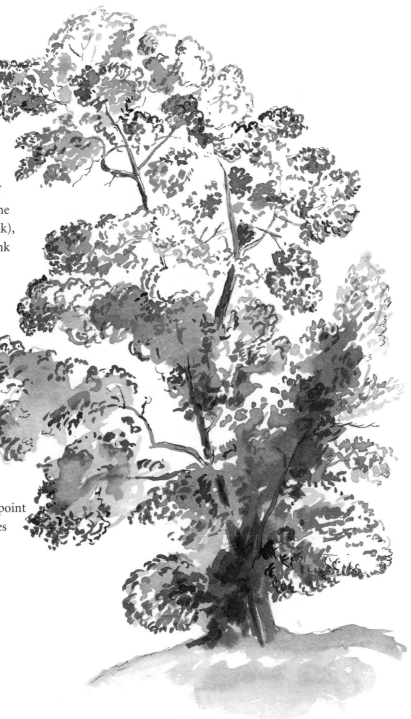

## Giovanni Battista Tiepolo (1692–1770)

Tiepolo is noted for his painted walls and, particularly, ceilings. Although difficult to emulate, his methods of drawing are worth studying. Loose, scrawling lines are accompanied by splashes of wash to give them solidity. What appear to be little more than scribbles add up to wonderful examples of a master draughtsman's first thoughts on a painting. Compare his drawings closely with his elegant paintings and you will see premonitions of the latter in the former.

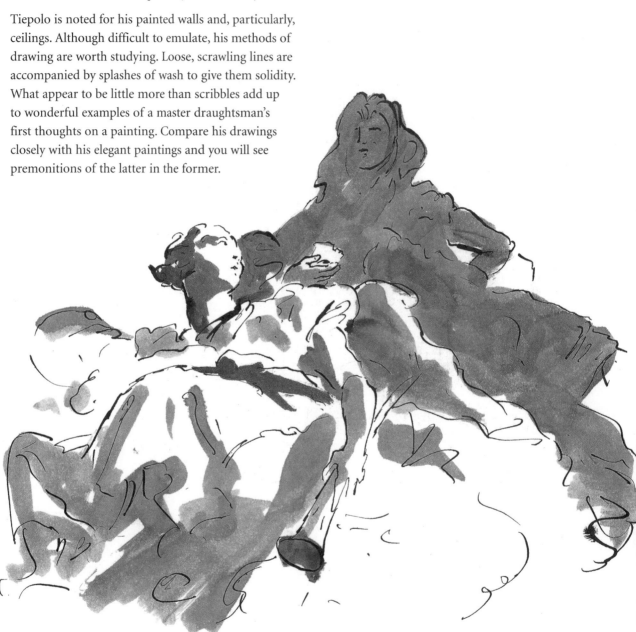

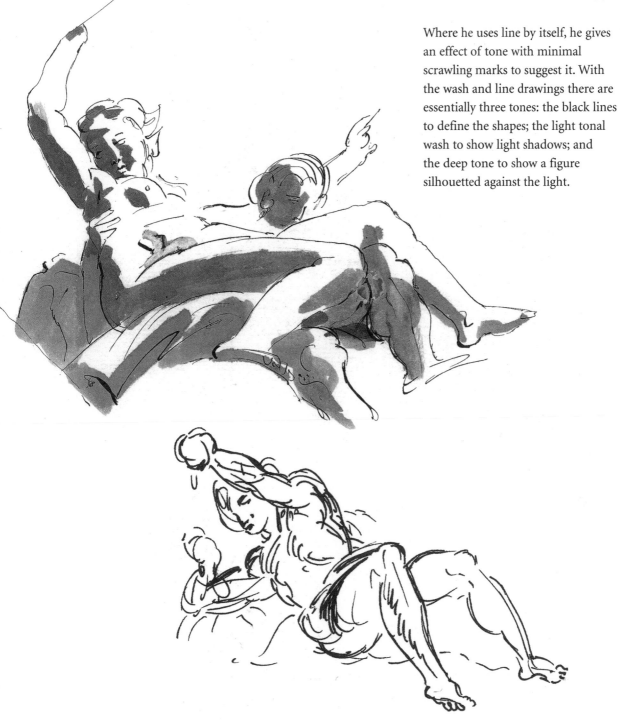

Where he uses line by itself, he gives an effect of tone with minimal scrawling marks to suggest it. With the wash and line drawings there are essentially three tones: the black lines to define the shapes; the light tonal wash to show light shadows; and the deep tone to show a figure silhouetted against the light.

### Antoine Watteau (1684–1721)

In Watteau's picture of a goddess, the dark outline emphasizes the figure and limbs, as do the patches of bright light on the upper facing surfaces. As we have seen on a previous spread, the toned paper makes white so effective and reduces the area you have to cover in chalk.

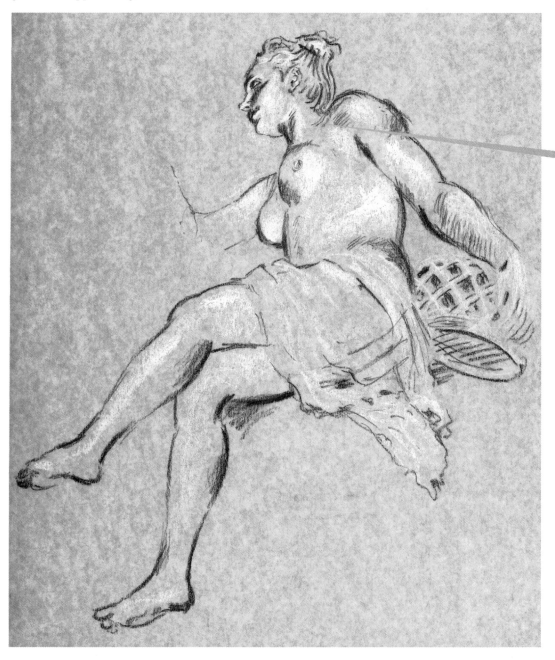

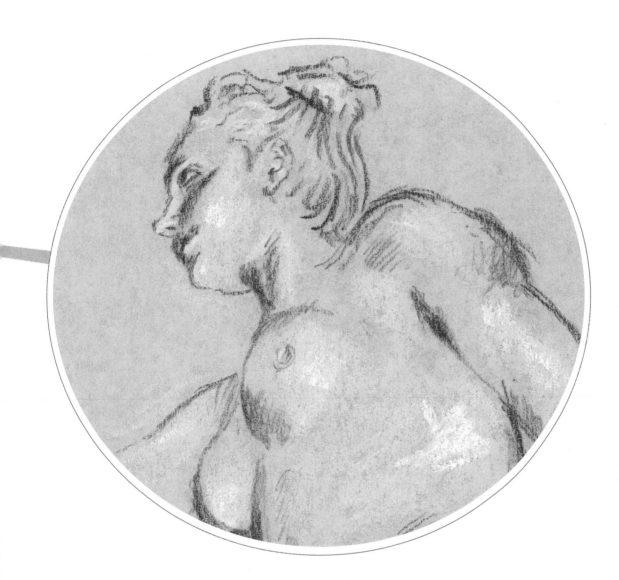

■ *This is a classically trained artist drawing in a similar way to Carpaccio (page 28) using a toned paper and just putting in the darkest and lightest tones in chalk. This enables him to reduce the actual amount of drawing to the minimum, but of course,* *he has to be that much more accurate in what he does put down. The difference between the earlier artist and Watteau is that the latter has the confidence to make his marks looser and softer-edged.*

### Leonardo da Vinci (1459–1519)

When we look at a Leonardo drawing we appreciate the immense talent of an artist who could not only see more clearly than most of us, but also had the technical ability to express his vision on paper. We see the ease of the strokes of silverpoint or chalk outlining the various parts of the design, some sharply defined and others soft, and in multiple marks that give a three-dimensional impression of the surface.

Leonardo regulates light and shade by means of his famous *sfumato* method (Italian for 'evaporated'), a technique by which an effect of depth and volume is achieved by the use of misty tones. The careful grading of the smudgy marks produces the appearance of three dimensions.

The dimensional effect is also achieved with very closely drawn lines that appear as a surface, and are so smoothly, evenly drawn that our eyes are convinced. There is elegance in the way he puts in enough tone but never too much. To arrive at this level of expertise requires endless practice. However it is worth persevering with such techniques because they enable you to produce the effects you want with greater ease.

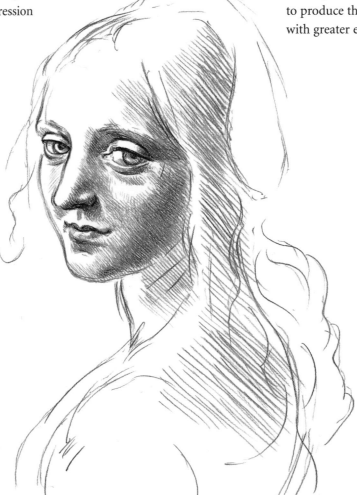

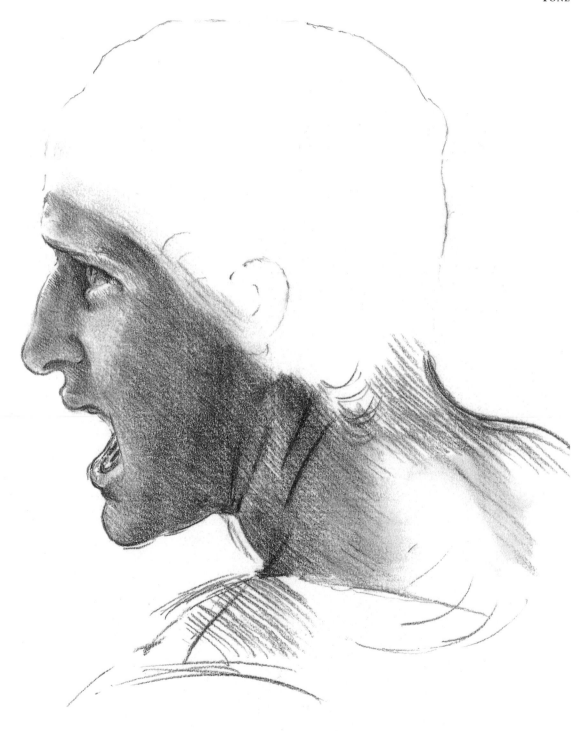

The chalk marks in this close up by **Pierre-Paul Prud'hon (1758–1823)** are very disciplined. A whole range of tones is built from the carefully controlled marks, which show up the form as though lit from above. Here, too, the middle tone is mostly covered over with gradations of black and white.

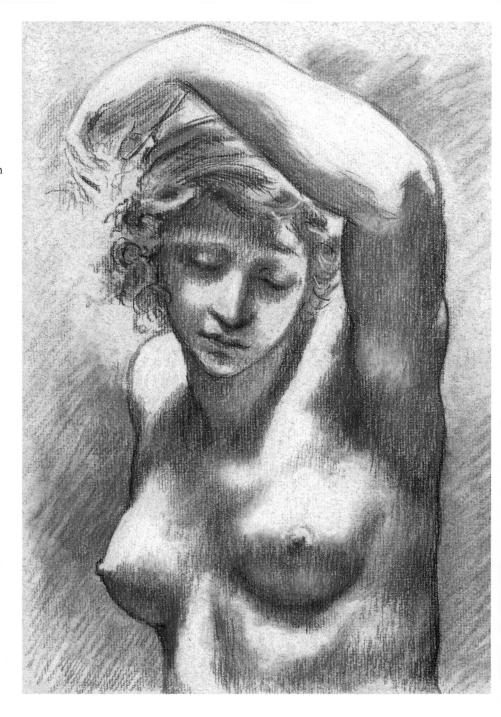

**Gian Lorenzo Bernini (1598–1680)** shows himself in sombre mood. The rather shadowy, soft look to the picture suggests that he is taking a romantic view of himself, but it is beautifully observed and the use of light and shade is masterful.

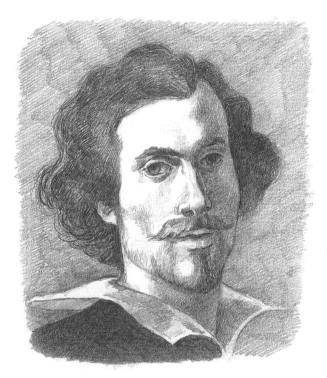

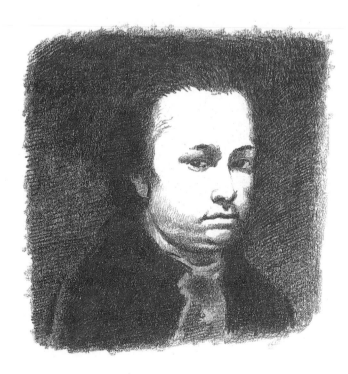

The original of this penetrating self-portrait by **Francisco de Goya (1746–1828)** was produced fairly early in his career. Here he was not afraid to reveal every defect of his own physiognomy – the slightly pudgy, pale complexion and somewhat disgruntled expression – and point them up by providing a contrasting dark background.

### Jean-Auguste-Dominique Ingres (1780–1867)

Ingres was an artist noted for his draughtsmanship. His drawings are perfect even when unfinished, having a precision about them which is unusual. He is thought to have made extensive use of the *camera lucida* – a device whereby a prism was used to transfer the image of a scene onto paper. This is probably correct, but nevertheless the final result is exceptional by any standards.

The incisive elegance of his line and the beautifully modulated tonal shading produce drawings that are as convincing as photographs. Unlike Watteau's, his figures never appear to be moving, but are held still and poised in an endless moment.

The student who would like to emulate this type of drawing could very well draw from photographs to start with, and when this practice has begun to produce a consistently convincing effect, then try using a live model. The model would have to be prepared to sit for a lengthy period, however, because this type of drawing can't be hurried. The elegance of Ingres was achieved by slow, careful drawing of outlines and shapes and subtle shading.

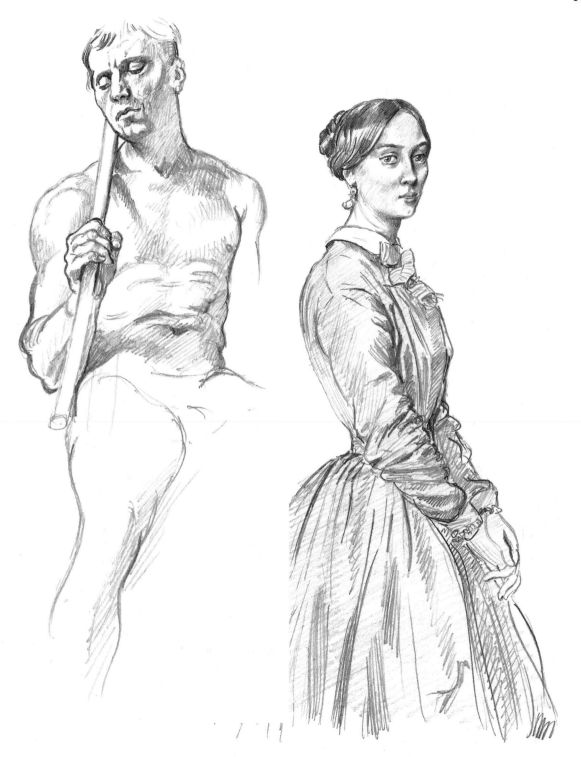

One of the most famous of 20th-century British figurative artists, **John Ward (1917–2007)** has chosen to portray himself in profile for this self-portrait (1983). He has found a brilliant way of conveying vivid animation and a business-like approach through the pose (the balance of the poised brush and palette, the half-glasses perched on the nose) and the dress (formal jacket and tie).

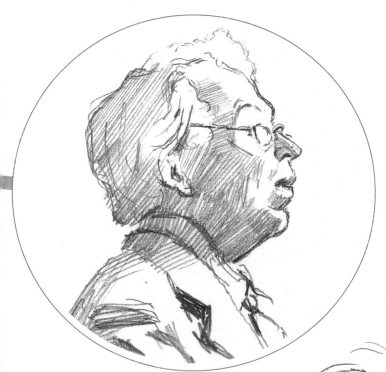

*■ Ward is using the classic approach to tone by using hatching to suggest shadow mass. Here, he is hatching in different directions so that the lines under the chin change direction as they go around the jawline; near the eye, the temple shadow is drawn in yet another direction. It all suggests the faceting of the facial planes, which helps to give a livelier feeling of dimension.*

**David Hockney** uses a similar technique but with a softer, smudged texture. This helps to give a close-up view of the face a less focused look. This self-portrait is a much more rugged affair. The dominant tonal area gives us a very generalized feel of the shape of the head, thereby sacrificing individual characteristics to achieve a more dimensional effect.

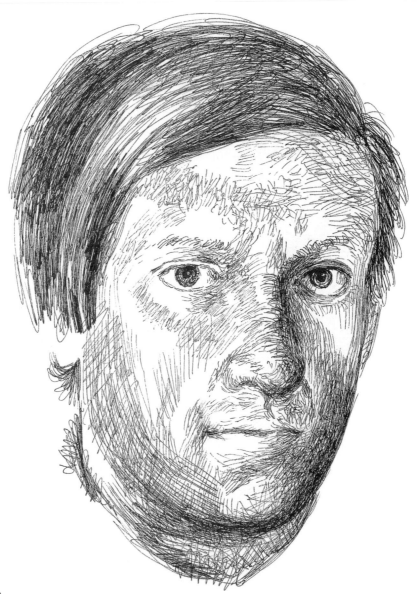

## Pablo Picasso

Multiple lines of varying length seem to describe the contours of this powerful self-portrait in ink by Picasso. The technique used is very interesting. Instead of being built up with successive layers of smooth, controlled hatching, the features are drawn with hook-like wiry lines. It's almost as though the artist has drawn directly onto his own face.

Each mark helps to describe the curve of the surface of the facial features. The method is effective because he has not tried to be economical with his lines. The scribbly looking marks used to carefully build up the face give a sort of coarse texture, the effect of which is to increase the feeling of substantiality.

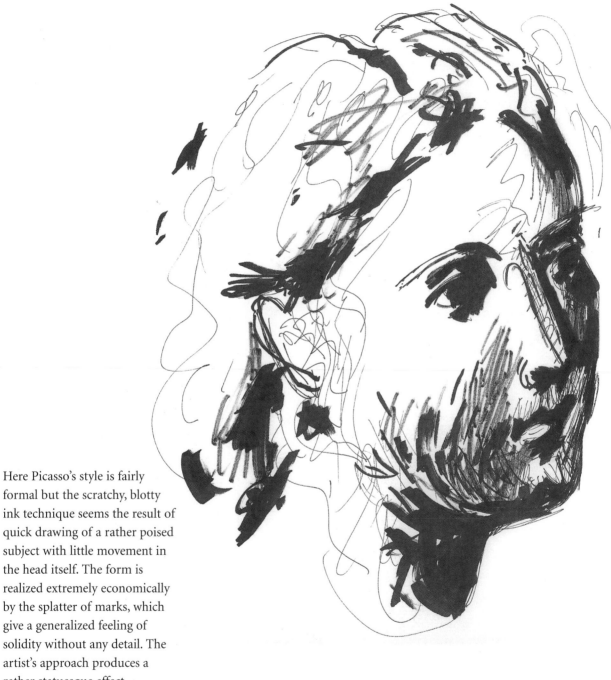

Here Picasso's style is fairly
formal but the scratchy, blotty
ink technique seems the result of
quick drawing of a rather poised
subject with little movement in
the head itself. The form is
realized extremely economically
by the splatter of marks, which
give a generalized feeling of
solidity without any detail. The
artist's approach produces a
rather statuesque effect.

### Henry Carr (1894–1970)

The English illustrator and painter Henry Carr was an excellent draughtsman, as these portraits show. He produced some of the most attractive portraits of his time because of his ability to adapt his medium and style to the qualities of the person he was drawing. The subtlety of the marks he makes to arrive at his final drawing varies, but the result is always sensitive and expressive. A noted teacher, his book on portraiture (*Drawing Portraits*, Longacre Press, 1961) is well worth studying.

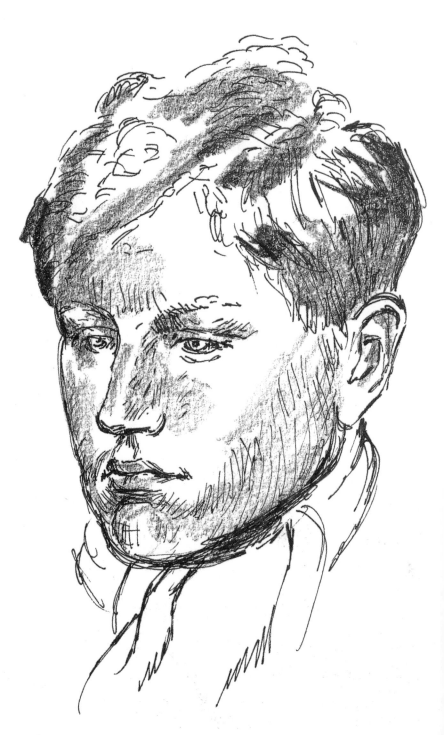

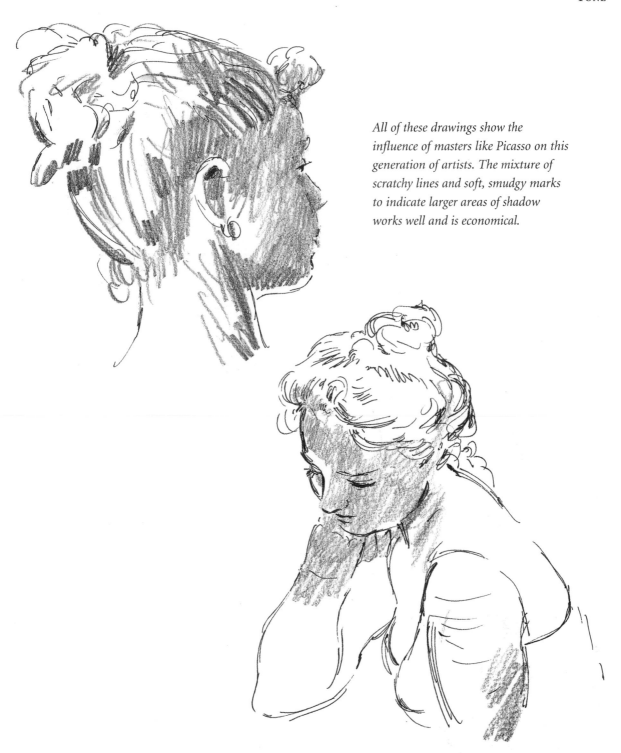

All of these drawings show the influence of masters like Picasso on this generation of artists. The mixture of scratchy lines and soft, smudgy marks to indicate larger areas of shadow works well and is economical.

### Pierre-Paul Prud'hon

The French neo-classicist master Pierre-Paul Prud'hon was a brilliant worker in the medium of chalk on toned paper. In these copies of examples of his work, he shows us two very effective ways of using light and dark tones to suggest form.

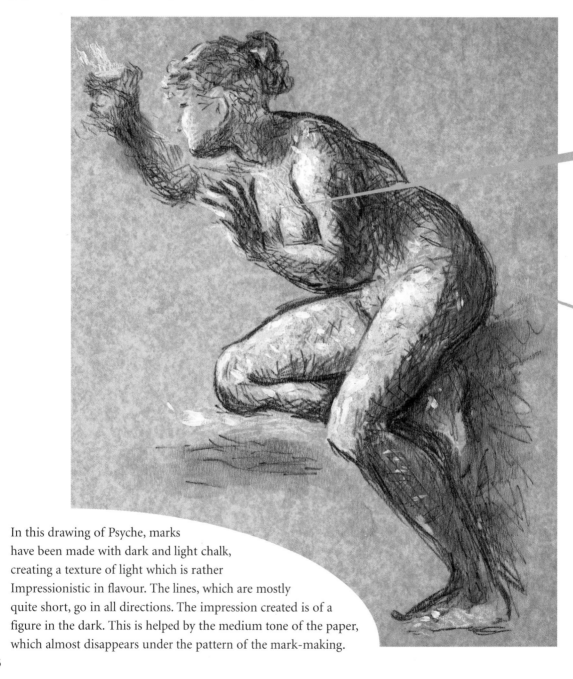

In this drawing of Psyche, marks have been made with dark and light chalk, creating a texture of light which is rather Impressionistic in flavour. The lines, which are mostly quite short, go in all directions. The impression created is of a figure in the dark. This is helped by the medium tone of the paper, which almost disappears under the pattern of the mark-making.

■ *The hand only just exists as a real hand but is rather as you would see it with a strong light falling on to and spilling around the edges of the fingers.*

■ *Note the scribble of marks in all directions, which can create a continuous tone of an unfocused nature.*

### Georges Seurat (1859–1891)

Seurat's style of drawing is very different from what we have seen so far, mainly because he was so interested in producing a mass or area of shape that he reduced many of his drawings to tone alone. In these pictures there are no real lines but large areas of graduated tone rendered in charcoal, conté or thick pencil on faintly grainy textured paper. Their beauty is that they convey both substance and atmosphere while leaving a lot to the viewer's imagination. The careful grading of tone is instructive, as is how one mass can be made to work against a lighter area.

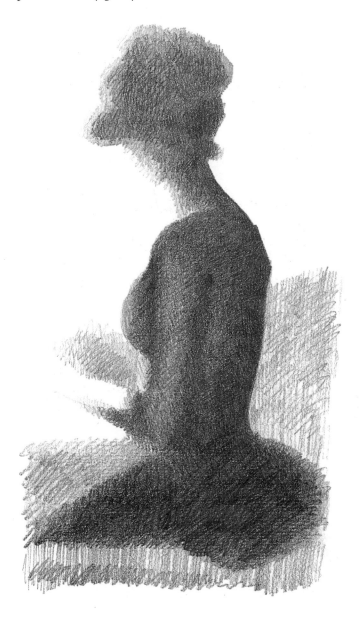

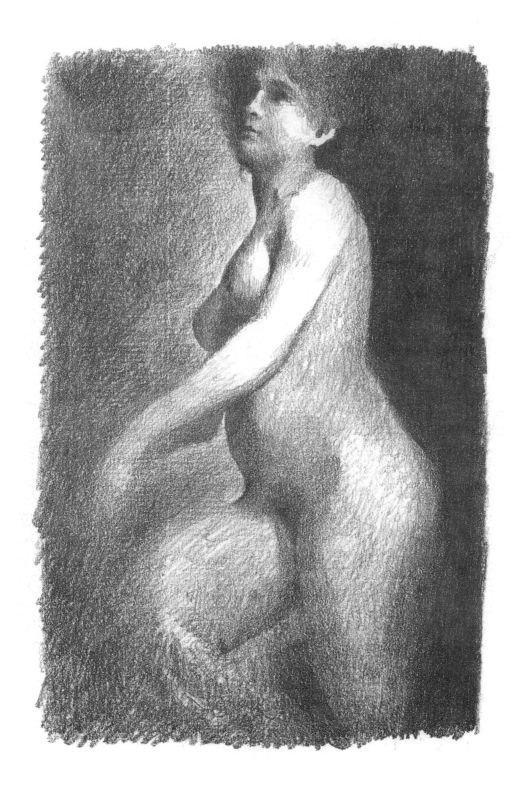

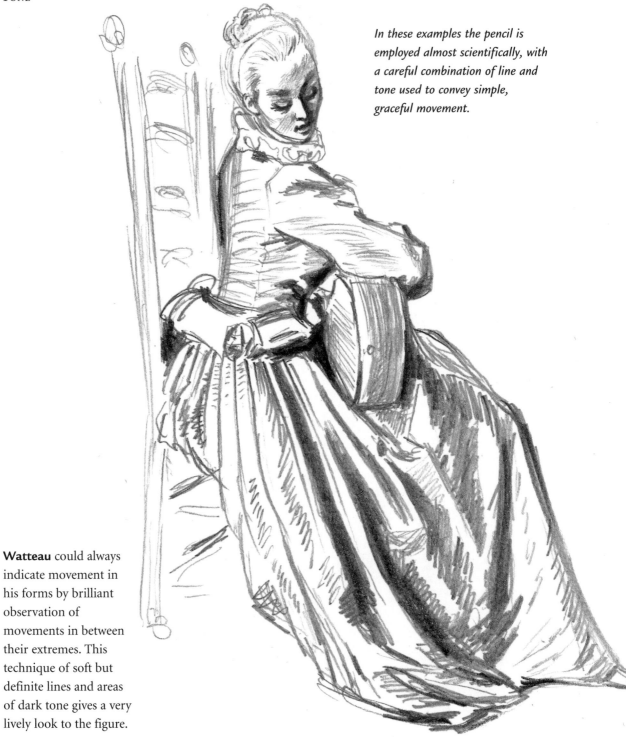

In these examples the pencil is
employed almost scientifically, with
a careful combination of line and
tone used to convey simple,
graceful movement.

**Watteau** could always
indicate movement in
his forms by brilliant
observation of
movements in between
their extremes. This
technique of soft but
definite lines and areas
of dark tone gives a very
lively look to the figure.

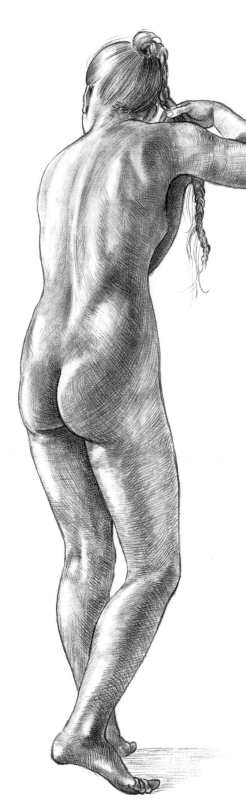

This meticulous pencil drawing by the German **Julius Schnorr von Carolsfeld (1794–1872)** is one of the most perfect drawings in this style I've ever seen. The result is quite stupendous, even though this is just a copy and probably doesn't have the precision of the original. Every line is visible. The tonal shading which follows the contours of the limbs is exquisitely observed. This is not at all easy to do and getting the repeated marks to line up correctly requires great discipline. It is worth practising this kind of drawing because it will increase your skill at manipulating the pencil and test your ability to concentrate.

## Otto Greiner (1869–1916)

Greiner's approach to form is essentially that of the classical artist, as this copy shows, with the light and shade carefully and sensitively handled. It's an effective if slow and painstaking method, well worth mastering.

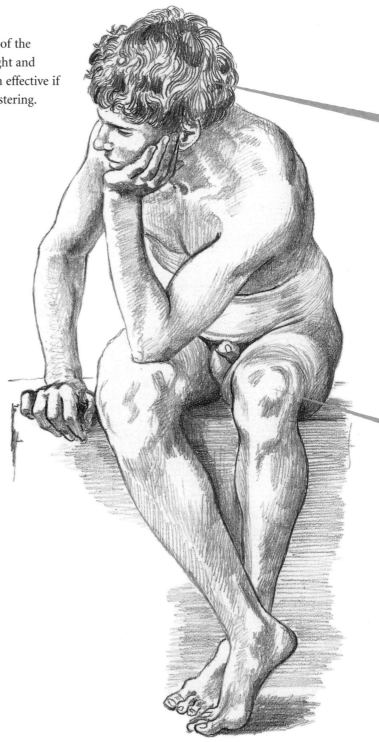

■ *Notice how some lines on the drawing follow the contours around the form and sometimes go across it.*

■ *The method of showing the texture of the hair is clever because it suggests immediately a different surface material from the rest of the body.*

■ *Would you know what this was when isolated like this? I think probably yes, after a moment of looking. But in the context of the whole figure it works extremely well.*

# Texture

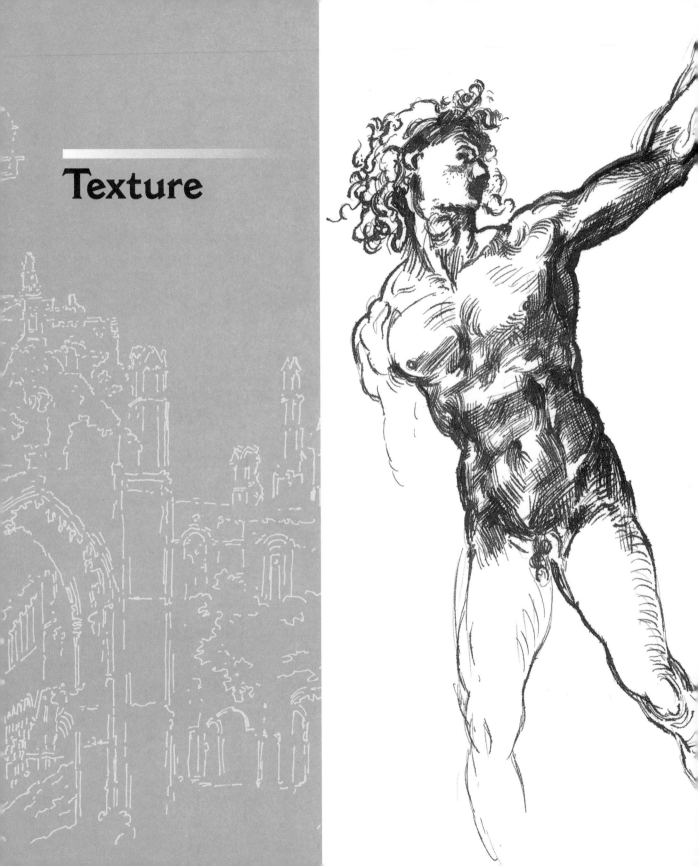

The representation of texture has an interesting function in a drawing because it is capable of doing two things at once. It partly convinces the viewer of the dimensional quality of a scene, and also imparts a general sense of touch to the picture. Although, of course, there is no actual touching involved, our intellectual stimulus is related to our experience of texture in real life. If, for example, a glass jar is drawn reproducing the reflections usually seen in real glass, the eye 'reads' that the material of the jar is glass and persuades our other senses that this is so. Not only that, the overall artistic handling of the picture can give us a sense of the density and materiality of the subject.

Every artist in this section has succeeded in reproducing scenes, people and objects with considerable skill in terms of textural quality; from surfaces that make you believe you can almost feel them, to scenes in which you can sense the space and solidity of features. Sometimes, the marks are drawn with a strong, almost bristly quality to them, so that as one's gaze wanders across the surface, scanning the scene, one gets an impression of tangible materiality. At other times, the smoothness and subtlety of the artist's marks create a homogeneity, which calms the visual response. The interpretation of texture is important in helping to connect our senses more closely to the subject matter of the composition.

### Maurice de Vlaminck (1876–1958)

In this landscape after Vlaminck the lines are thick and textured and the areas of tone have been marked in more softly. The total effect seems to have been achieved with a mass of swirling, strong, solid lines. No stylistic distinction is observed between the trees and the houses behind them. The overall impression conveyed is that the natural world is as substantial as man's.

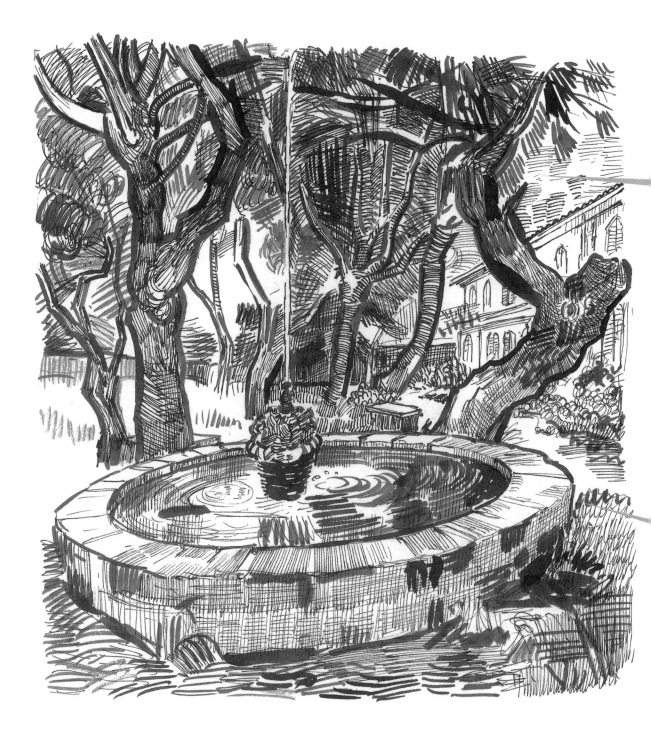

**Vincent van Gogh (1853–1890)**
In Van Gogh's *Fountain in the Garden of St Paul's*, there is graphic emphasis on the lines of the various trees and stones and the handling of textural effects to create tone and weight. The mixture of large slashing marks and fine hatched lines builds a convincing and vigorous picture that packs quite a punch.

■ *Look at the fine detail of the lines criss-crossing, to suggest the rough surface of the stone surround of the fountain, limited by the thick, solid lines of the upper edge and the ripples in the water.*

In this loosely drawn copy of a composition by **John Constable (1776–1837)**, the areas of trees and buildings have been executed very simply. However, great care has been taken to place each shape correctly on the paper. The shapes of the trees have been drawn with loosely textured lines. The areas of deepest shadow show clearly, with the heaviest strokes reserved for them.

When producing landscape drawings it is very easy to be daunted by the profusion of leaves and trees. Do not attempt to draw every leaf. Draw leaves in large clumps, showing how the brightly lit leaves stand out against ones in the shadow. Each group of leaves will have a characteristic shape which will be repeated over the whole of the tree. Obviously these will vary somewhat, but essentially they will have a similar construction. You can do no better than to look at Constable landscapes and notice how well he suggests large areas of leaves with a sort of abstract scribble. He also suggests the type of leaf by showing them drooping or splaying out, but he doesn't try to draw each one. The only part of a landscape where you need to draw the leaves in detail is in the nearest foreground. This persuades the eye into believing that the less detailed areas are further back.

The Italian painter **Giorgio Morandi (1890–1964)** had a particular style that is like no other. His etchings of still-life subjects have a dark solidity about them, as in this example. He achieved this effect by piling on fine lines of cross-hatching which, taken in combination, create very substantial, dramatic darks and lights.

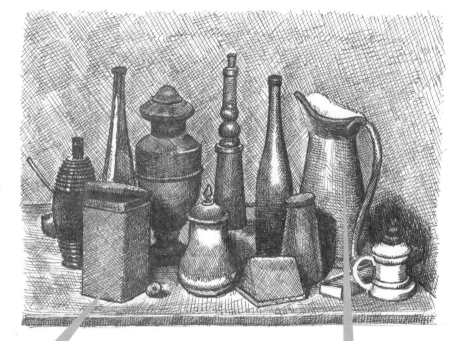

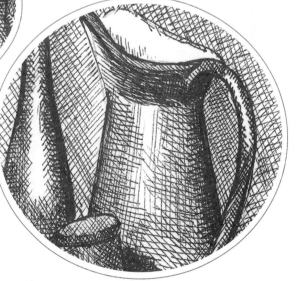

■ *Look at the regular cross-hatching of lines that help to suggest the hard texture of the tin box, and the slightly less tight forms of the shelf it is standing on.*

■ *The loose, large, open texture of the background space contrasts with the carefully graduated cross-hatching that indicates the cylindrical volume of the enamelled jug, catching the light at certain points.*

## Diego Rivera (1886–1957)

Here we look at a still life by Rivera, the revolutionary Mexican artist who painted many large murals in the 1930s and 1940s. This rather refined pencil drawing looks anything but revolutionary, with its carefully graded tones, which give a strong effect of texture and dimension. The only thing that tells us it is a 20th-century drawing is the rather naïve wobble to the shape of the decanter and the simplicity of the folds of the cloth. Apart from that it has a timeless elegance.

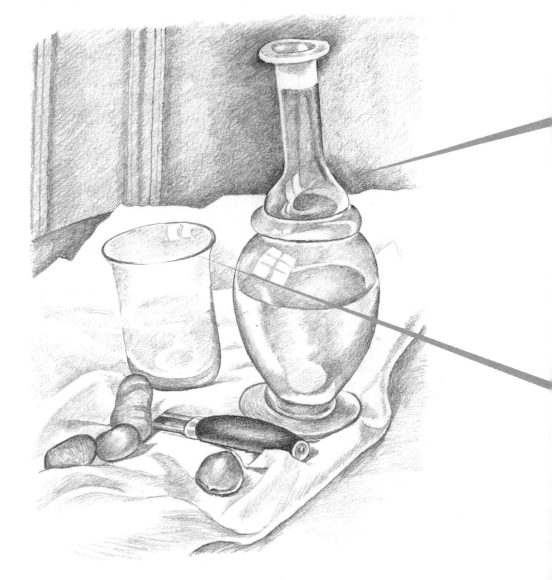

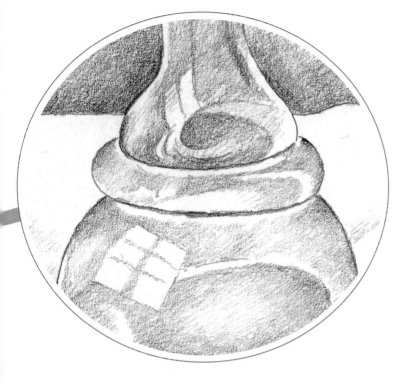

■ *The variations of pencil texture on this drawing of a glass receptacle tells us a lot about the material it's made from, with the water within reflecting the light of the room.*

■ *Note the difference in texture between the darkened background, the white tablecloth and the clear, shining glass.*

This next copy, of a **Michelangelo**
drawing, is much more heavily
worked over than the Rivera still-life,
with hefty cross-hatching capturing
the muscularity of the figure. The
texture is rich and gives a very good
impression of a powerful, youthful
figure. The left arm and the legs are
unfinished but even so the drawing
has great impact.

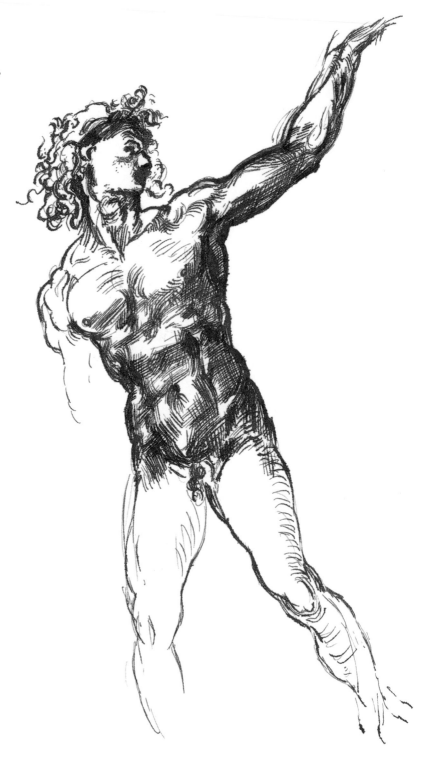

**Henry Fuseli (1741–1825)** drew this self-portrait when he was in his thirties. It shows the anxieties and self-doubt of someone mature enough to be aware of his own shortcomings. B and 2B soft pencils were used for this copy to capture the dark and light shadows as well as the sharply defined lines depicting the eyes, nose and mouth.

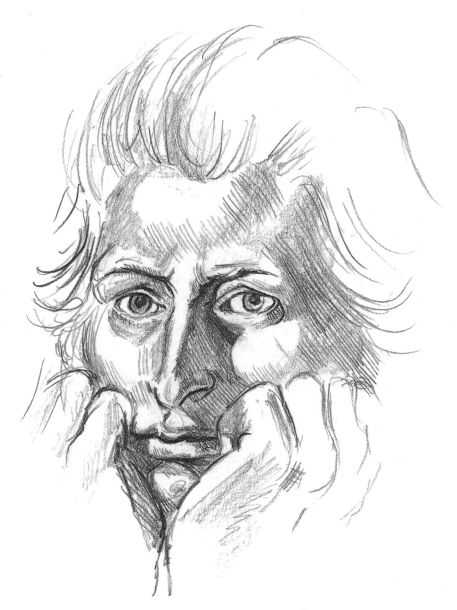

■ *Note the textural handling of the face with its evenly drawn tonal lines, and vigorous and free outlines.*

## Guercino

Drawn in pen and ink, after Guercino, these two
examples are graphic depictions of the ravages of age,
although there is no record of how old the men were.
I tried to emulate Guercino's methods, using bold
strokes in some places (hair and hood) with tentative
broken lines.

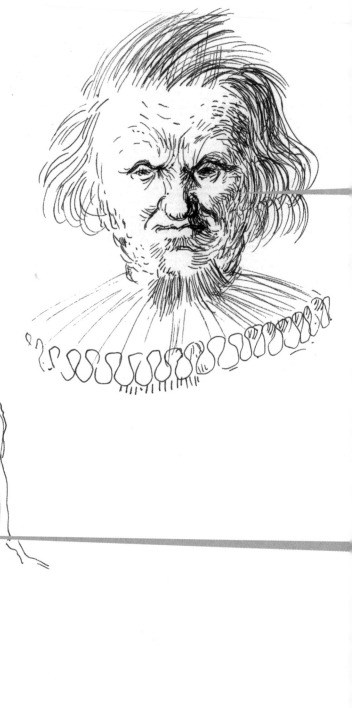

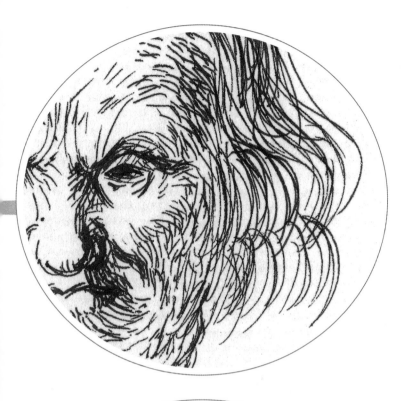

■ *These wiry, boldly drawn lines create the texture of the rather unkempt hair and also the slightly coarse-looking skin on the face.*

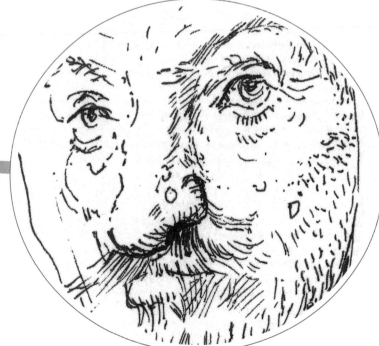

■ *The details of this face have a texture that convinces us of the corrugated quality of the skin of this battered-looking man. It is expressive of how the skin might feel.*

In his masterly original of this ink line drawing, **Jacopo Tintoretto (1518–1594)** was careful to get the whole outline of the figure. The curvy interior lines suggest the muscularity of the form. There is not too much detail but just enough to convince the eye of the powerful body; every muscle here appears to ripple under the skin. The barest of shading suggests the form.

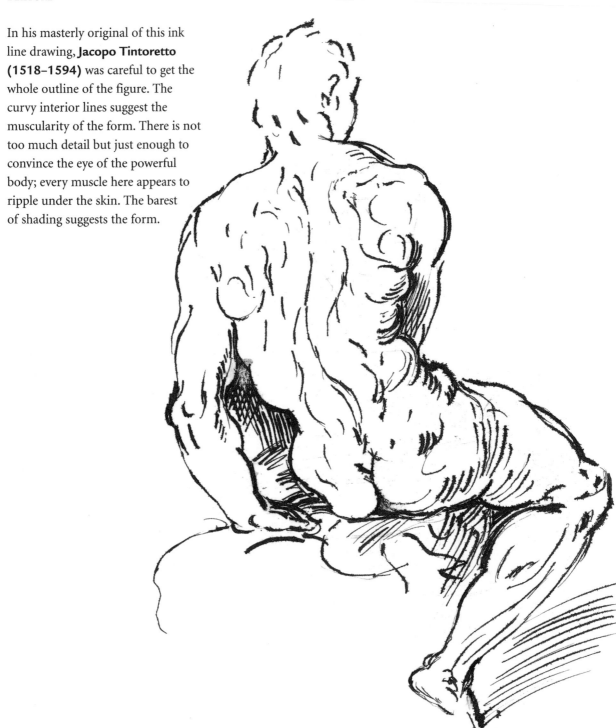

**Michelangelo**'s drawing is much smoother in texture because he has put in the halftones and not only the bare lines as in Tintoretto's. This texture gives a more tactile quality to the figure.

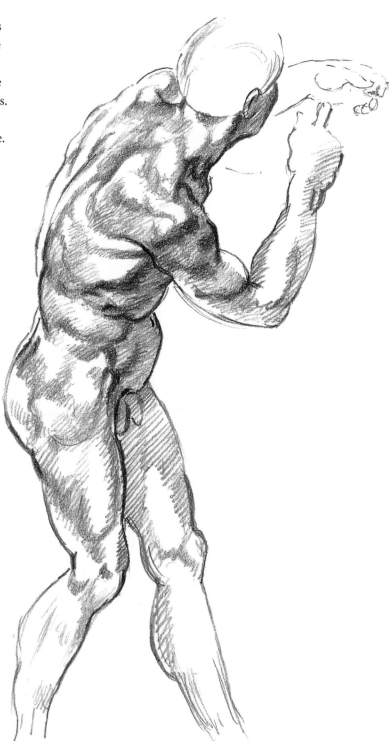

In this drawing the great Renaissance artist **Raphael Sanzio (1483–1520)** used a very particular technique of the time, which was probably influenced by Michelangelo. The use of ink in clearly defined lines and lightly textured cross-hatching, gives a very precise result in which there is no doubt about the shape and bulk of the figure. It is a good, albeit rather difficult, method for a beginner that is worth practising and persisting with.

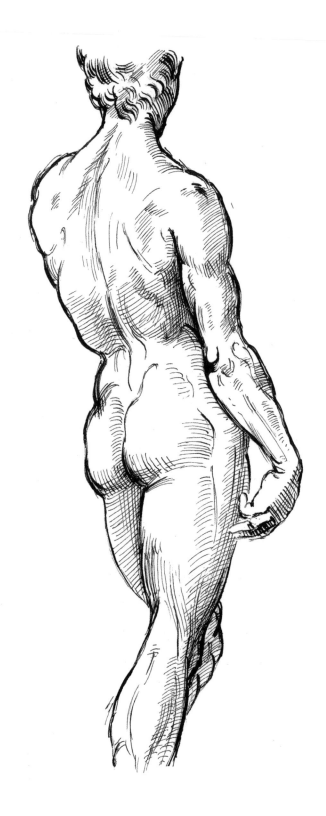

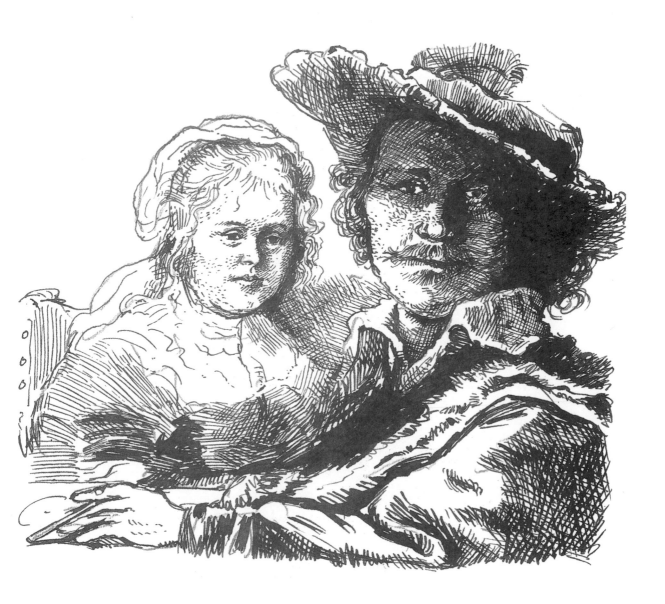

This double portrait of **Rembrandt van Rijn (1606–1669)** and his wife looks a bit odd because she is set back behind her husband. Possibly the artist had to use a mirror to assist in drawing them both and as a result she would necessarily be more distant in perspective. He has tried to balance the effect by showing his own face in shadow and highlighting that of his wife. Look at the dense texture, where he is producing an effect similar to his tonal paintings. The texture of the ink lines gives an impression of dark shadow on the man's face under the brim of his hat, while the woman's is lighter, with a dotted texture to give a softer look.

# Form

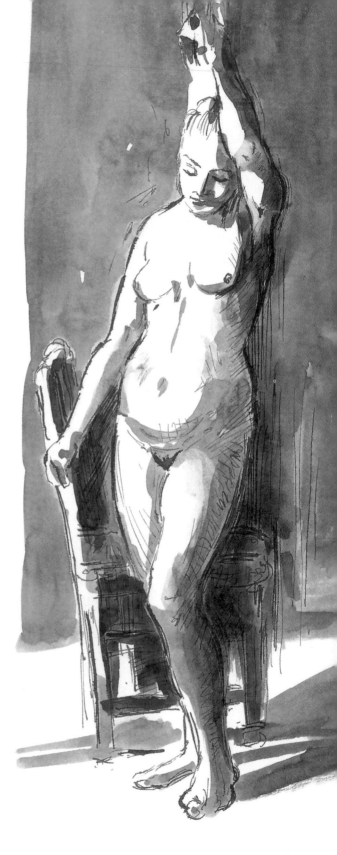

The previous chapters have dealt with elements of line, tone and texture, depicted in drawings by master artists. These elements help to convince us of the form of objects, people or scenery. Form itself is the way a draughtsman tries to convey the three-dimensional structure of an object. It is of course another illusion (like texture), but by orchestrating the marks on the surface of the drawing, the artist induces the impression of seeing a form in space. This can be done in a number of different ways, and we have by no means exhausted the possibilities of doing it here. All the artists cited in this book want to demonstrate to the viewer how any person, animal, object, or landscape may be interpreted through the marks that they set down on the paper. We all know that the surface we are looking at is two-dimensionally flat, but with great skill and understanding of how our visual sense works, these artists work to show us that two-dimensional marks can be read as three-dimensional things occupying space.

The previous sections have shown in a fragmentary way how these illusions of form and space can be produced, but of course the artist needs to keep the whole work in mind in order to put all these methods together harmoniously.

An interesting challenge, for an artist who has achieved some good results, is to create a form with an economy of marks. This is not quite as easy as it sounds, but with a bit of practice you will soon learn ways of doing it. Finding suitable master drawings is part of the fun, and then you learn to copy their methods without merely reproducing their drawings. Don't be afraid to copy the masters until you find out how they worked in detail.

## FORM

*Form is always difficult for an artist, and each time that the attempt to show form on a flat surface succeeds it is partly due to how we think we see real form in real space.*

**Raphael** was a master draughtsman, who with quite small areas of tonal drawing, and indications of the turn of a shape, away from or towards the viewer, convinces us that indeed we are looking at a three-dimensional form. This kneeling figure of a girl is not heavily overworked, but we can see quite easily her solidity and rounded form.

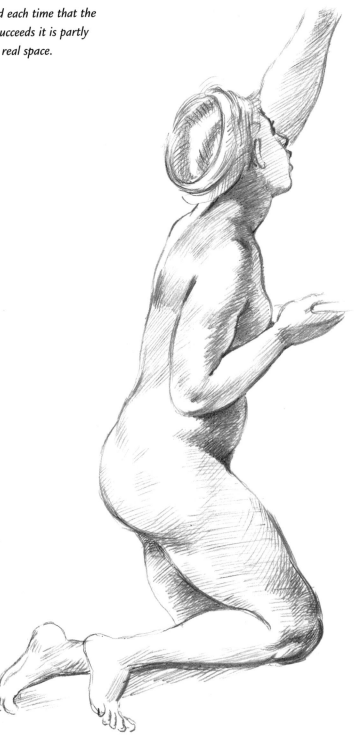

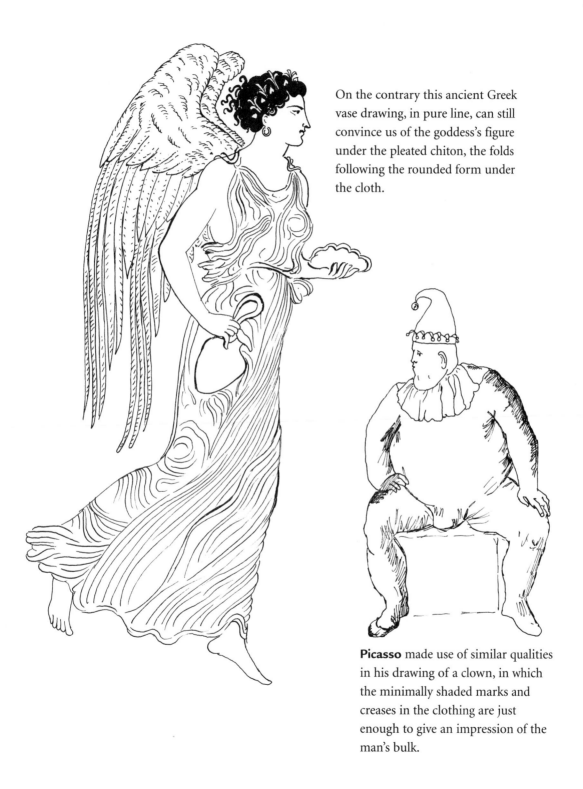

On the contrary this ancient Greek vase drawing, in pure line, can still convince us of the goddess's figure under the pleated chiton, the folds following the rounded form under the cloth.

**Picasso** made use of similar qualities in his drawing of a clown, in which the minimally shaded marks and creases in the clothing are just enough to give an impression of the man's bulk.

## Raphael

The perfection of Raphael's drawings must have seemed extraordinary to his contemporaries, even though they had already seen the works of Filippo Lippi, Botticelli, Michelangelo and Leonardo. His exquisitely flowing lines show his mastery as a draughtsman; notice the apparent ease with which he outlines the forms of his Madonna and Child, and how few lines he needs to show form, movement and even the emotional quality of the figures he draws. His loosely drawn lines describe a lot more than we notice at first glance. It is well worth trying to copy his simplicity, even though your attempts may fall far short of the original. The originals are unrepeatable, and it is only by studying them at first hand you will begin to understand exactly how his handling of line and tone is achieved.

Pen and ink is special in that once you've put the line down it is indelible and can't be erased. This really puts the artist on his mettle because, unless he can use a mass of fine lines to build a form, he has to get the lines 'right' first time.

Once you get a taste for using ink, it can be very addictive. The tension of knowing that you can't change what you have done in a drawing is challenging. When it goes well, it can be exhilarating.

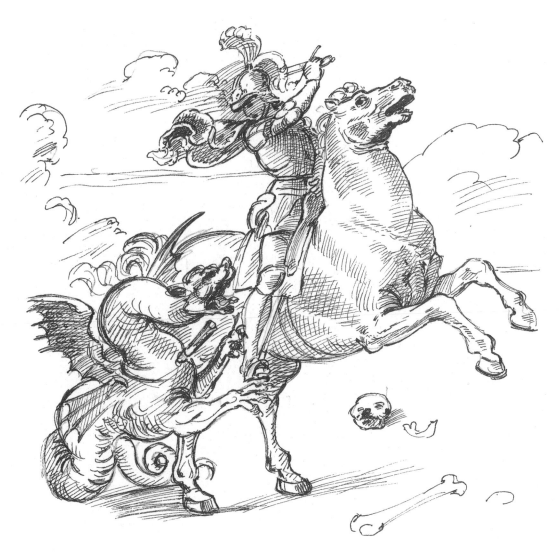

This copy of another Raphael is more heavily shaded in a variety of cross-hatching, giving much more solidity to the figures despite the slightly fairy-tale imagery. The movement is conveyed nicely, and the body of the rider looks very substantial as he cuts down the dragon. The odd bits of background lightly put in give even more strength to the figures of knight, horse and dragon.

*Here we look at the effects of form that can be obtained by using a mixture of pen and brush with ink. The lines are usually drawn first to get the main shape of the subject in, then a brush loaded with ink and water is used to float across certain areas to suggest shadow and fill in most of the background to give depth.*

*A good-quality solid paper is necessary for this type of drawing; try either a watercolour paper or a very heavy cartridge paper. The wateriness of the tones needs to be calculated to the area to be covered. In other words, don't make it so wet that the paper takes ages to dry.*

**Rembrandt**'s handling of form is remarkably straightforward and very effective. The washed tone and the slight scratchy texture of the figure and background clearly shows us the form of the posed female body in a room lit by a direct side light. This copy of a Rembrandt is very dramatic in its use of light and shade.

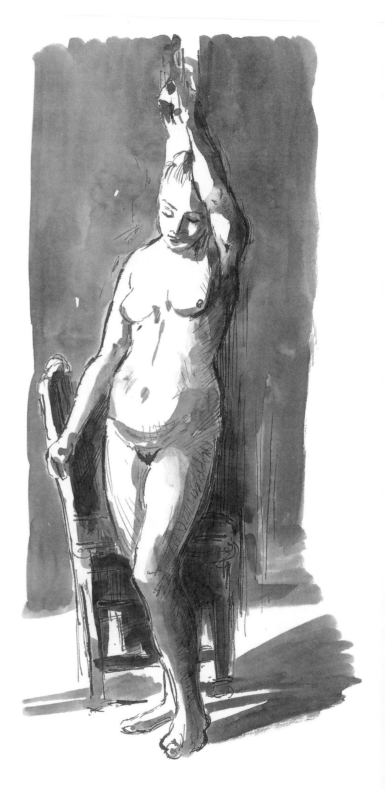

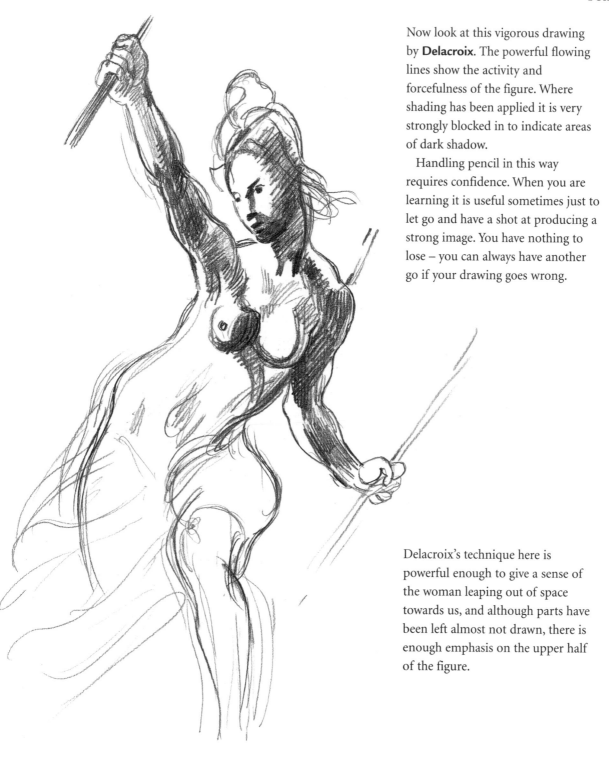

Now look at this vigorous drawing by **Delacroix**. The powerful flowing lines show the activity and forcefulness of the figure. Where shading has been applied it is very strongly blocked in to indicate areas of dark shadow.

Handling pencil in this way requires confidence. When you are learning it is useful sometimes just to let go and have a shot at producing a strong image. You have nothing to lose – you can always have another go if your drawing goes wrong.

Delacroix's technique here is powerful enough to give a sense of the woman leaping out of space towards us, and although parts have been left almost not drawn, there is enough emphasis on the upper half of the figure.

*Both the artists shown here have made magnificent studies of animals in action and repose, and these two examples show how a carefully faceted version by* **Delacroix** *and a* *more linear version by* **Victor Ambrus (b. 1935)**. *Both manage to convey the weight and dimensional aspects of these animals.*

Delacroix was a pupil of Guérin, a follower of the great neo-classicist David. It was from this tuition that he gained an understanding of line, mass and movement which he exploited in his more adventurous drawings. In this study he skilfully suggests, in a few rapidly drawn lines, the tone and weight of the lion. Delacroix travelled widely and carried his sketchbooks with him wherever he went, to the great advantage of both his own art and that of his followers.

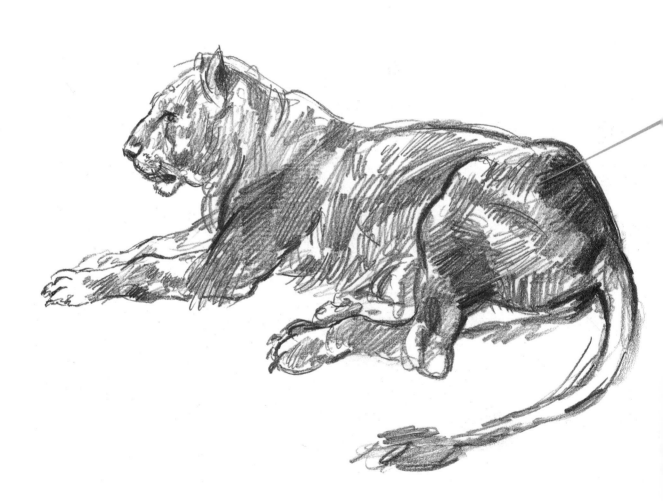

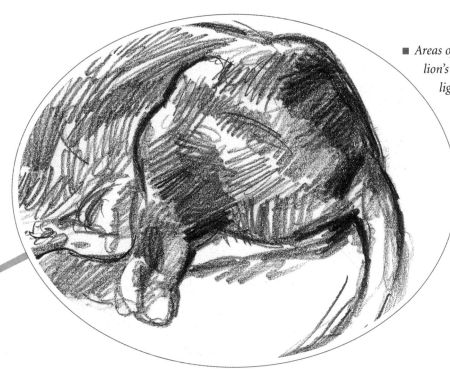

■ *Areas of dark tone layered over the lion's rump, combined with lighter patches where the white of the page shows through, create the impression of a heavy, powerful form.*

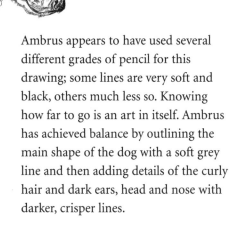

Ambrus appears to have used several different grades of pencil for this drawing; some lines are very soft and black, others much less so. Knowing how far to go is an art in itself. Ambrus has achieved balance by outlining the main shape of the dog with a soft grey line and then adding details of the curly hair and dark ears, head and nose with darker, crisper lines.

When using line and wash, the handling of the wash is particularly important, because its varying tonal values can be used to create different effects. Here we look at two drawings by **Claude Lorrain**.

■ *Lorrain's technique of line and wash is an effective way of showing form. This sensitive pen line drawing of part of an old Roman ruin has a light wash of watery ink to suggest the sun shining from behind the arch. The wash has been kept uniform.*

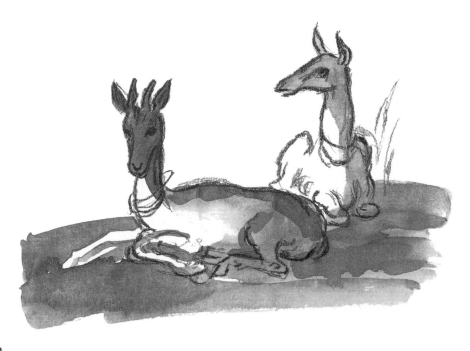

■ *These two deer are fairly loosely drawn in black chalk. A variety of tones of wash has been freely splashed across the animals to suggest form and substance.*

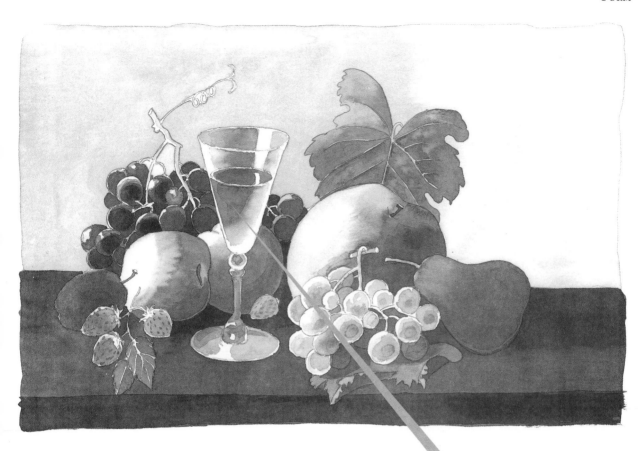

This Renaissance-type drawing, after a painting by **Severin Roesen (1815–1872)** executed in 1870, is a graded wash of tone inside carefully drawn pencil outlines, and requires a great deal of control of your materials and tools. Try it out, but don't be discouraged if it doesn't always work. It takes a bit of time to get the precision needed in handling the brushes and pigment. To make it easier, use a good, thick watercolour paper. The tonal wash will diffuse better and be easier to control.

Roesen's watercolour technique shows how it is possible to give an effect of form by carefully graded tones around the shapes of objects. The glass of wine is particularly effective.

93

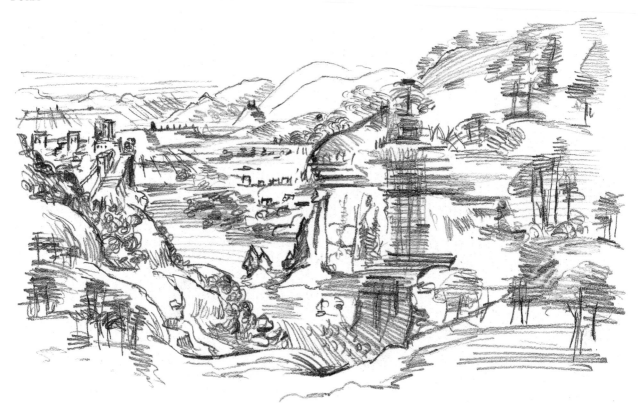

The myriad layers of features make this type of landscape very attractive to artists. This example is after **Leonardo**. Notice the way details are placed close to the viewer and how the distance is gradually opened up as the valleys recede into the picture. Buildings appear to diminish as they are seen beyond the hills and the distant mountains appear in serried ranks behind. This is a good example of using lightly sketched, impressionistic forms to create an effect of space and distance.

Here is a large, dramatic sky, after **Constable**, depicting a rainstorm over a coastal area, with ships in the distance. The sweeping linear marks denoting the rainfall give the scene its energy. Constable has used the tiny forms of the ships to show the sheer scale and fury of the storm unleashed from the sky, creating an impression of awe in the viewer. The effect of stormy clouds and torrential rain sweeping across the sea is fairly easily achieved, as long as you don't mind experimenting a bit. Your first attempt might not be successful, but with a little persistence you will soon start to produce interesting effects, even if they are not exactly accurate.

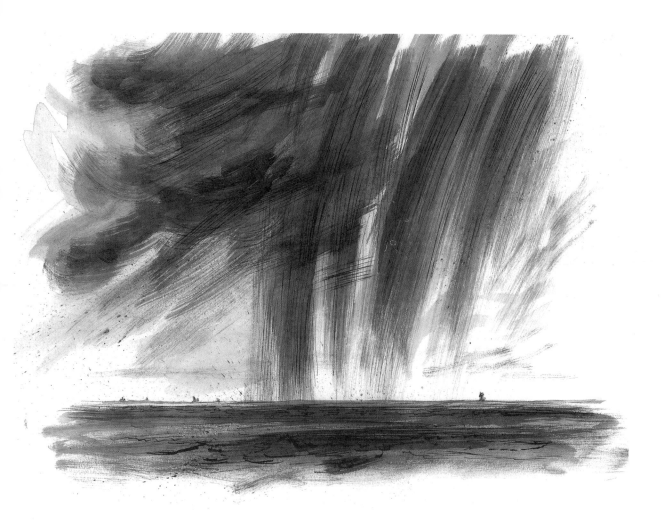

This pen and wash example, after **J.M.W. Turner**, offers large areas of tone and flowing lines to suggest the effect of a coastal landscape.

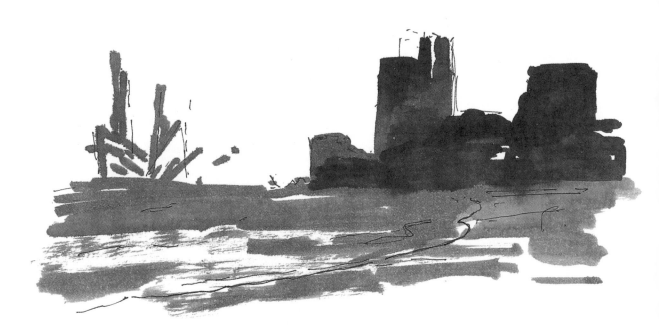

Turner's landscape implies form by the density of the splashed-on tone. The building is solid and light-blocking, whereas the ship-like marks suggest something much less tangible. The black mass of the buildings also sets a limit to the sweep of grey landscape in the foreground. This helps to create a sense of perspective in the scene, with the curve of the beach culminating in the massive castle-like structure.

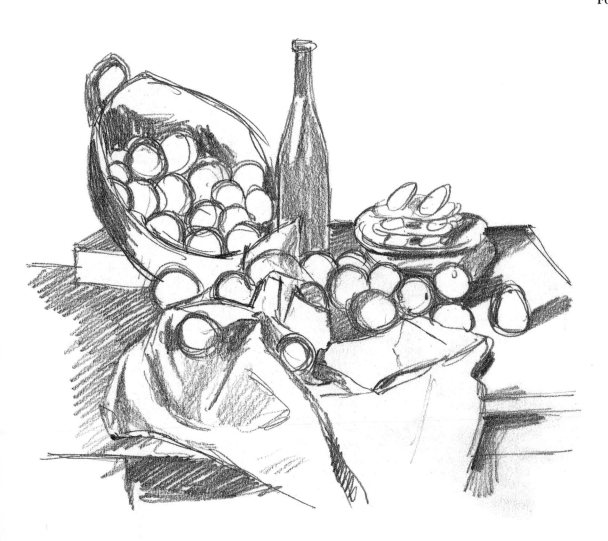

**Paul Cezanne**'s **(1839–1906)** keen observation of the form of objects was one of his great talents. Here in this still life, although everything is drawn in the most minimal fashion, it is clear that the forms spilling across the tabletop have a solidity about them. This is a bit surprising when we see how the drawn marks are so minimal.

The bottle and folds in the tablecloth give assistance as a vertical element to the spilled abundance of fruit in the centre of the picture. The relationship of the structure of each object is submerged into the main shape and yet runs through the whole picture to make a very satisfying composition.

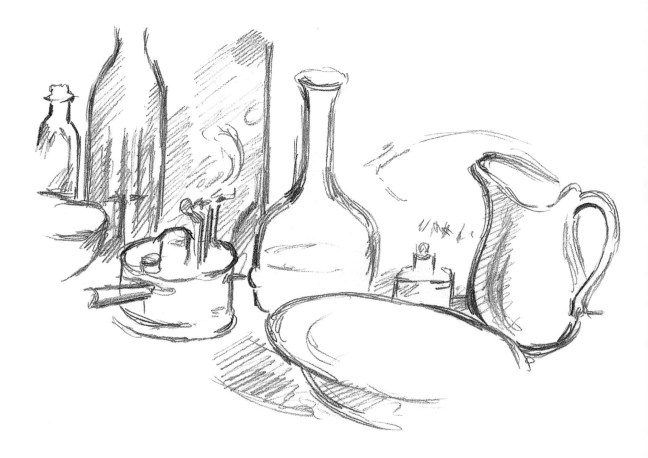

**Cézanne** tried to discover the form of objects by drawing multiple lines around their edges. He was trying to give multiple views of his objects, such as you get when you view something from many slightly different angles. In this example his lines suggest that you can actually see round the edges of the objects.

The Cubists (artists such as Braque, Léger, Ozenfant and, shown here, **Picasso**) took Cézanne's analysis one stage further by attempting to draw objects from contrasting viewpoints – from the side, front, above, below, and so on. In the process they had to fragment their images to be able to show these various approaches in one picture. This led to the typical cuboid sets of images for which they were named. These artists succeeded in changing how we look at the world, although their methods are rarely employed now.

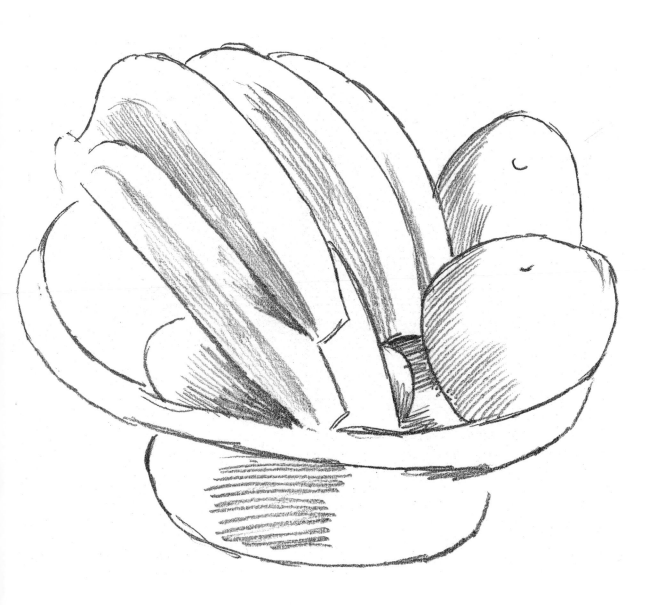

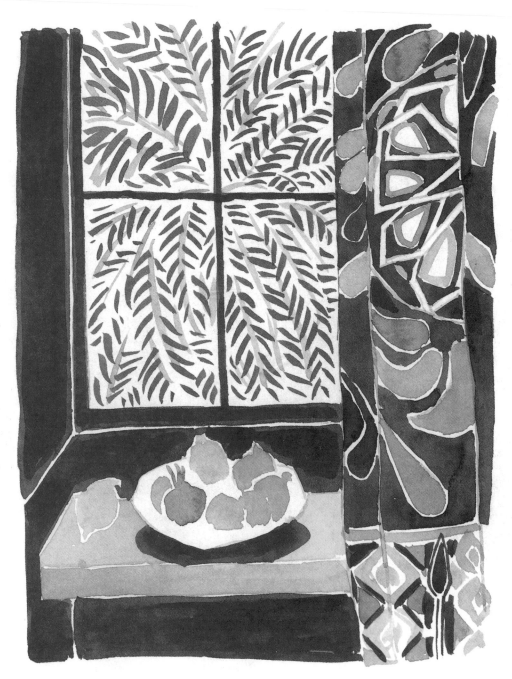

**Matisse**'s **(1869–1954)** still life in front of a window with an Egyptian curtain is here rendered in brush and wash technique which is kept very simple to suit the style that he favoured. The patterning of the shapes is a favourite device of this artist. Although it may seem a straightforward process, it requires great discrimination in determining exactly how the original scene should be simplified into a jigsaw of forms.

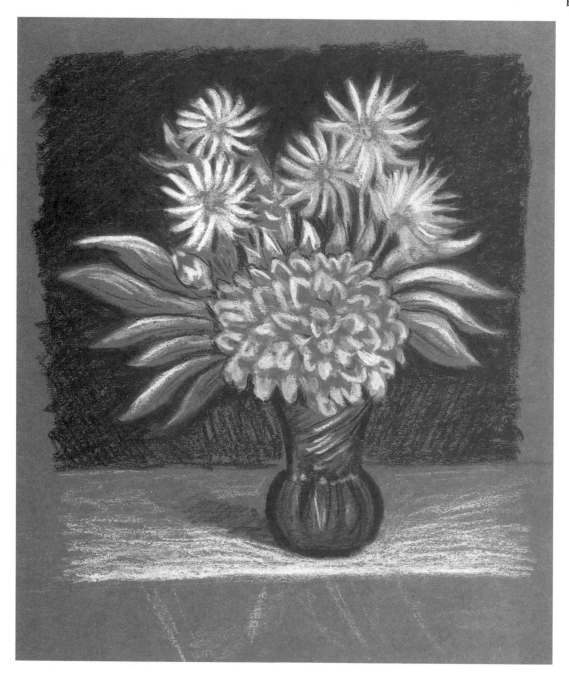

A chalk drawing like this one after **Henri Rousseau (1844–1910)** can be very powerful and decorative at the same time. The simplicity of the repetition of shapes and tonal patterns in *Vase of Flowers* (1900) make this an almost folk art kind of picture, and the intensity of the chalk on the tinted paper provides a powerful impact, heightened by its simplicity.

This study by **Filippo de Pisis (1896–1956)**
is drawn in a looser, more impressionistic way. Here
the intention of a 20th-century artist is to create a
feeling of light glancing off the ingredients in an
arrangement of apples and a melon slice. It is
almost dissolving into the surrounding space. The
form is there, but shimmering with so much
reflected light that its substance seems to be
merging with the background.

*The most formidable task confronting any artist is how to draw the three-dimensional human form convincingly in one way or another. There are many ways of doing this. Over the next few pages we look at some different approaches.*

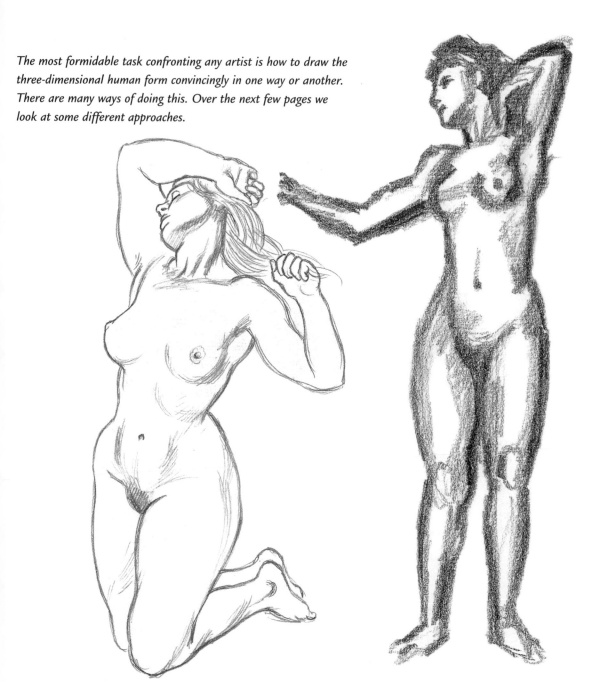

The work of **Franz Stück (1863–1928)** is linear in style; the bulk of the form is realized with very few lines, allowing our mind to fill in the empty spaces with the fullness of the flesh.

The example above, also a copy of a Stück, is more dramatically drawn. Although the edges are soft there is a powerful fullness of form, with chalky-looking tonal marks indicating the roundness of the body.

103

### Edgar Degas (1834–1917)

Degas was taught by a pupil of Ingres, and studied drawing in Italy and France until he was the most expert draughtsman of all the Impressionists. His loose flowing lines, often repeated several times to get the exact feel, look simple but are inordinately difficult to master. The skill evident in his paintings and drawings came out of continuous practice. He declared that his epitaph should be 'He greatly loved drawing.' He would often trace and retrace his own drawings in order to get the movement and grace he was after. Hard work and constant efforts to improve his methods honed his natural talent.

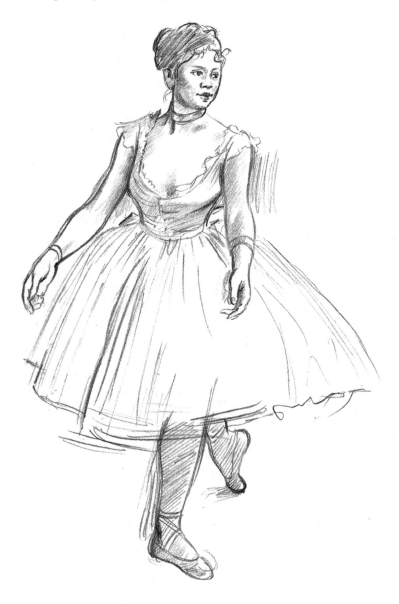

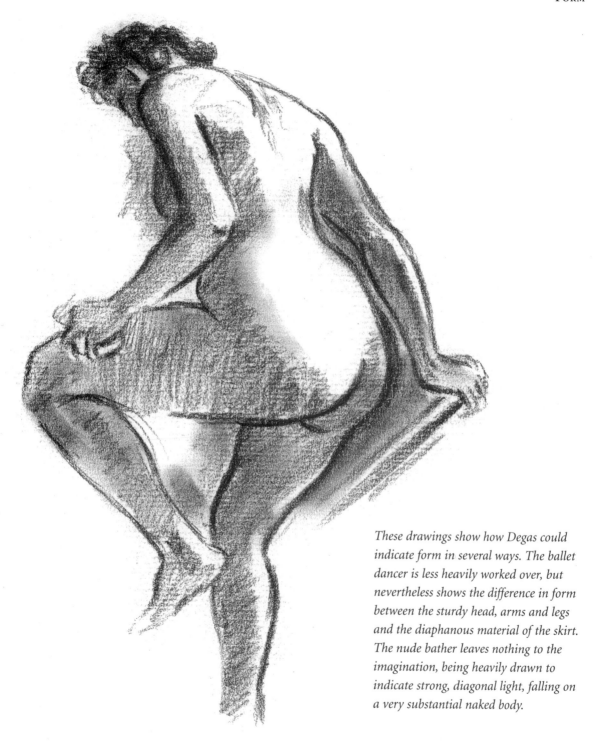

These drawings show how Degas could indicate form in several ways. The ballet dancer is less heavily worked over, but nevertheless shows the difference in form between the sturdy head, arms and legs and the diaphanous material of the skirt. The nude bather leaves nothing to the imagination, being heavily drawn to indicate strong, diagonal light, falling on a very substantial naked body.

This drawing by **Titian (1485–1576)** is very loose but demonstrates a real understanding of the way the forms of the human body look when intertwined. The strength of the deeper shadows contrasts with the areas of strong light. This artist's knowledge of colour was so good that even his drawings look as though they were painted. He is obviously feeling for texture and depth and movement in the space and not worried about defining anything too tightly. The lines merge and cluster together to make a very powerful tactile group.

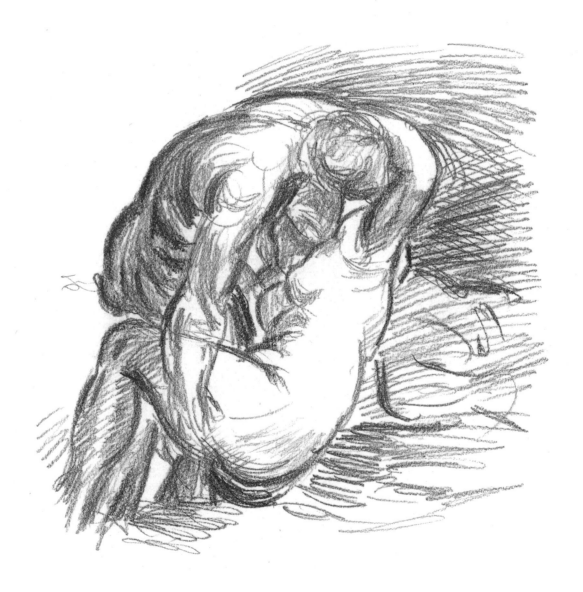

A copy in chalk of a portrait of
**Jean Edouard Vuillard**'s
**(1868–1940)** mother, done when
she was in her eighties, describes
age in a most economic way.
Echoing the original, I was sparing
with the tone and detail, and
allowed the wavering lines to
follow the gentle disintegration of
the flesh on the face. How does
Vuillard convince us of the
substantial presence of the
economically drawn head?
Somehow we can still tell the
difference in form of the cloth
collar and cap, and the bone
structure of the head.

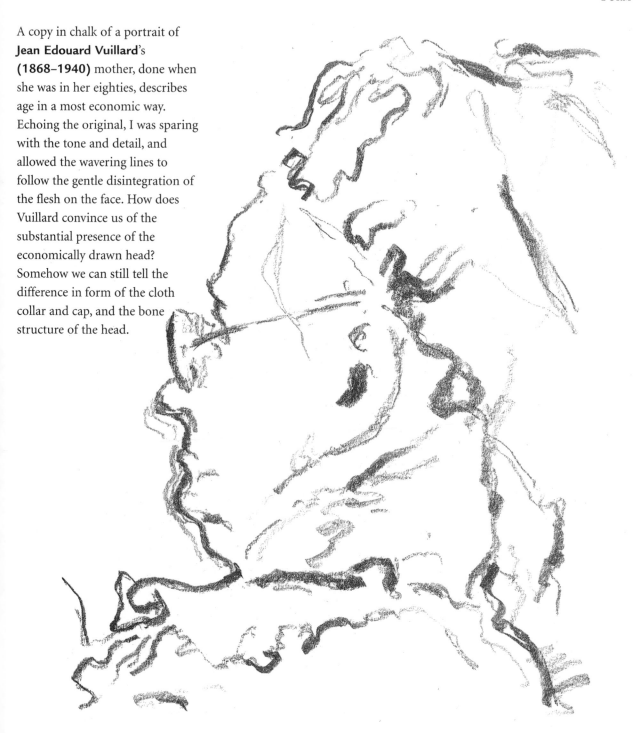

One of the most successful of contemporary artists, **David Hockney** has been able to follow his delight in drawing the human face in an age when many artists have all but forgotten how to produce a likeness. In this copy of an original he made in 1983, the intense gaze makes it clear that he misses nothing. His handling of the form is very spare and yet highly effective. Hockney's head is drawn so that we can see its substantial roundness under a strong light with dark shadow under the chin.

The details of the face are simplified and most of the tonal values dispensed with in this copy of a drawing of Aristide Maillol by fellow sculptor **Eric Gill (1882–1940)**. The different emphasis in the outlines helps to give an effect of dimensionality, but it is more like the dimensionality of a bas-relief sculpture, which is perhaps what this study in pencil and stub was about. The line and smudged tone method of describing form is effective in a very formal way.

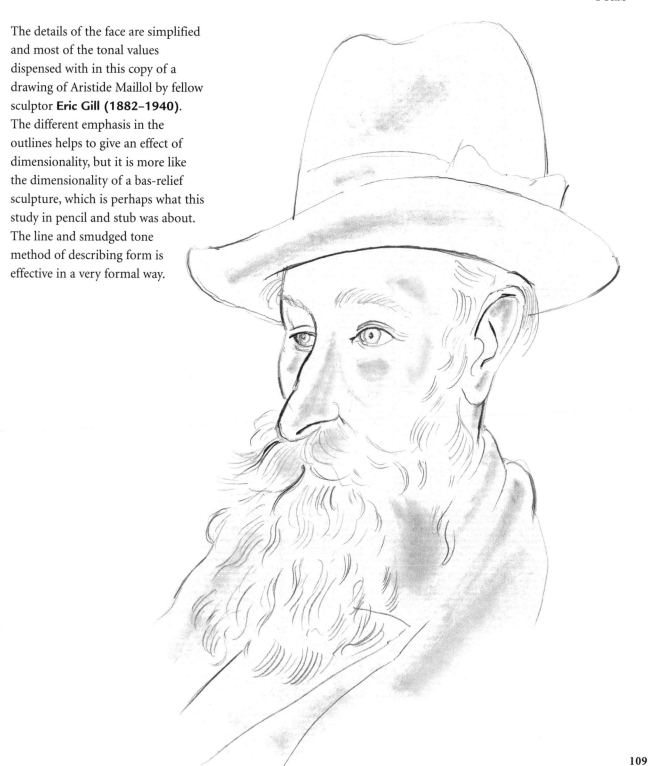

## Cézanne

In the self-portrait and the view of the village of Estaque shown on these pages, Cezanne has somehow managed to show form in space; that is, give an effect of solidity or depth by his rather sparse shading and markings of the shapes. He has not shown the classical shade and light relationship, but he hasn't entirely left them out either.

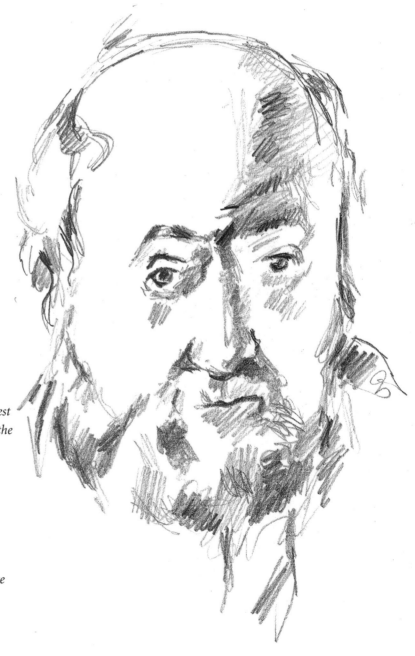

*In this self-portrait the area of darkest tone helps to give the impression of the important areas of form, especially around the eyes and nose. The large tonal areas down one side of the forehead and beard help to connect the main protuberances of the face with the generally rounded shape of the head. With great economy of drawing, Cézanne is able to convince us that we are seeing a three-dimensional head.*

The economy is even more pronounced in this landscape. Large areas of blank space are limited by faint markings showing the main blocks of buildings. A few heavier markings here and there emphasize the shadows or intensity of colour in the scene. This rather minimal way of denoting solid masses in space gives a very strong sense of the space between the buildings in the foreground and those further away.

If you decide to show form in this way, be careful not to put in too many lines or heavier marks. Fewer marks seem to produce greater awareness of form in the viewer.

# Space

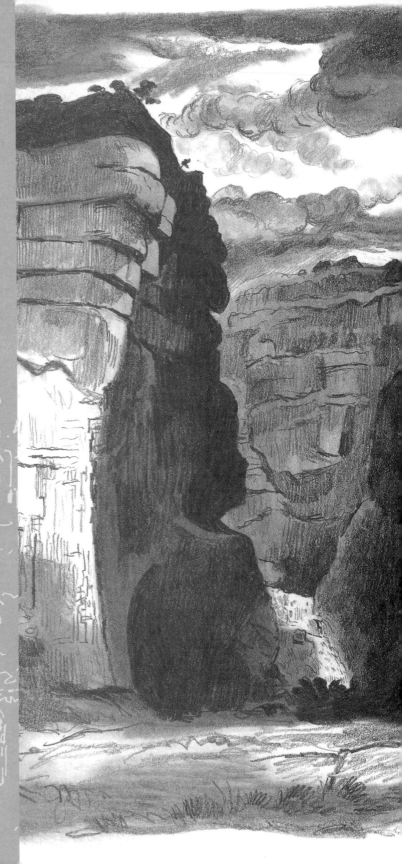

This section deals with something that is not at all obvious at first glance, but once you have seen how it works, it can lend a great deal of power to your drawings. Across the surface of a picture, you can, of course, leave spaces between your marks in an effort not to crowd the scene too much, but this doesn't deal with creating the apparent space behind the surface plane of the picture. To do this, you will need to put into effect all the other techniques that you have tried out so far, and see how they can help create a feeling of depth. You will notice that the depth of tone, the strength of line, and the kind of texture you use when making your drawing marks can have quite an influence on whether something seems closer to, or further from, the picture plane. It is particularly noticeable in landscapes how this understanding of the effects of perspective, in line and aerially, can make a huge difference to how you see the picture. A heavy line often seems much closer to the eye than one that is very faint. A dark tone can bring an object closer to you, and detailed texture can give the impression of something close-up. Conversely, lighter tones and less detailed texture can thrust an object further back into the distance. So look carefully at the way these master artists have handled their lines, tones, textures and form in order to give a convincing account of the apparent space in the picture. It is often the contrast of one mark against another that creates the right impression.

*For the artist, interior space which we find inside a house is an example of a 'controlled' visual space. Usually the doors* *and windows show no other spaces beyond the immediate room walls.*

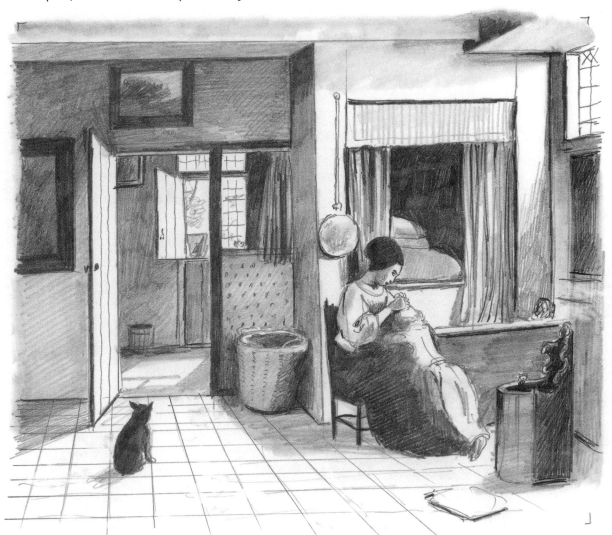

**Pieter De Hooch (1629–1684)** often included quite a large area of the inside of a house, particularly the family rooms. In this example, his interior spaces are very considered and help to create an aspect that goes through the room into the next and then out of the window to the outside world. The little dog sitting opposite the doorway draws the eye through to the larger space. The mother and daughter, placed well over to one side, sit in front of an alcove in which the bed is set, making a dark, enclosed recess. This juxtaposition of light open space and dark inner space gives the composition a lot of interest, apart from the presence of the figures.

This composition after **Andrew Wyeth** shows a room with large windows and an open door leading to the sea, with the seashell on the top of the large wooden chest emphasizing the location. The emptiness of the room gives spacious qualities to a very simple but elegant still-life statement. This is a fine example of how the genre frequently suggests the movement of life which is stilled just at this minute.

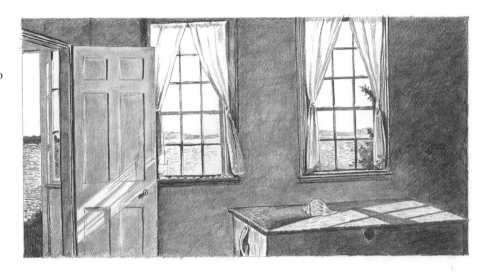

An even larger space looking out through windows typifies Wyeth's picture of a milking room in an outbuilding of a New England farm. The care with which he has depicted the shiny milking pail, the old tin cup on the piece of wood and the spigot from which a stream of water pours into the worn stone sink and then drains over the edge gives an intimate picture of a piece of country life. It is simple, spacious and strongly redolent of hard, old-fashioned farm work.

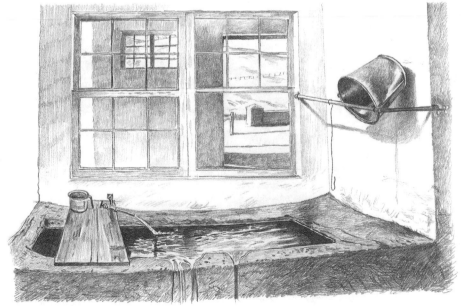

*Drawing outdoor spaces presents the artist with a new range of challenges. In these two idyllic landscapes, after* **Claude Monet (1840–1926)** *(below) and* **Pieter Breugel (1525–1569),** *the vegetation is reduced to the minimum and the land is white with snow. This creates a strange spatial awareness, with a line of sight — the river and the trees respectively — pulling our attention into the distance. Because of the white snow and dark sky, and the silhouetted shapes against it, the actual distance is harder to judge.*

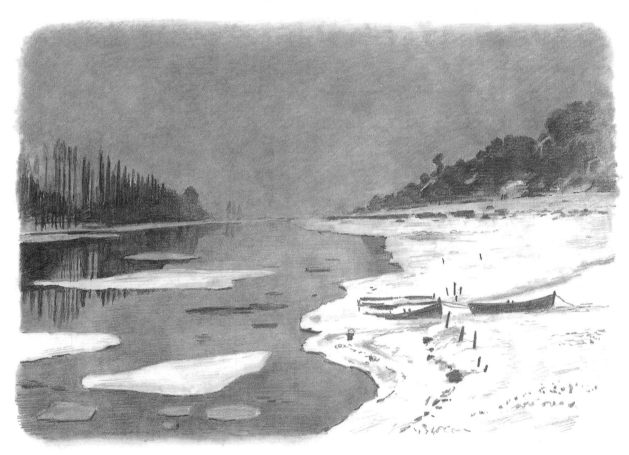

*Here the situation is easier to judge, and there are many more clues for guessing the distance in these pictures. Monet does it with tonal changes and Corot with perspective of the diminishing buildings.*

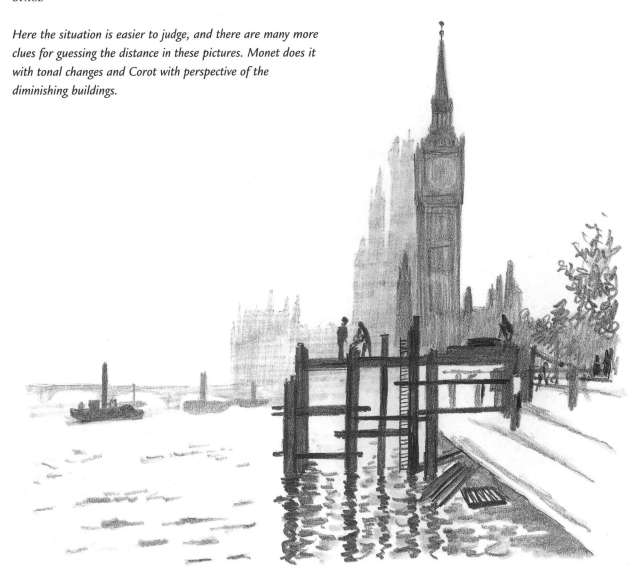

In this scene (also after **Monet**), of the River Thames near Westminster, there are various clues to distance including, most tellingly, clever use of layers of tone. The contrast between the differently sized objects tells us clearly that the jetty is closer to us than Big Ben and that the steam tug is closer to us than the bridge. However, most persuasive is the change in tonal values of the buildings and objects as they recede into the background, aided by the misty quality of the atmosphere. In the near foreground, the jetty is strongly marked in dark tone, contrasting with the embankment wall and the dark and light surface of the water. Behind this is the rather softer tone for the bulk of the tower of Big Ben and the small tugboat on the bright water. Beyond, other buildings are faintly outlined against a pale sky.

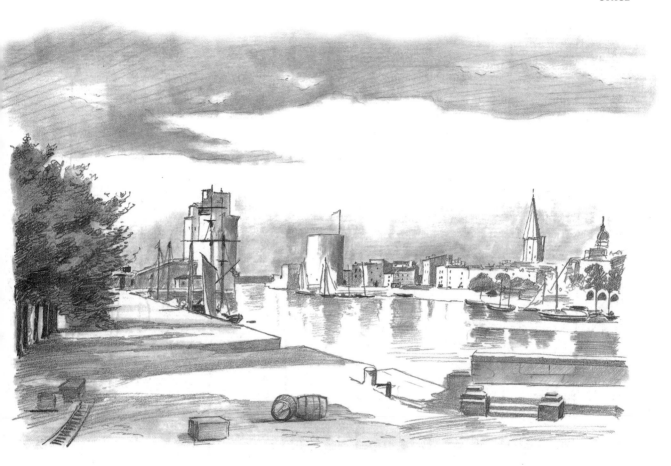

The effect in this landscape of the port of La Rochelle after **Jean-Baptiste-Camille Corot (1796–1875)** is of a vast space across the centre of the picture, nicely defined by the brightly lit buildings, but suggesting there is much more space beyond them and out to sea. The length of the quay recedes in perspective off to our left. The row of trees helps this effect by drawing our eye in this direction. (I have purposely left out a group of figures with horses dotted around this space to allow us to concentrate on the spatial effect.) At the far end of the quay is a tower jutting out into the harbour with the masts of boats and ships projecting up to obscure part of the building. An expanse of water fills the middle ground. Stretched out along the far right side of the harbour is a row of buildings including a church steeple and a small dome. A large round tower acts as a focal point marking the end of the quayside. Along the length of the far side of the harbour ships and boats are moored, and buildings are brightly lit by the sunlight, which reflects in the limpid water.

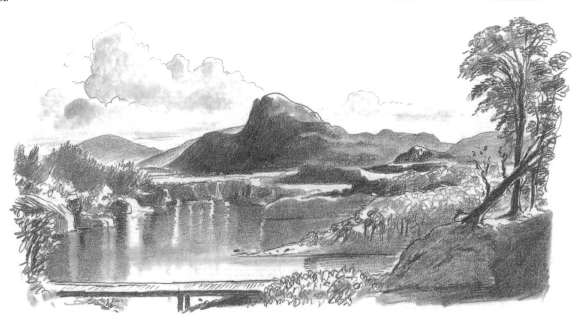

There are plenty of interesting contrasts in this example after **Frederic Edwin Church (1826–1900)**: water, trees, hills and a jetty in the front. However, the most ominant feature is the rocky hill in the middle distance standing out starkly against the skyline. This holds the attention and helps us to consider the depths shown in the picture.

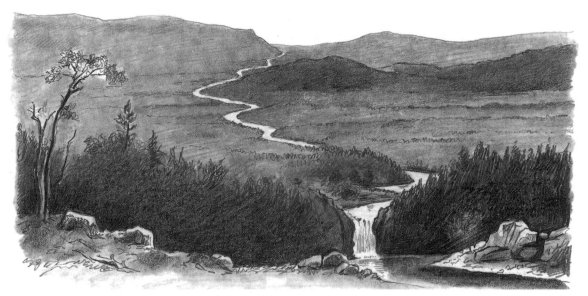

The river in this view of the Catskill Mountains after **S.R. Gifford (1823–1880)** leads the eye through the picture. The contrast between the dark tree-clad contours of the land and the brightly reflecting river draws us into the composition and takes us to the horizon.

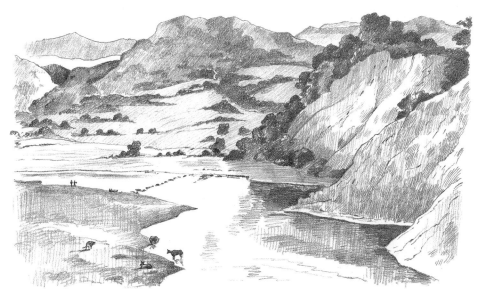

In this example after **Thomas Cole (1801–1848)** the high viewpoint allows us to look across a wide river valley to rows of hills receding into the depth of the picture. The tiny figures of people and cattle standing along the banks of the river give scale to the wooded hills. Notice how the drawing of the closer hills is more detailed, more textured. Their treatment contrasts with that used for the hills further away, which seem to recede into the distance as a result.

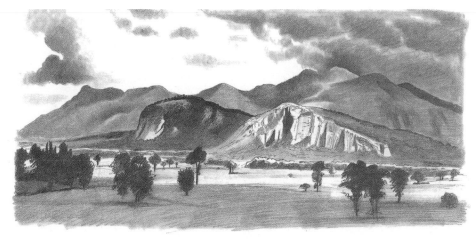

This drawing of Moat Mountain (after **Albert Bierstadt, 1830–1902**) includes several elements that combine to soften its aspect. The vegetation growing over the folds of the rocky slopes and the fairly well-worn appearance of the rocks, visible signs of glaciation in the remote past, have a softening effect. The dark clouds sweeping across the mountain tops and the silhouetted trees looming up from the plain in the foreground also help to unify the composition. This handling of foreground, middleground and background features creates a sense of monumental, timeless space.

*These are dramatic examples of creating the effect of a large spacious landscape to dwarf and isolate the figures shown in them.* **Caspar David Friedrich (1774–1840)** *does it with a dramatic sunset glow, which reduces the landscape to a series of undulating ridges divided by glowing water;* **Andrew Wyeth** *gives us a high horizon with an almost empty field sweeping up to where large buildings tower above the scene, dwarfing the reclining figure.*

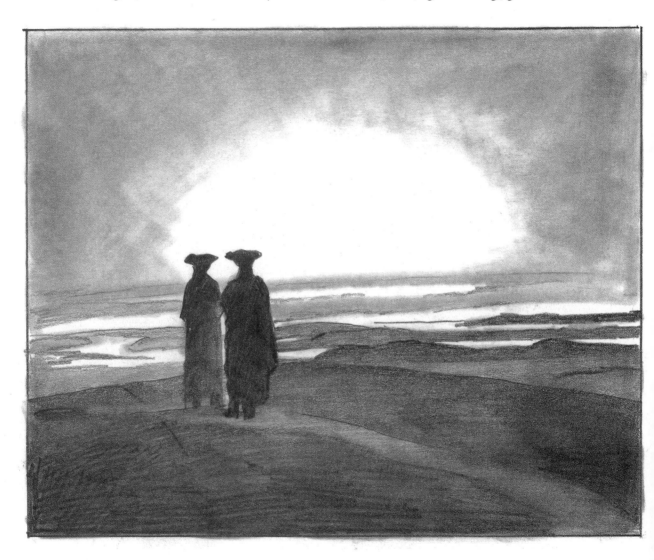

This picture of two figures looking at a sunset is taken from a painting by the German Romantic painter Caspar David Friedrich. The two men are standing on the dark land silhouetted against the bright sky and the way they are huddled close to each other in a space where nothing else interrupts the horizontal emphasis of the scene suggests some sort of lonely mood. Peaceful but separate.

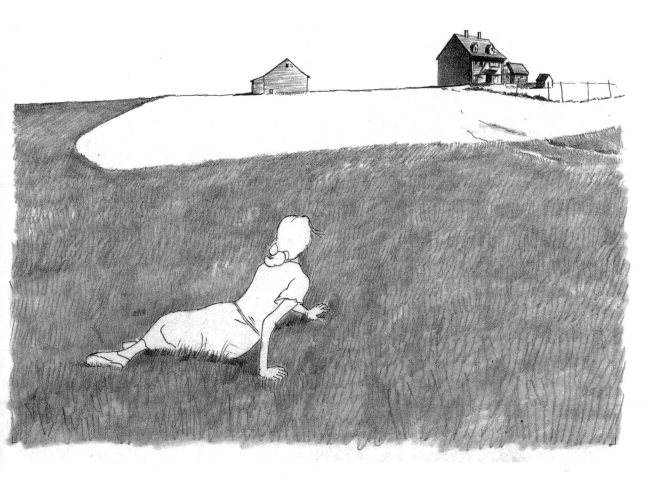

The same device is taken a stage further in a copy of one of Wyeth's most famous pictures, *Christina's World*. The key is the figure of the woman in the foreground and the barn and houses set up on the skyline in the background. The device creates a space between the viewer and the horizon. We can tell from the relative sizes of the woman's figure and the house that the house is at least 100 m (110 yd) from our position. The texture of the grass reinforces this information.

The curve of the edge of the uncut hay gives our eye a lead into the skyline. This is closer to us because we are down on the crippled Christina's level. With this dramatic method of showing space, even close objects appear to be on the skyline.

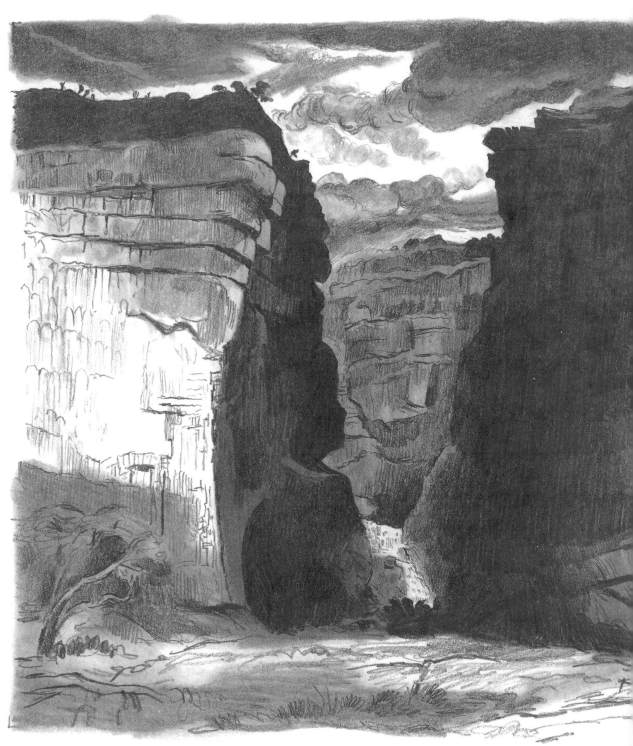

### James Ward (1769–1859)

The Romantic artists of the 19th century vied with each other to produce dramatic landscapes of towering crags and toppling mountains. Ward's *Gordale Scar* belongs to this great tradition, its effect so powerful as to almost overwhelm the first-time viewer. Many other painters at this time in Europe and America were producing works of staggering size and powerful dramatic effect, such as Friedrich and Bierstadt. Sometimes size does matter.

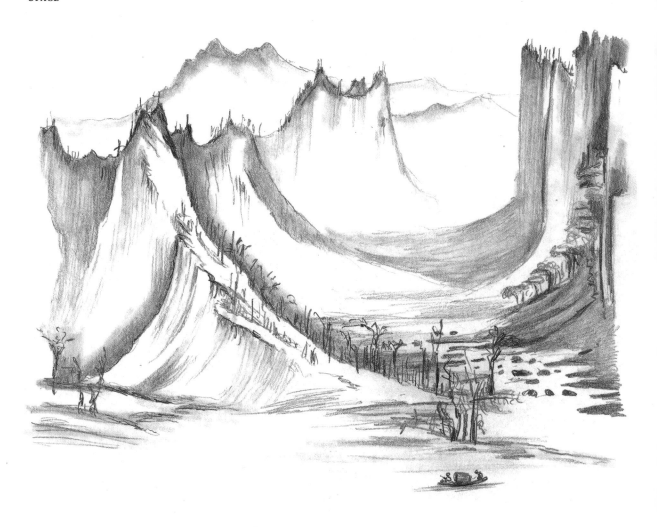

*Fishing in a Mountain Stream*, after **Hsu Tao-Ning (d. 1066)**, is the earliest landscape included in our selection (*circa* 11th century). The style is markedly different from the previous example and the technique astonishingly advanced for the period. No artist in Europe would have been expert enough to give an impression of receding space with anything like this effect. The size and spaciousness of the landscape with its vast perpendicular mountains and gaping gorge is almost breathtaking.

This landscape is a depiction of perfection, with the artist shaping the various heights according to his design and editing out anything that upsets the unworldly harmony and beauty of the scene.

*This artificial organisation of space shows how an artist's imagination can easily produce a convincing landscape as long as the viewer accepts the conventions used to portray it.*

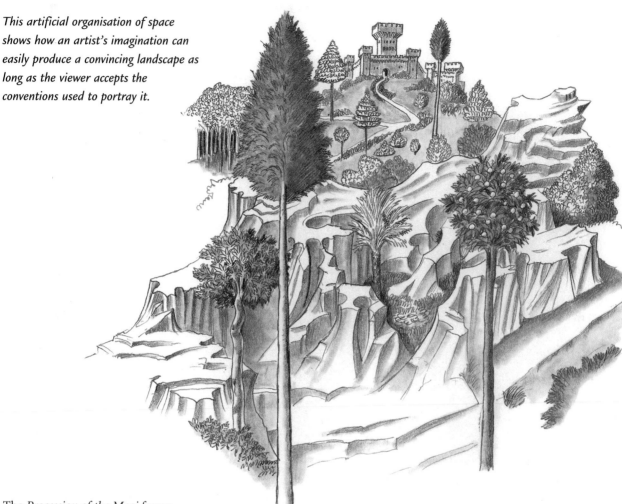

The *Procession of the Magi* fresco cycle was painted by **Benozzo Gozzoli (1420–1497)** for the chapel of the Medici family's town house in Florence. In this copy I have left out people and animals to concentrate on the landscape, which is not by any means a natural view of the countryside around Florence. To begin with there are no rocky outcrops like this in the area – in fact, not in any area, because Gozzoli has used a medieval convention and

envisaged the landscape by draping cloth over scaffolding or boxes. He could easily have painted realistic rocks, but the convention of using traditional forms so his public would not be disturbed by innovation outweighed the Renaissance desire to study nature. He has, however, put in plants found in the area, although idealized to an extreme. Some of the details are familiar – the castle in the

background representing Jerusalem, for example, resembles the Medici Villa at Caffaggiolo – but overall the impression is of a formalized and carefully tidied-up landscape to suit the artistic design of the fresco cycle. Even the perspective is reduced, purposely so; Gozzoli would have been aware of the principles of perspective. Everything is secondary to the telling of the story.

127

*Both of the artists shown here understand the dynamics of spatial relationships, particularly where the human figure is concerned.* **Sidney Goodman's (b. 1936)** *composition of a group of friends produces a spacious rather empty room,* grouping *the figures around a table with a window to light it all.* **Michael Andrews (1928–1995),** *out in a garden, uses the staggered placing of his family members to produce a feeling of depth, and even the passing of time.*

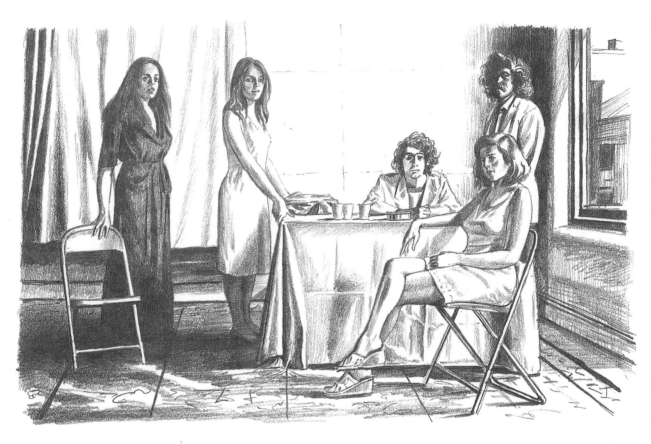

In this copy of Sidney Goodman's *Portrait of Five Figures* (1973) we see a neo-classicist emphasis on what is a very contemporary composition. The effect with the carefully arranged figures is akin to that achieved by the 19th-century French painter Jacques-Louis David in a painting called *The Death of Socrates*, which is grouped and lit in a similar way. However, in this example the people are looking at the viewer, so it is obviously meant to be a portrait. The significance of the picture would be lost on most viewers. The symbolism relates directly to art itself and the fact that this is a modern version of a school of painting last seen in revolutionary France at the beginning of the 19th century.

Harking back to the work of earlier artists is a constant theme in the history of art. Most artists have taken this path at some point, as a way of discovering new possibilities. The insight gained by trying to incorporate a work that you admire into your own can be of immense benefit to the development of your own style.

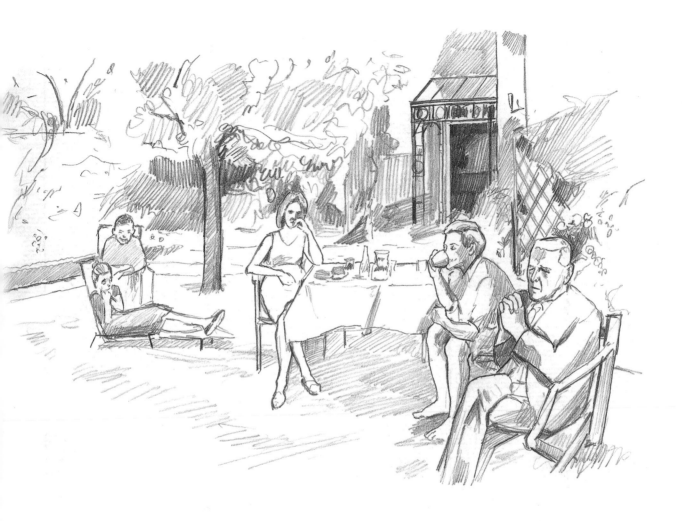

This is a copy of one of Michael Andrews's first large pieces of work, a group portrait of his family in their garden in Norfolk on a summer afternoon. The original painting is at least 1.8 m (6 ft) high and took two years to complete.

After drawing up a sketch, which gave him the positions of the individuals, Andrews then had to make more careful individual studies. He also worked from photographs. The final picture is quite a dynamic composition, spread across the canvas and in some depth from front to back. The drawing of the figures has been kept relatively simple, with the two nearest the viewer the most precisely detailed.

# How to do it

Here we look at some of the details of drawing techniques that artists use in their search to produce good pictures. We see how the artist can apply the techniques to advantage, and bring some real skill to bear on the production of significant mark-making. The materials are important and will give the picture the particular look which is required by the artist. The handling of materials is not difficult, but it does need practice in order not to look laboured. You will also have to consider how you build up a picture, so that it proceeds in a fashion that doesn't have you regretting the first marks that you made when you get to the last.

It cannot be stressed too much how important regular practice is to produce drawings that you will be proud to have achieved. The more you practice, the quicker will come the sort of results that will please you. Don't forget to try out different materials as well, because each attempt with new materials helps to increase your understanding of those that you have already used.

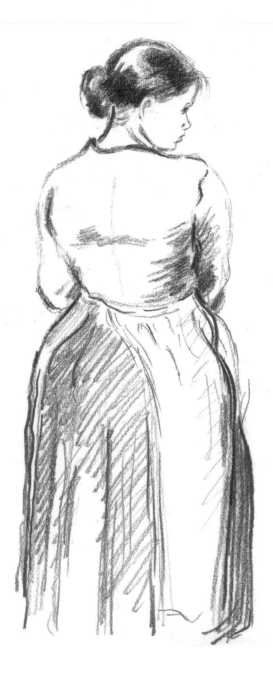

*These drawings by two masters of impressionism show how human character and presence can be conveyed even in a sketchy manner.*

**Camille Pissarro**'s **(1831–1903)** young peasant woman is drawn with the maximum of economy and the minimum of marks on the paper. Although the lines are very sparse there is no doubt in our minds that this is a substantial young woman with sturdy limbs and torso. The shoulders look strong and the waist solid. Although there are probably layers of petticoats under the skirt, it looks as though she is probably well developed in the hip area as well. Our eyes fill in all the spaces to see her as the artist did.

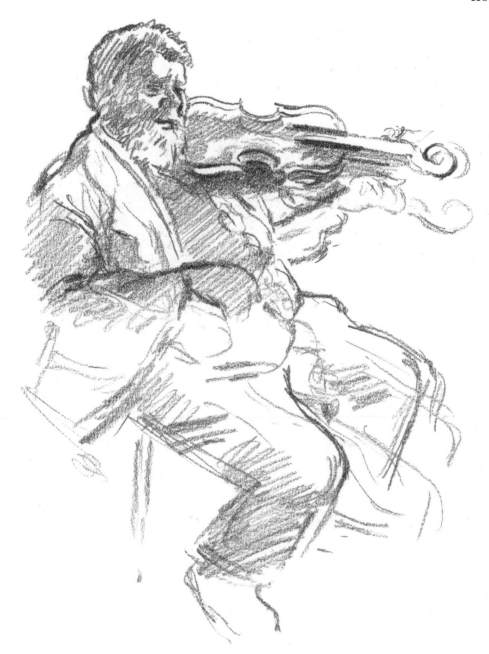

Despite the sketchy nature of this charcoal study after **Degas**, we gain an immediate understanding of the bulk of the violinist enveloped in his sturdy 19th-century suit. Although the suit is cut, like all suits of the time, to hide the figure, the solid dimension of the man is not hidden from us; the rounded quality of the sleeves and legs of the garments and the generous protuberance in front make it very obvious that the clothing is covering a sizeable body.

**Cézanne** attempted to produce drawings and paintings that were true to the reality of form as he saw it. He is the structural master-draughtsman without parallel in this section. All artists since his time owe him a debt of gratitude. His great contribution to art was to produce a body of work that saw the world from more than one viewpoint. The Cubists were inspired by his example to try to draw the objective world from many angles, and in doing so they revolutionized traditional forms of representation.

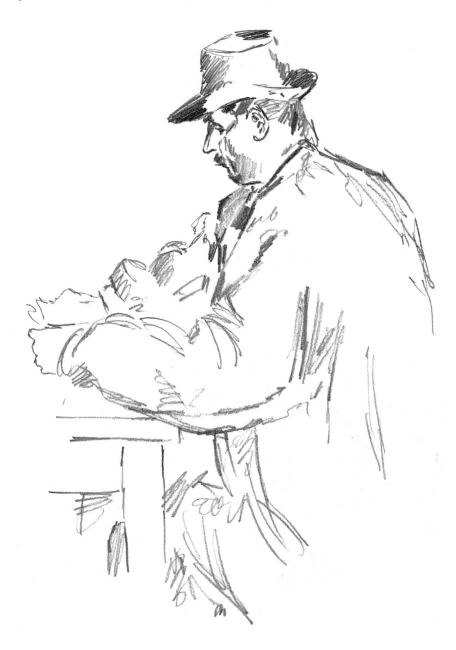

*Careful juxtaposition of figures, one to another, is a very effective way of producing a good composition. Picasso's*

*obvious contrast between a reclining and a seated figure makes a powerful statement.*

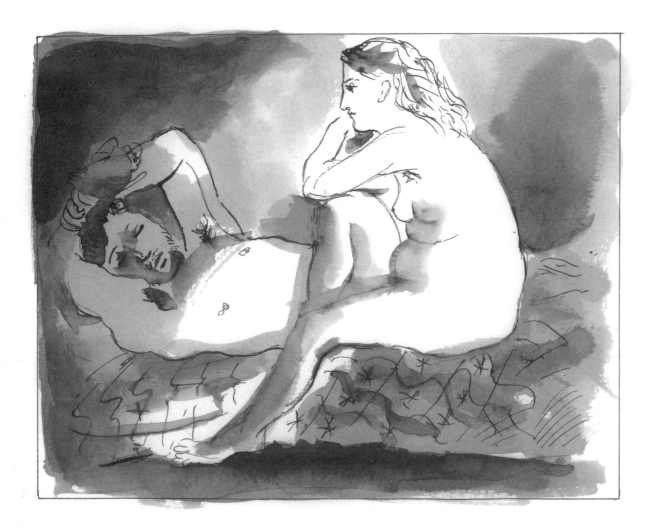

The **Picasso** drawing of the girl sitting on the bed beside the sleeping man was one of a series he drew of the relationship between a man and woman whether as artist and model, satyr and nymph or just two lovers. This pen and wash drawing has all his panache and understanding of how to portray figures so that the relationship is obvious in one way, but has overshadowing ambiguity as well. Who are this couple? Are they Psyche and Cupid, or just a woman waiting for her lover to wake up? The point to notice is the interesting juxtaposition of his horizontal upper body obscured halfway down by her curved, thoughtful pose with one leg off the couch. Her pale, rounded body set in the darkened room has a stately sort of naturalness about it. Her gaze and his sleeping countenance suggests some bond or tension between them.

135

One of the most superb draughtsmen among the French artists of the 18th century, **Watteau** painted remarkable scenes of bourgeois and aristocratic life. His expertise is evident in the elegant and apparently easily drawn figures he drew from life.

Like all great artists he learnt his craft well. We too can learn to imitate his brilliantly simple, flowing lines and the loose but accurate handling of tonal areas. Notice how he gives just enough information to imply a lot more than is actually drawn. His understanding of natural, relaxed movement is beautifully seen. You get the feeling that his are real people; he manages to catch them at just the right point, where the movement is balanced but dynamic. He must have had models posing for him, yet somehow he implies the next movement, as though the figures were sketched quickly, caught in transition. Many of his drawings were used to produce paintings.

■ *In this drawing after Watteau, a girl is about to be helped up from a sitting position, her silky but voluminous skirts all bunched up around her bent legs. The bodice is figure hugging, with the cape and sleeves of a stiffer quality, making very strong folds where the arm bends. Watteau's loose, quick lines make us realize this was drawn from life and he has captured the effect of formal dress material in a most economical way.*

The drawings of **Rembrandt** probably embody all the qualities that any modern artist would wish to possess. His quick sketches are dashing, evocative and capture a fleeting action or emotion with enormous skill. His more careful drawings are like architecture, with every part of the structure clear and working one hundred per cent. Notice how his line varies with intention, sometimes putting in the least possible and at other times leaving nothing to chance. What tremendous skill!

To emulate Rembrandt we have to carefully consider how he has constructed his drawings. In some of his drawings the loose trailing line, with apparently vague markings to build up the form, is in fact the result of very clear and accurate observation. The dashing marks in some of his other, quicker sketches show exactly what is most necessary to get across the form and movement of the subject. Lots of practice is needed to achieve this level of draughtsmanship.

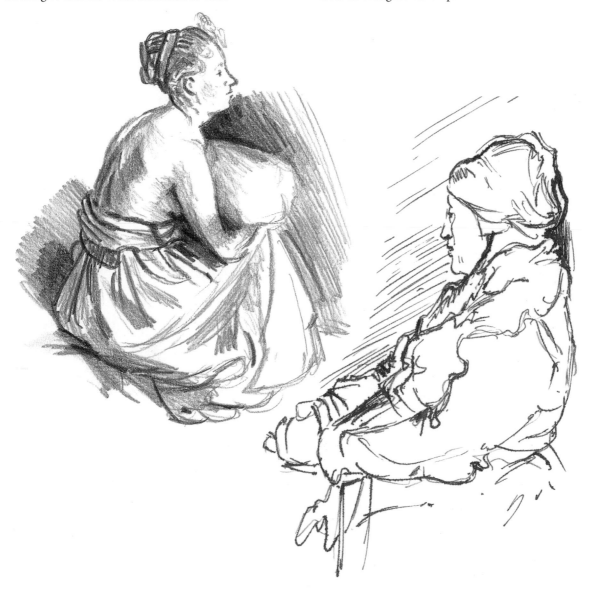

**Geoffrey Elliott (b.1935)** produces figures that represent universal forms. He is not trying to produce portraits in the accepted way. Elliott is obviously more interested in the general forms inhabiting the landscape than in trying to reproduce individuals on paper. This approach teaches us that to draw well, you don't have to produce an intimate portrait of your subject. Good drawing can be purely an expression of aesthetics and an experience of form.

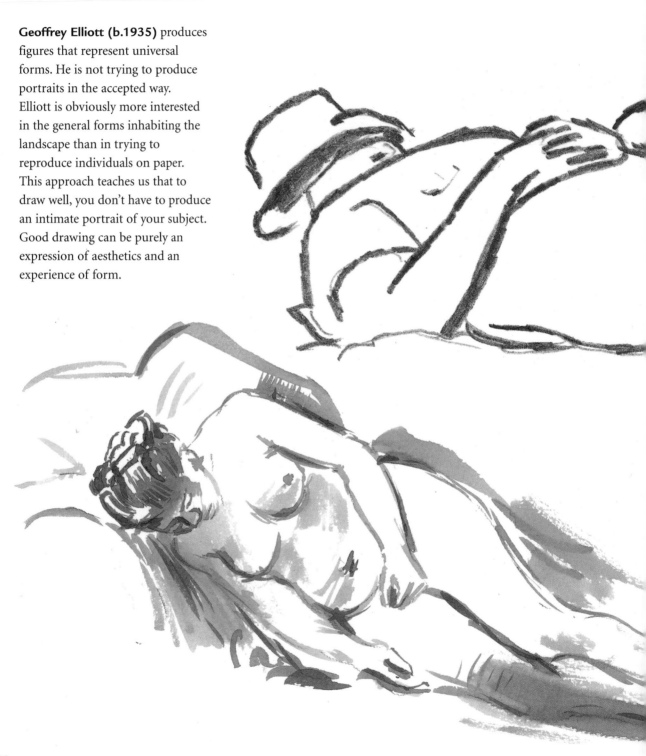

■ *These reclining figures are from Geoffrey Elliott's sketchbook of drawings of people on a beach in Sussex. They are universal in form, but personal qualities emerge despite the absence of obvious emotional expression or movement.*

■ *This drawing of a reclining nude woman by* **Rembrandt** *in 1658 shows how brilliant he was with the use of a brush. The economy of the line and the handling of the very light tonal areas yield maximum effect with very little drawing.*

139

**Diego Velázquez (1599–1660)**

Now that you've looked at some possibilities with the human figure in a variety of positions, try drawing from a famous classical figure painting, Velázquez's *The Toilet of Venus* (also known as 'The Rokeby Venus'), using tone to increase the dimensional qualities of your drawing.

Pay attention to the direction of the light source, as this will tell you about the shape of the body. Keep everything very simple to start with and don't concern yourself with producing a 'beautiful' drawing. Really beautiful drawings are those that express the truth of what you see.

*1. Sketch in the main outline, ensuring that the proportions are correct. Note the lines of the backbone, shoulders and hips. Check the body width in relation to the length and the size of the head in relation to the body length. Pay special attention also to the thickness of the neck, wrists, ankles and knees. All of them should be narrower than the parts either side of them.*

*2. Finalize the shape of the limbs, torso and head. Then draw in the shapes of muscles and identify the main areas of tone or shadow.*

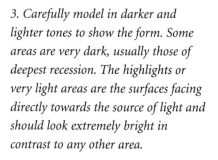

*3. Carefully model in darker and lighter tones to show the form. Some areas are very dark, usually those of deepest recession. The highlights or very light areas are the surfaces facing directly towards the source of light and should look extremely bright in contrast to any other area.*

140

When you have finished applying tone, give your figure a place to exist in by adding tones to the background. These will enhance your drawing by throwing the strongly defined areas of light forwards, thereby increasing the three-dimensional effect.

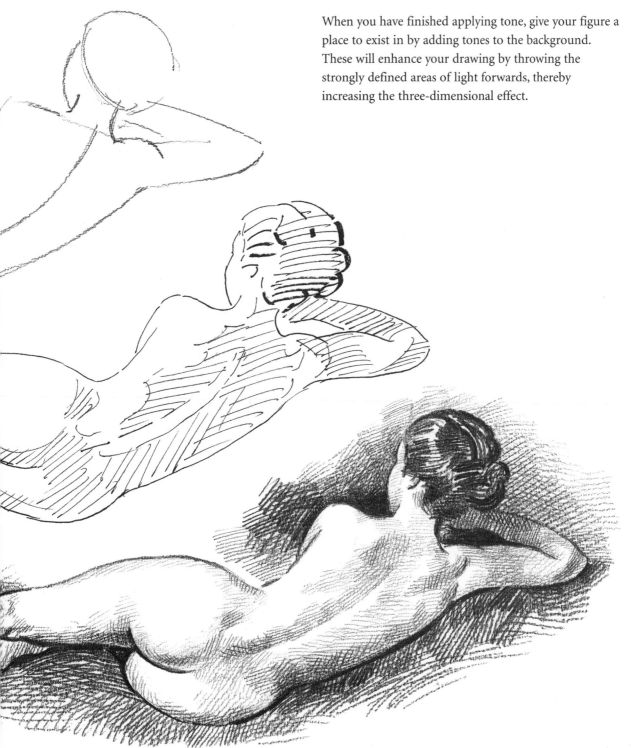

141

*The techniques of drawing with different materials shown on the following pages will give you some idea just how they are done.* **David Hockney** *is a major draughtsman of the modern art scene. The example of his work illustrated here is a relatively straightforward way of drawing the human figure.*

This portrait of film director Billy Wilder (right) was drawn by Hockney in 1976. He is sitting in a director's chair, the script in his hands underlining his profession. The body is skewed slightly sideways with one leg on a support. The drawing is mostly just a pencil line with some carefully chosen areas of fine-toned hatching. The whole is a tour de force of almost classical pencil drawing.

The pencil work used for this large old tree in a
wood (after **Samuel Palmer, 1805–1881**) is loose
in technique. At the same time, however, it is very
accurate at expressing the growth patterns of the tree,
especially in the bark. It is best described as a carefully
controlled scribble style, with lines following the
marks of growth.

*The pencil is, of course, easily the most used instrument for drawing. However, our early experience of using a pencil can distort our perception of its possibilities, which are infinite.*

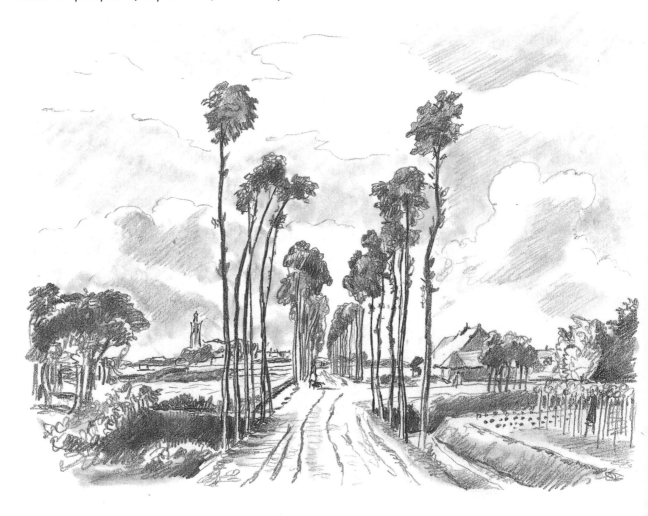

In *Road to Middelharnis* (after **Meindert Hobbema, 1638–1709**) we see a fairly free pencil interpretation of the original, using both pencil and stump. The loose scribble marks used to produce the effect in this drawing will seem simple by comparison with our next example.

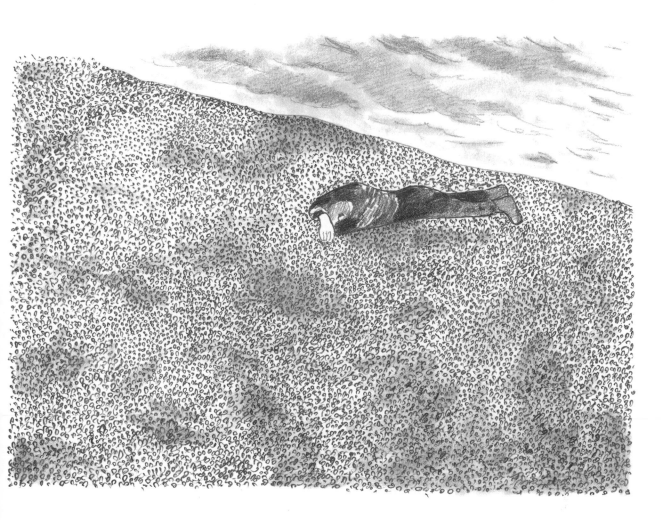

American artist **Ben Shahn (1898–1969)** was a great exponent of drawing from experience. He advocated using gravel or coarse sand as models to draw from if you wanted to include a rocky or stony place in your drawing but were unable to draw such a detail from life. He was convinced that by carefully copying and enlarging the minute particles, the artist could get the required effect.

When you tackle a detailed subject, your approach has to be painstaking and unhurried. If you rush your work, your drawing will suffer. In this drawing, after putting in the detail, I used a stump to smudge the tones and to reproduce the small area of sea.

145

*As well as the pencil, the pen is a subtle and versatile medium for drawing. Generally speaking any fine-pointed nib with a flexible quality to allow variation in the line thickness is suitable for producing landscapes.*

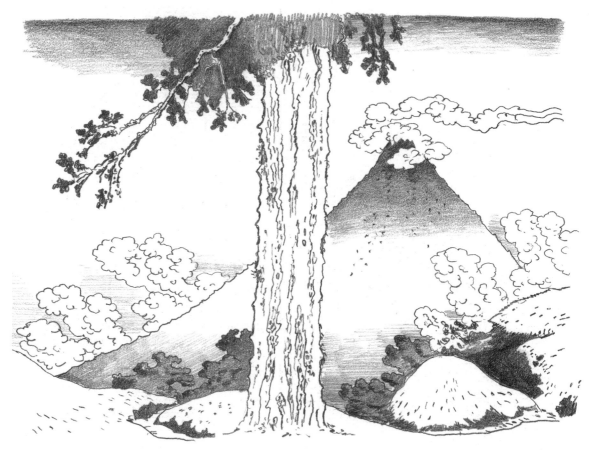

For his original of Mount Fuji the Japanese artist **Katsushika Hokusai (1760–1849)** probably made his marks with a bamboo calligraphic nib in black ink. I have made do with pen and ink, but even so have managed to convey the very strong decorative effect of the original. Note how the outline of the tree trunk and the shape of the mountain are drawn with carefully executed lumps and curves. Notice too the variation in the thickness of the line. The highly formalized shapes produce a very harmonious picture, with one shape carefully balanced against another. Nothing is left to chance, with even the clouds conforming to the artist's desire for harmonization. With this approach the tonal textures are

usually done in wash and brush, although pencil can suffice, as here.

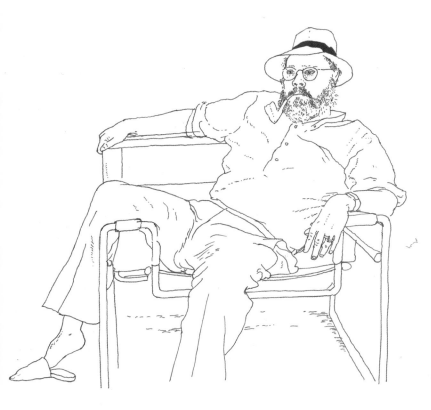

**David Hockney**'s picture of Henry Geldzahler (left), drawn in Italy in 1973, shows his friend relaxing in a big tubular steel chair out in the garden, straw hat and all. Geldzahler liked posing for his portrait and so was always keen to arrange himself in an interesting attitude. The thin, even pen line has a precision about it, but is also quite sensitive to the quality of the material of the clothes and the hair. The slightly cautious, meandering quality of the line gives a feeling of care and attentiveness in the drawing. This style is simple but extremely effective.

■ *Hockney's medium here is a fine-line graphic pen.*

147

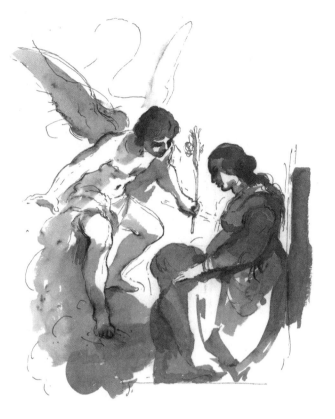

This drawing made by the Italian master **Guercino** in 1616 was a sketch for a small devotional picture of the Annunciation with the Archangel Gabriel descending from heaven bearing a lily, symbol of Mary's purity. The line in ink which Guercino uses to trace out the figures is very attractive, because although it is sensitive it also has a confidence about it which shows his great ability. The drawing has areas of tone washed in with watered-down ink and the wet brush has also blurred some of the lines, as the ink is not waterproof. His handling of dark areas contrasting with light is brilliant, and shows why his drawings are so much sought after by collectors.

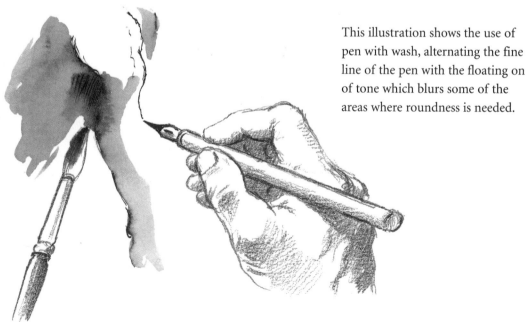

This illustration shows the use of pen with wash, alternating the fine line of the pen with the floating on of tone which blurs some of the areas where roundness is needed.

Beginners generally do not get on well with brush and wash. Watercolour, even of the tonal variety, demands that you make a decision, even if it's the wrong one. If you keep changing your mind and disturbing the wash, as beginners tend to do, your picture will lose its freshness and with it the most important quality of this medium.

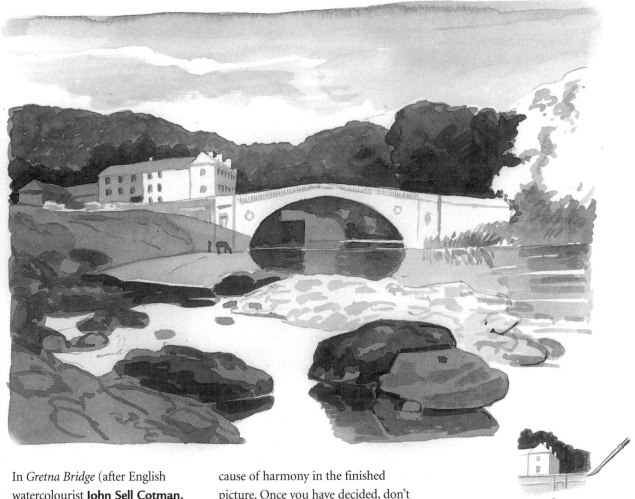

In *Gretna Bridge* (after English watercolourist **John Sell Cotman, 1782–1842**) the approach is very deliberate. The main shapes of the scene are sketched in first, using sparse but accurate lines of pencil, not too heavily marked. At this stage you have to decide just how much detail you are going to reproduce and how much you will simplify in the cause of harmony in the finished picture. Once you have decided, don't change your mind; the results will be much better if you stick to one course of action. The next step is to lay down the tones, starting with the largest areas. When these are in place, put in the smaller, darker parts over the top of the first, as necessary. You might want to add some finishing touches in pencil, but don't overdo them or the picture will suffer.

149

*Chalk-based media, which include conté and hard pastel, are particularly appropriate for putting in lines quite strongly and smudging them to achieve larger tonal effects, as you will see from the example shown, after* **Cézanne**.

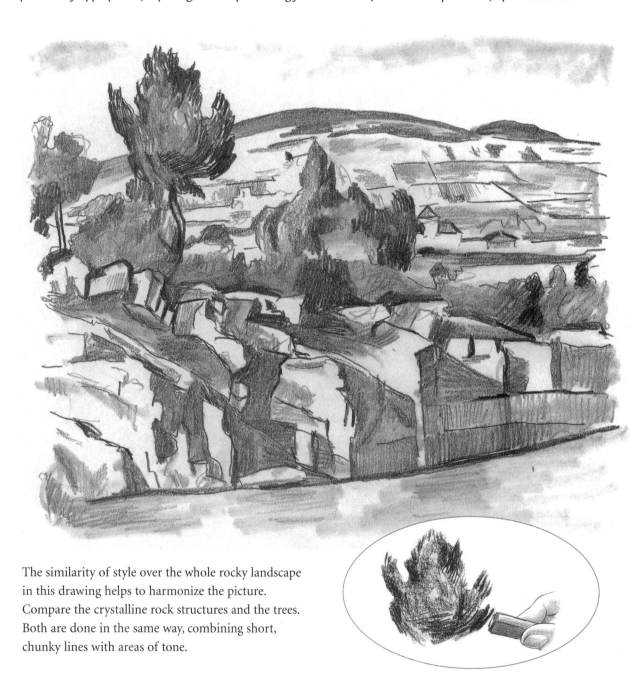

The similarity of style over the whole rocky landscape in this drawing helps to harmonize the picture. Compare the crystalline rock structures and the trees. Both are done in the same way, combining short, chunky lines with areas of tone.

*The use of different mediums is very much a question of choice by the artist, but it is a good idea to try out a few to give you an idea about which techniques you may want to use when confronted by decisions in drawing.*

Degas's pastel drawing of a ballet dancer practising pointe exercises is one of many he produced during the 1860s. His brilliant use of pastel gives great softness and roundness to the form and his masterly draughtsmanship ensures that not a mark is wasted. This is a very attractive medium for figure studies because of its speed in use and the ability to blend the tones easily.

Pastel goes on quite quickly and easily but a careful handling of the tonal areas is necessary to build up the tone rather than try to achieve the final result in one attempt.

**Picasso** dominated the art world for the greater part of the 20th century. He took every type of artistic tradition and reinvented it, demonstrating that a master artist can break all the rules and still produce work that strikes a chord with the casual observer. The image below, for example, is an interesting hybrid : two pieces of toned paper are cut out for the neck and face, with the features and hair drawn in with pencil.

Although he distorted conventional shapes almost out of recognition, the final result was imbued with the essence of the subject he was illustrating. He experimented in all mediums, but in his drawings we can see the amazing dexterity with which he confounded our preconceptions and gave us a new way of seeing art. His sketchbooks reveal his wide range of abilities and are an inspiration to all artists.

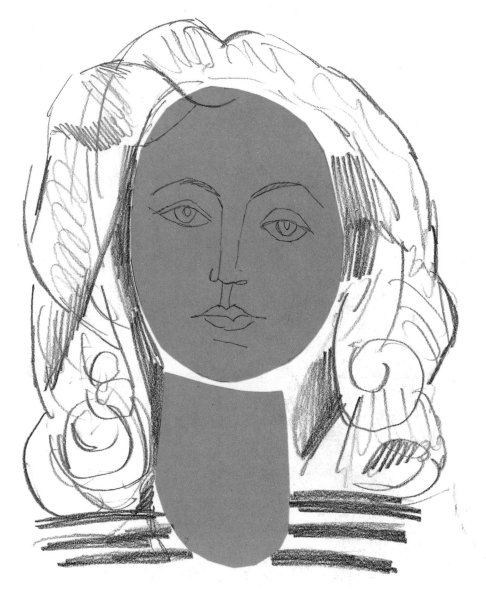

*In different ways, both the drawings on this page use a simple outline. Such simplicity serves to 'fix' the main shape of the drawing.*

*A much more economical method of drawing has been used for the portrait below, but note that this has not been at the expense of the information offered about the subject depicted.*

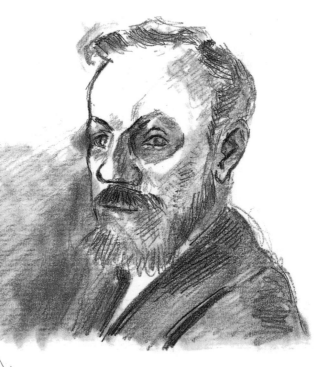

**Matisse** uses tone to build up his head and shoulders, using sometimes smudgy and sometimes linear marks.

In this rapid and lyrical drawing the artist, **John Vanderbank (1694–1739)**, is almost looking back at us over his shoulder. Vanderbank sticks to line and uses it very economically to give just enough feeling of the darker shadows. His wiry line is very expressive. Although it may seem a difficult pose it is quite common in self-portraiture where, if the artist is using a drawing board on an easel, he has to look across his shoulder in order to see his reflection in the mirror.

153

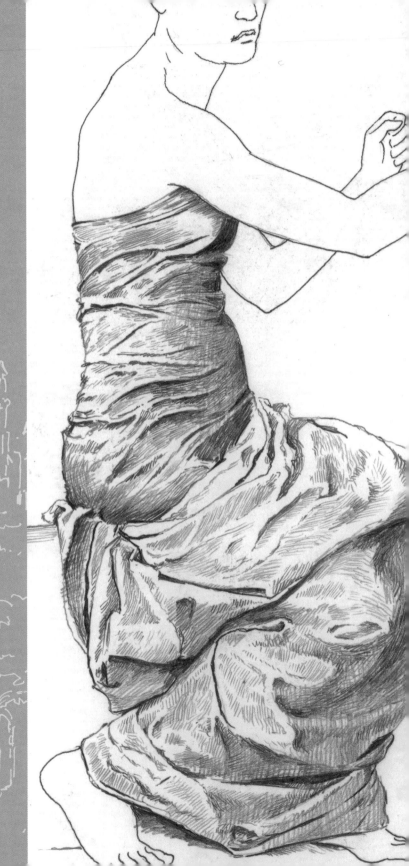

# How real
# is this?

The works in this section are in the nature of a series of *tours-de-force*, where the artists have shown their skills in a particularly impressive way. Not all are well-known, but by virtue of the piece shown, they are fine examples of super-illusionist pictures that pack a punch by their skill. From the Renaissance onward, many artists worked in the *trompe l'oeil* method, which aimed to produce a picture so realistic that, at first glance, people would think it was the real thing. This usually meant that it would have to be placed in a way that already suggested it was the actual object, such as the Roman floor mosaic of food scraps on page 162, or a painted set of shelves in an 'alcove'. It was a sort of art joke, and was intended to raise pleasantly surprised laughter, as well as impressing by its realism. Not all of these drawings are of the *trompe l'oeil* genre but, by means of their techniques, they all have a convincing power to trick the viewer. The penultimate example (see page 168) is a nice joke that might have been kept in an artist's studio to impress his clients.

**Stanley Spencer
(1891–1959)**

Taken together, these portraits relay some basic truths about the art of the portraitist. In the two Spencers we are confronted by penetrating honesty; the portraits represent two different stages of his career, but despite the distance of 46 years between them, both demonstrate the artist's honesty and his lively interest in the visual world he was recording. The younger Spencer is portrayed as a more expectant and confident individual. The second drawing was done in the year of his death and there is a clear sense of mortality as well as humility.

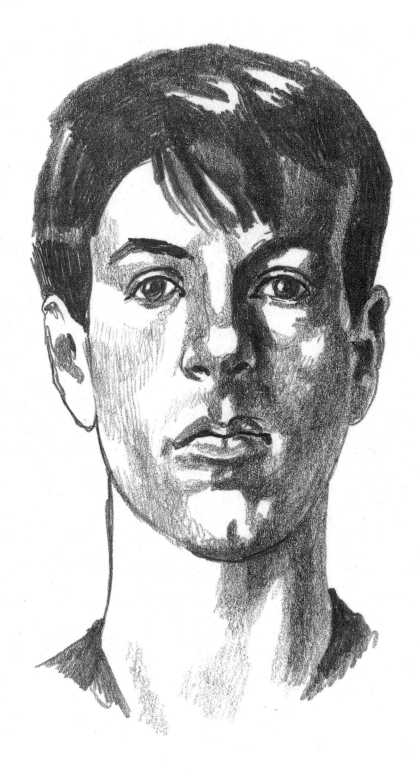

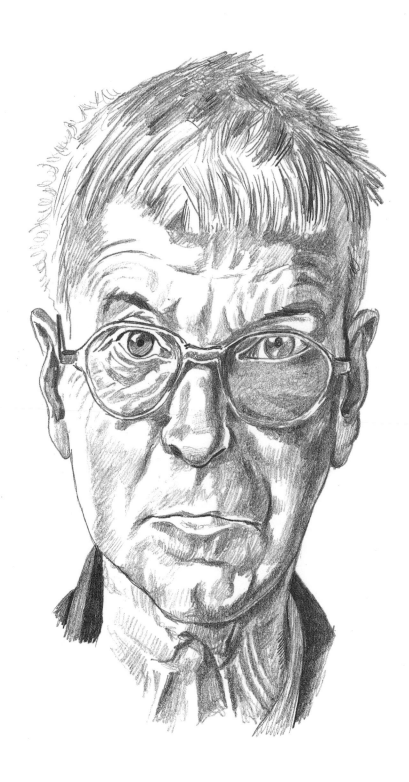

One of the qualities of Spencer's work was the determination to leave nothing out, and show everything possible. This sort of realism is difficult but attractive to the artist because of the technical problems to be solved in giving a convincing feel to the human features.

In one of the best dog portraits of the 20th century, by **Lucian Freud (b. 1922)**, the artist's first wife, Kitty, is shown with a white bull terrier cuddling up to her lap. The original was painted in tempera, a very meticulous method where you use a brush almost like a pencil, and so lends itself to depiction in pencil, as here. The whole portrait is really of Freud's wife but the dog is so clearly defined that it almost takes over the picture. The only way that the human model keeps the attention is because she has bared one breast and has enormous luminous eyes. Hundreds of tiny strokes were necessary to capture the dog's smooth but hairy coat for this copy.

Depictions of the texture of animal skin and the materiality of cloth is often the time when an artist can show off the ability to produce a quality of drawing that is as convincing as a photograph. This detailed working over of a large area of texture in this way can often be a most powerful tool in convincing the viewer of the reality of the subject.

This piece of drapery is after a **Leonardo da Vinci** study.
Rendered in a painstaking ink technique of hatched lines,
it is a very classically inspired piece of work. A fine pen
nib lends itself very well to this sort of drawing, although
there were at least two grades of nib size used here in
order to obtain this effect.

*These two pages show how the human body can be represented quite graphically, either by the way the form is dressed or, at the opposite extreme, disguised to appear very different from its real form. This interesting variation on the use of clothing to portray or distort the figure has been noticeable throughout history, with costume moving from one extreme to the other over the centuries.*

In this example the artist **Otto Greiner** dressed his model in such a way as to show clearly how the female figure looks, wrapped in fabric which accentuates her shape. The lateral wrinkles and folds pulled tightly around the body give a very sharply defined idea of the contours of the torso, while the softer, larger folds of the cloth around the legs show their position but simplify them into a larger geometric shape so that the legs form the edges of the planes of cloth.

This figure after **Lucian Freud** is covered by a raincoat, jumper and trousers, which go a long way towards disguising the figure beneath. The only clear indication of the figure is at the shoulders and where the arms bend, so we can tell that the subject is quite thin. The coat is loose and thick enough to create heavy folds around the body. The trousers are also loose and shapeless and we could be looking at a mere skeleton hidden by clothing. It is not an easy task for the artist to see such a figure beneath the costume, but Freud is a significant artist who has still managed to give some feel of the body.

This picture is after one of the oldest still lifes in existence, a Roman mosaic. Here the Roman artist has carefully depicted odd bits of residue from a feast that might have been dropped onto the floor during the meal. The very accurate depiction of the shells of sea urchins and shellfish, the pips and stones of olives and fruit, the stalks of grapes and the remains of gnawed bones of fowl make a very interesting all-over pattern.

These eggs and pots are also from one
of the earliest pieces of still life extant
– a fresco painting from the walls of
Pompeii, which was preserved to the
present day by the volcanic eruption of
Mount Vesuvius, which buried it in lava
and ash.

It is unusual to come across such
ancient paintings, and very interesting to
realise that artists of the classical era
knew all the tricks of illusionism and
could portray the world in as realistic a
fashion as the Renaissance painters.

*Two examples of trying to deceive the eye; one classical, which limits the subject to a few well chosen objects and painting them convincingly against a plain, dark background; and the other rather more modern, which is to push the objects so close into the face of the viewer that we can see nothing with which to compare them, and so overwhelms the sensation of sight.*

This very simple picture is after that master of French still life **Jean-Baptiste-Siméon Chardin (1699–1779)**, who was so renowned in his own lifetime that many collectors bought his works rather than the more complex figure compositions by the artists of the Paris Salon. This picture shows fruit, water and a flower. The heap of strawberries on a basket is unusual as a centrepiece and the glass of water and the flower lend a sensitive purity to the picture.

The 20th-century American artist **Georgia O'Keeffe (1887–1986)** often produced very large pictures of flowers, fruit and other objects. In this picture we have a number of apples laid out without any careful pattern – just rows of apples going off both sides of the picture and out of the top. The close-up effect of such a simple arrangement creates a very different effect from more classical still-life pictures.

*Inanimate objects, all of one type, can help to give verisimilitude to the picture, because this piles on the effect repeatedly and lulls our more critical response.*

This composition by an 18th-century master shows shelves of music books and some musical scores. It refers to a musical theme, but has a scholarly look because this is where the composer is working to produce the raw material that instruments will eventually play.

In the still life of seashells on a shelf by **Adrian Coorte (1685–1723)**, the sea is nowhere to be seen. The elegant beauty of these sea creatures' exo-skeletons makes an attractive picture in its own right, apart from the pleasing connotations of the ocean.

The typical joke of the *trompe l'oeil* painter is one that we can really enjoy being deceived by.

This picture by **Cornelius Gijsbrechts (c.1610–c.1678)** is one of the oddest and most amusing still-life subjects I have ever come across. It is apparently the reverse of a framed canvas, but is in reality an image in a *trompe l'oeil* manner actually painted on the surface of a canvas. Presumably the other side of it looks the same but is the real back of the picture. It is a nice joke, which probably works better as a painting than a drawing, but I could not resist including it as a remarkable piece of still-life composition that plays with reality.

A beautiful sweep of landscape (after **Corot**) set in the Haute Savoie. The scope of the viewpoint is broad and shows mountain ranges in the distance. Closer up we see large trees in full foliage with, in the foreground, a large empty slope of grass, scrub and ploughed land. The broad movement from the high left towards the lower right side of the picture is balanced by the large group of trees at left of centre.

Corot was a master of landscape painted in a soft and intimate manner. He could convey the soft texture of leafy trees and other plants, and looking at his work always gives a very real impression of landscape on the eye.

*When trying to capture a realistic skyscape there is always the problem that the cloud formations and the light will keep changing. The easiest sky is of course a completely clear one, but it is quite interesting to try to show something more of the weather than just halcyon days. The feeling of reality that* *can be worked into a clouded sky is very attractive to an artist, because if he or she gets it right a lot of the rest of the picture will also seem more convincing. However clouds are difficult because of their diaphanous nature, and it is all too easy to make them look too solid, which rather spoils the*

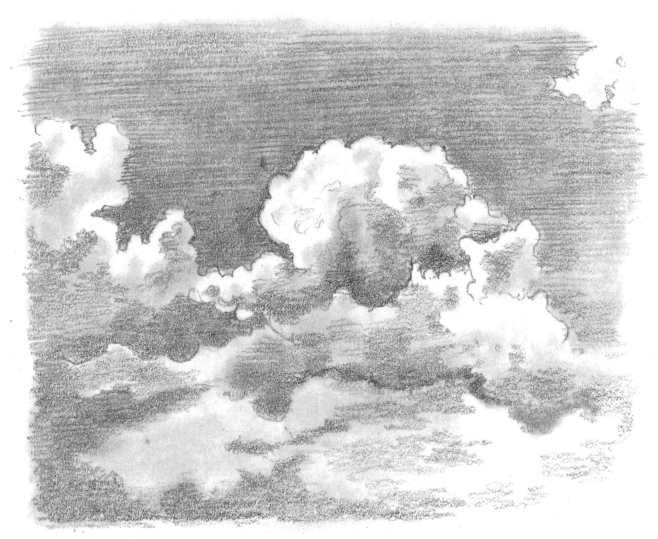

Some studies, such as this one originally by **Willem van de Velde II (1633–1707)**, were of interest to scientists as well as artists and formed part of the drive to classify and accurately describe natural phenomena.

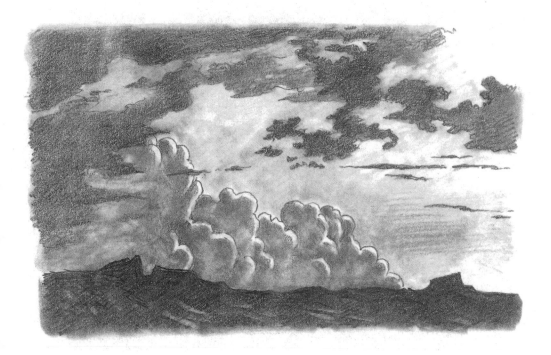

The cloud effects are the principal interest in this work after **Alexander Cozens (1717–1786)**. The three evident layers of cloud produce an effect of depth, and the main cumulus on the horizon creates an effect of almost solid mass.

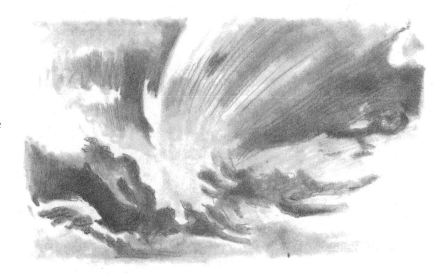

Together with many other English and American painters, **J.M.W. Turner** was a master of using cloud studies to build up brilliantly elemental landscape scenes. Note the marvellous swirling movement of the vapours, which Turner used time and again in his great land- and seascapes.

171

# Style

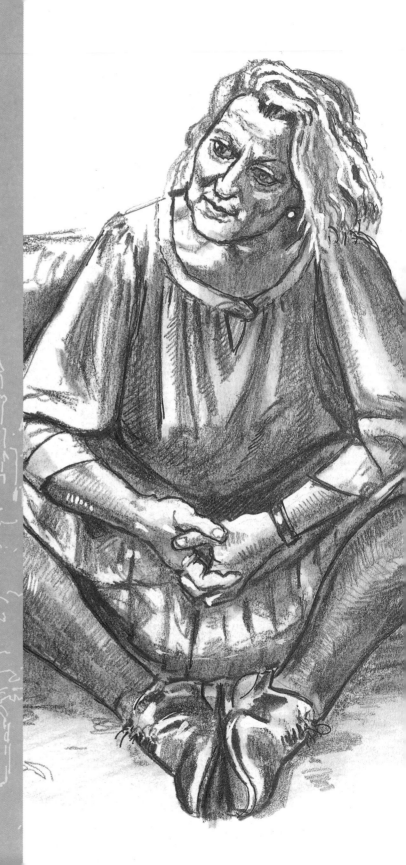

We recognize the moment when a beginner wants to achieve a certain style in their art, and this is quite natural. However, it is important to realize that true style doesn't come from merely wishing to have one but by honing all your skills in order to be able to draw whatever you like, without worrying about how you fit into the stylistic canon. Most great artists started drawing like their teachers and only evolved a style of their own over a significant number of years. So, what we are discussing is not some fleeting desire to be stylish, but a long struggle to draw the world as the artist sees it.

All the styles shown here are the result of many years of practice and have evolved from the artists' own view of life, and how they think that they should interpret it. The first two examples exhibit a tendency to a romantic notion of the world; others are more naïve or more abstracted in their approach. Many examples are very decorative and some are surreal, but all have arrived at their particular point of view from a long process of refinement. So, if you are a beginner, try not to concern yourself too much with your own style but go for some of those shown here to see if you naturally want to follow a particular system. Anyway, it is good for your practice to experiment with different styles, because it can reveal how competent you are at your stage of development.

These are both, in a way, romantic evocations of buildings: one the romance of New York skyscrapers, super-smart buildings that hint at a sophistication beyond most of our means; the other the nostalgia for a past steeped in history and mysterious forms that are now difficult to achieve.

In *The Shelton* (after **Georgia O'Keeffe**) we view an impressive skyscraper depicted with the sun bouncing off it. This style requires you to keep your work clean and sharply defined, and to grade your tones the way that they would appear in a black and white photograph. As a beginner, you could use a real photograph as a guide, incorporating all the odd, accidental distortions that occur in the photographic medium, such as reflections and lens flare.

In this copy of **John Piper**'s **(1903–1992)** view of Fotheringay Church at night, the building is etched sharply against a very dark sky, with the architectural outlines of the main shapes put in very strongly. The texture of the crumbling surface of the old church is well judged, as is the decorative effect provided by the mouldings around the doors and windows. The depth and contrast in the shadows ensures that the effect of bright moonlight comes across well.

The Japanese landscape painter **Hiroshige (1797–1858)** took his forms from nature but was more interested in the spirit or essence of his scenes as works of art. He didn't want to produce simple facsimiles of what he saw. He looked for the key points and balance in elements of his choosing and then carefully designed the landscape to influence our view. Only the most important shapes and how they related to each other were shown. Usually their position and place was adjusted to imbue the picture with the most effective aesthetic quality. The landscape was really only a starting point for the artist, whose understanding, perception and skill were used both to bring the picture to life and to strike the right vibration in the onlooker. The experience was not left to accident.

From the naïve school of drawing, this depiction of
Karlsbad (after **Antonin Rehak (1902–1970)** gives
an impression of perspective knowledge, but the
actual detail and definition of each part of the picture
is of the same intensity whether near, far or in
between. This technique makes for a decorative,
playful style of drawing.

*The Birth of the World* after **Ivan Rabuzin (b. 1921)**, an extraordinary image of a world made up solely of trees, carefully graded and lined up neatly, is a typical effort of a naïve painter producing a pre-historical or mythological subject. Great care has gone into each tree, obsessively repeated, with the clouds repeating the image in the sky. Nothing looks as though it just happened; only a very careful gardener would produce an effect like this. Of course this landscape is not meant to be mistaken for reality. Its very formality contributes to its strength, making you aware that the whole scene is designed for a purpose.

There is no disguising that *Virgin Forest at Sunset* after **Le Douanier Rousseau (1844–1910)** is an imaginary scene. The lush vegetation conveys the feel of the jungle, although the plants themselves look very much as though they have been copied from the engravings that were current at this time in geographical books and magazines.

The artist probably also supplemented his knowledge by visits to the botanical gardens in Paris. In the original, figures and animals are set within the carefully composed disorder of luxuriant plants; they are left out in this version. Although this is obviously the view of an urban dweller and naïve in style, the overall effect is very impressive.

*Both these painters subdue the form of the landscape to their own artistic view of the world.*

Based on *Mornington Crescent in Winter* by **Frank Auerbach (b. 1931)**, this picture is very abstracted. The darkest strokes were done in ink with a brush, which was also used to put in some areas of lighter tone. The effect of solid mass was achieved with chalk, built up in layers and with each new layer of strokes sometimes nearly obliterating those beneath.

In *The Lighthouse*, after **Carlo Carra (1881–1966)**, the landscape looks almost natural except for the strange quality shared by the buildings, which are highly simplified. This is the world of images in the mind, the mental image being considered nearer reality than the physical appearance that we usually consider to be real. Having said that, where does the image of a landscape we look at appear but in our minds? How do we know what is 'out there', except by the evidence of our own senses? Whether the mental image we receive is any less real than the apparent dimensional outer world is not easy to decide.

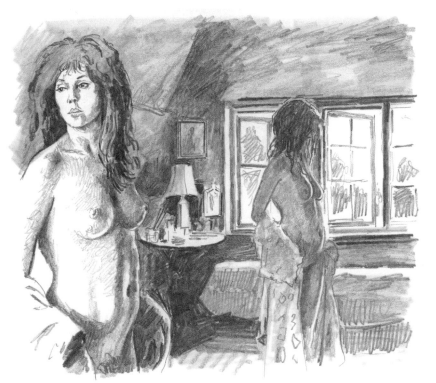

In the **Peter Kuhfeld (b. 1952)** composition shown here, the nude girl in his studio faces towards the window, casting a reflection in a large mirror behind her that shows her opposite side and the window looking out across gardens. In effect we see two figures from different angles. This creates depth and added interest in the picture and we feel we only need to see a little more to one side to view the artist also mirrored in the scene.

In this outdoor scene, also by Kuhfeld, a girl is seated reading at a table in the garden. She is surrounded by flowers and foliage and there is just the indication of a window in the background. The table has been used for refreshments and perhaps once again the presence of the artist is hinted at in the utensils on the table. As with the nude girl in the studio, this is a very intimate scene but the enclosed space is now outside and we understand the open-air feel with the expanse of white tablecloth, iron chairs and abundant surrounding vegetation.

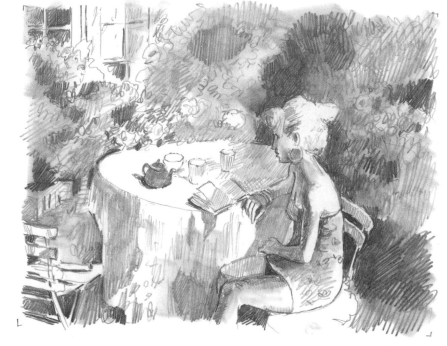

*Some artists take a representational way of drawing and then present it in an especially intimate fashion. The careful arrangements are obviously not totally natural, but look natural enough to be believable.*

In **Lucian Freud**'s double portrait of himself and his wife in a Parisian hotel bedroom, the poses are as informal as the situation is ambiguous. Why is she in bed and he standing by the window? Obviously he needed to be upright in order to produce the portrait but he hasn't shown us that he is the artist. There is no camera, sketchbook or easel and brushes in his hands. So what could be his intention? There is an explanation that Freud's wife was ill in bed at the time, so it may have been that he hit on the arrangement because it was the only way he could paint them both. In the hands of a first-class artist this unusual approach has become a groundbreaking idea. The slightly accidental look of the composition is very much of the period in which it was painted (the 1950s).

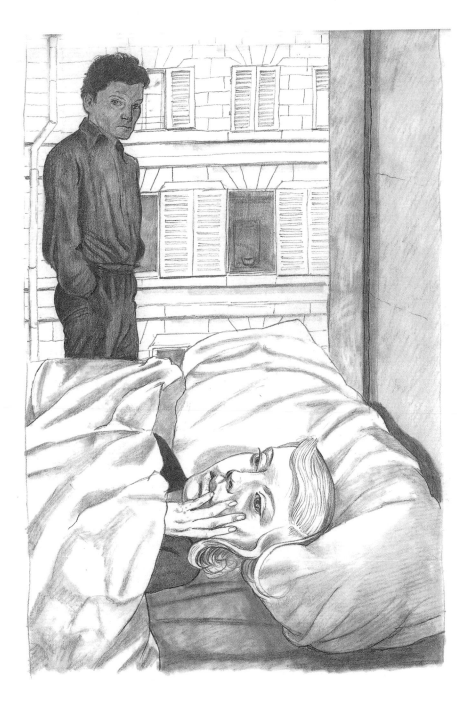

**Chuck Close (b. 1940)**, an American painter, produces portraits of an immense size. They are often in style similar to the passport photograph that you would get from a photo-booth, but drawn about 1.5–1.8 m (5–6 ft) high and with meticulous attention to photographic realism. Their combination of heroic-sized proportions and meticulous miniaturist technique produces monumentally powerful images.

You might find the idea of trying this for yourself rather daunting. In reality, I think you will find it very liberating and immensely rewarding.

The simplest approach is first to project a slide photograph of your model, to the largest size you feel you can handle, onto a wall covered with cartridge paper. Draw your model in outline so that all the proportions are correct. When you have done this, forget the slide and turn your attention to the model. With them in front of you, proceed to draw the portrait up, using the outlines to ensure you get the shapes right. See how far you can take the detail, especially the hair, which can be very difficult at this size. The most fun comes when you start to draw the eyes and mouth and have to transfer what you see to such an immense size.

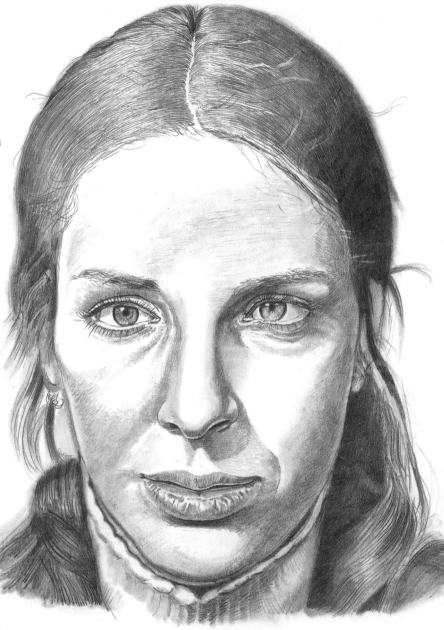

Good luck and enjoy yourself. You'll probably surprise yourself with your skill.

184

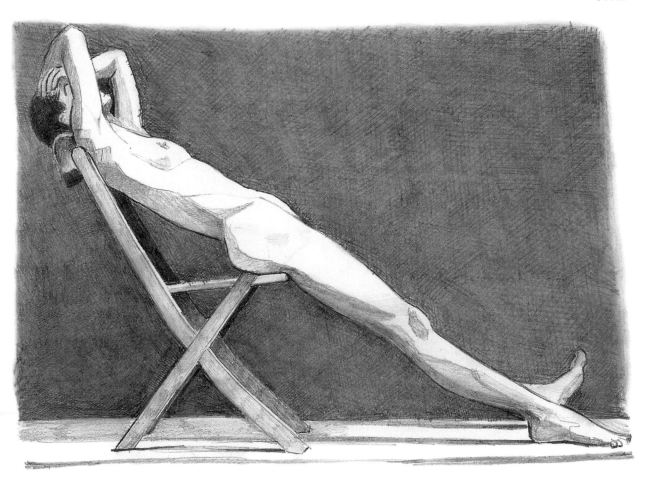

**Euan Uglow's (1932–2000)**
masterly way of producing a figure
was extremely accurate but time-
consuming; he was known to spend
years on just one painting. Uglow
built-up this nude figure from
hundreds of painstakingly measured
marks on canvas or paper to
produce an effect of monumentality.

This geometric vigour is also
reflected in the carefully placed
surfaces of tone and colour, which
build to a structured and powerful
view of the human form. Inevitably
this approach necessitates the
sacrifice of some elements of
individuality.

Shown here is a drawing after **Thomas Gainsborough
(1727–1788)**, a master draughtsman capable of creating
form with very little in the way of significant marks. He
managed to convey bulk and solidity without having to
labour the point with highly detailed contour hatching.

The Gainsborough is of a
fashionable lady drawn at
Richmond, glancing back at the
artist as she walks past in her
beautiful floating silk dress and big
black hat. The solidity of the body
under the garments is implied by
little touches of chalky lines,
smudged tones and white body
colour, which tells us of the
fascinating form of this rather
coquettish young woman. What
is very obvious is that this is a
human body, youthful and
light-footed but also
substantial.

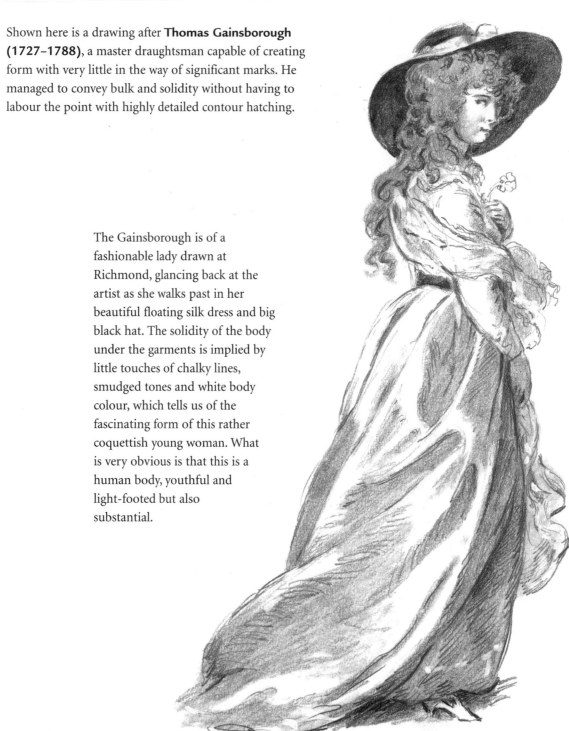

The approach of **Tamara de Lempicka (1898–1980)** in both drawings and paintings was very stylized. In this copy of a portrait of her husband, Tadeusz, the sharp edges of the main shapes have to be put in quite accurately but very smoothly, easing out any small bumps and dents. The tones are put in mostly in large areas without much concern for small details. The end result is a solid-looking, simplified drawing.

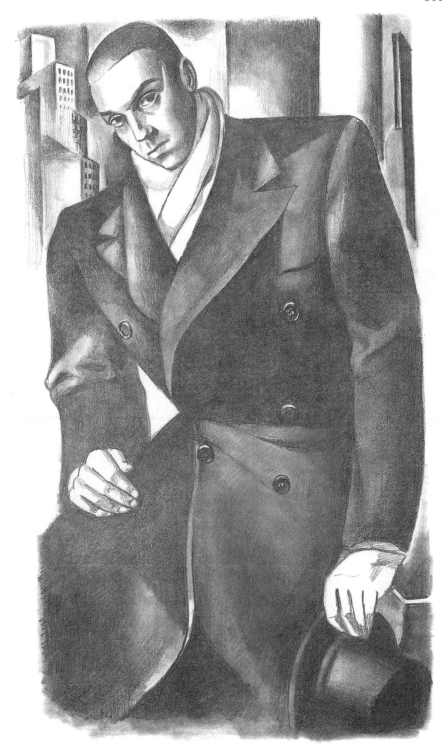

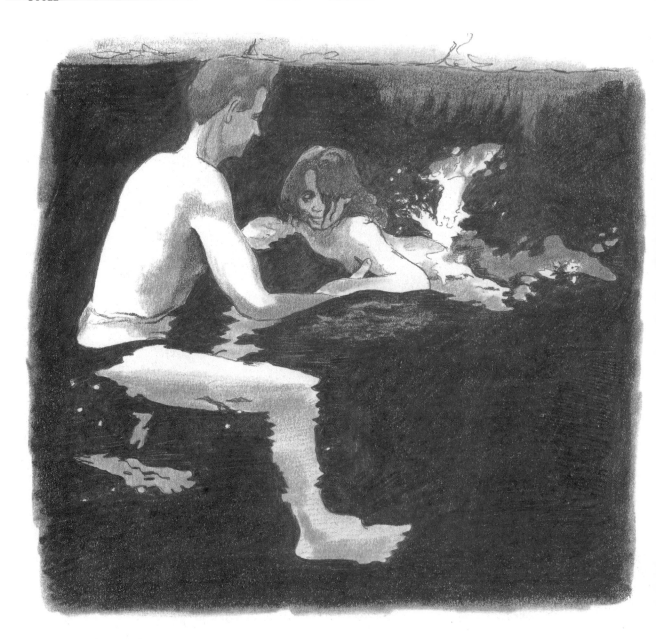

The artist **Michael Andrews** painted a picture of himself and his daughter in a rock pool, where he is helping her to learn to swim. Here he has obviously drawn on photographic imagery to produce this rather attractive painting and he uses the refraction and rippling effect well in depicting the parts of the body below water. He has reduced the splashes to a minimum, making them show up sharply against the dark depths of the pool. The balance of the large, almost vertical figure and the small horizontal one helps to create an interesting compositional element.

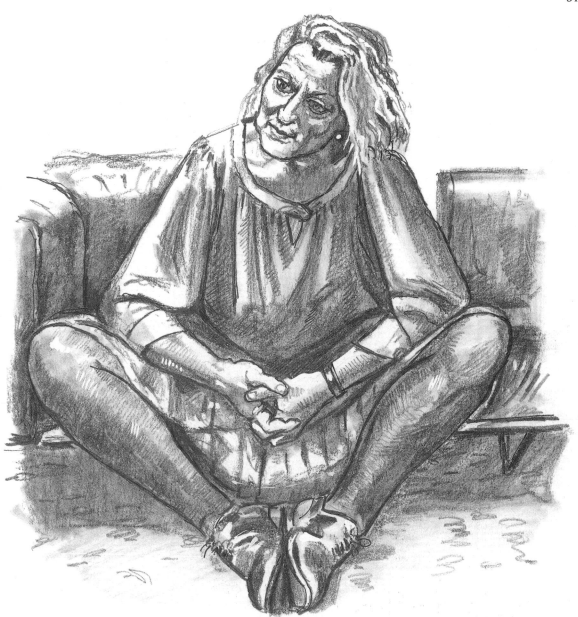

The original of this portrait of academic and writer Germaine Greer by **Paula Rego (b. 1935)** was made in pastel on paper laid on aluminium; this copy is in chalk, pencil and pen and ink.

The difficulty of producing a simple black and white copy of coloured pastel is that the slightly coarser medium of the fast-moving pastel has to be reproduced both smaller and finer while retaining the feel of the original. Careful handling of the different mediums is required to make such a copy work so that it does justice to the attributes of the original.

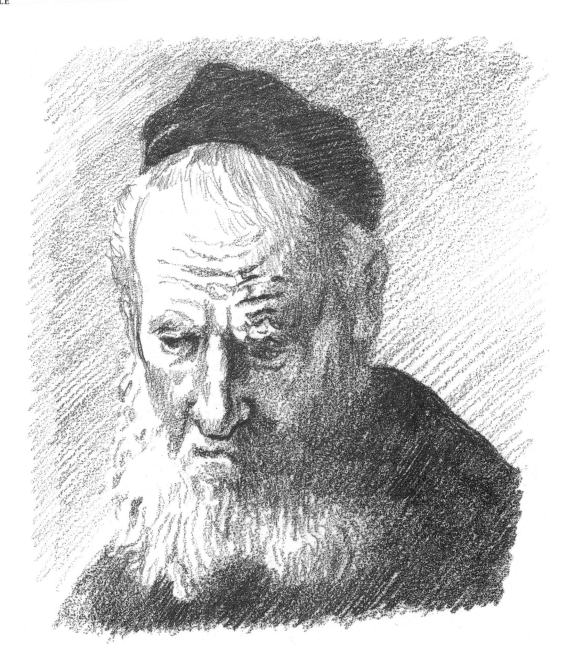

The definition in this copy of **Rembrandt**'s portrait of his father, who was in his early seventies, derives from the use of tonal areas instead of lines. The technique with the pencil is very smudgy and creates an effect that is very similar to one you would get with chalk.

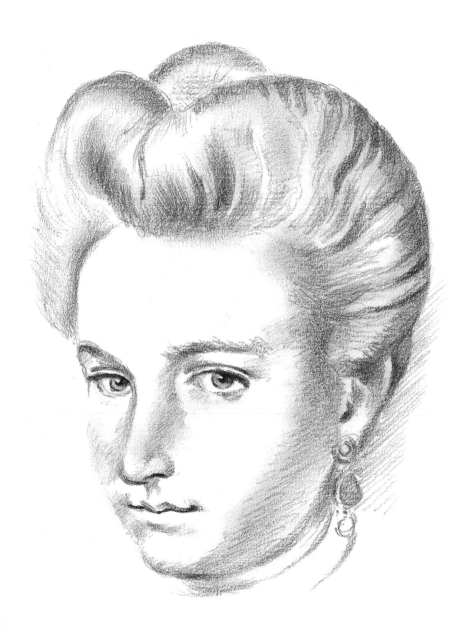

This copy of a portrait of Gabrielle d'Estrées by a follower of **François Clouet (c. 1522–1572)** was executed by carefully stroking on lines of soft B and 2B pencil. In some areas chalk was delicately added. Sharp lines have been applied only around the eyes, nostrils and mouth. Clouet reveals her as wary and self-composed beyond her eighteen years, and yet we are not convinced this is more than a pose.

*Although both these artists go for a simple technical style, the way that they design their pictures creates a new kind of tension and unexpectedness which is attractive to our visual awareness. This makes us rethink what we consider good drawing to be.*

In the linear drawing shown left, after *Inhale, Exhale* (2002) by **Michael Craig-Martin (b. 1941)**, the ordinary mechanical gadgets of modern living are thrown together in a way that confuses the onlooker by placing large objects such as filing cabinets and step ladders against scaled-up versions of a video cassette, pencil sharpener, light bulb and metronome. The pedestal chair in the middle acts as a focal point, and the whole picture is pulled together by the almost mail-order catalogue style of the impersonal drawn line. Michael Craig-Martin is one of the few artists who uses this sort of technical detachment from their subject.

This very simple example by the Italian artist **Renato Guttuso (1912–1987)** shows just two eggs and an egg cup. The arrangement of the eggs on a surface with the curve of the egg in the eggcup jutting up into the background tone of the far wall makes a very abstract and tightly perfect design.

This still life after **Francisco de Zurbaran (1598–1664)**
is lit strongly from the side; the strength of the light
and the fact that the arrangement is set against such
a dark background produces the effect of spotlighting,
attracting our attention to the picture and giving a
rather theatrical flavour.

The most obviously symbolic pictures produced in the still-life genre were often concerned with the passing of time and approach of death. This still life after **Bruyn the Elder (1493–1555)** is a simple but effective composition with its blown-out candle, the skull with its jaw removed to one side and the note of memento mori on the lower shelf. The dark shadows under the shelf set the objects forward and give them more significance.

*These works are both in a very traditional style, and do not attempt to break the boundaries of artistic technique. However the very normalcy of the technique makes us appreciate the subject matter more than usual, and it is easy to see that both these artists were masters of their style.*

Our first picture is of a classic 18th-century still life, by the Italian artist **Carlo Magini (1720–1806)**, of bottles of wine, oil pots, a pestle and mortar and the raw ingredients of onions, tomatoes, pigeon and sausages. This is a very traditional picture of the basic preparation for some dish. Note the balance achieved between the man-made objects and the vegetables, bird and sausages. The hardware is towards the back of the kitchen table and the food is in the front.

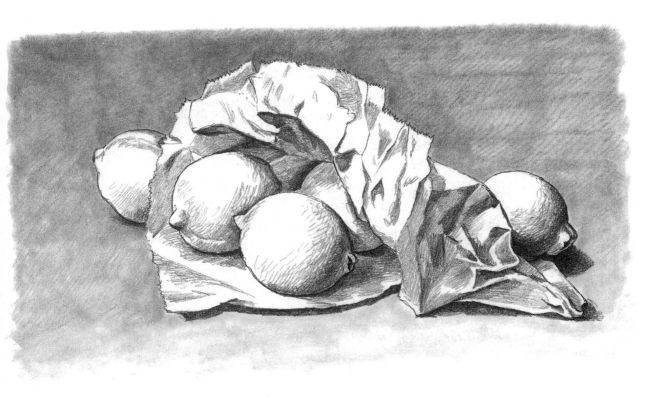

This picture of a few lemons spilled out of a crumpled paper bag has a simplicity and elegance that the British artist **Eliot Hodgkin (1905–87)** has caught well. It looks quite a random arrangement but may well have been carefully placed to get the right effect. Whichever the case may be, it is a very satisfying, simple composition.

Drawing from subject matter found in the kitchen is a time-honoured occupation for most artists, and the pleasing variety of shapes does give you plenty of practice. Also, because the subject matter is likely to be put to use in the near future, it encourages you to get a move on with the drawing. Not too slowly, or the objects will be transformed into a meal.

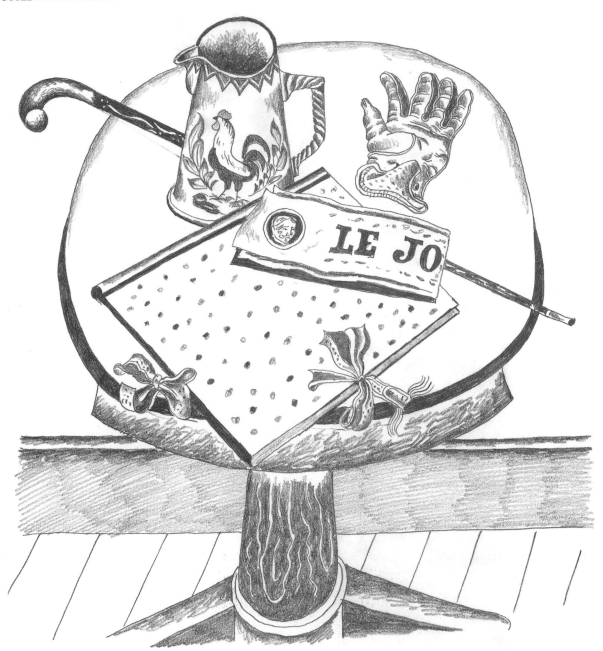

This very decorative still life by Spanish artist **Joan Miró (1893–1983)** has an informal look but is presented in a very formalized, pattern-like way that produces a very interesting, almost geometrical set of shapes and spaces. The pattern of the wood grain is as important in its texture as is the spotted art folio, the decorated jug, the masthead of the newspaper, the strongly diagonal walking stick and the soft, writhing look of the empty glove.

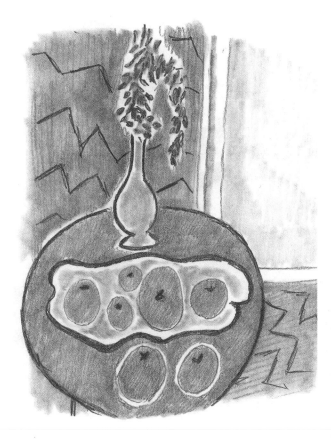

This still life after **Henri Matisse** is even more arbitrary about the way it uses the shapes of the fruit and flowers. These shapes are important, but not because of their actual substance; Matisse's interest was in the way they are arranged across the table, which is drawn tilted up towards our gaze. The whole set of shapes creates a very formal pattern, defining the area aesthetically but taking very little notice of the meaning of food or flowers.

British painter and printmaker **Craigie Aitchison (b. 1926)** produces pictures of plants in vases which reduce everything to the minimum form for maximum effect. His lonely, vulnerable flowers held in an elegant but sturdy container are centrally placed and have the simplicity of a child's drawing, but with a sort of heightened significance. The notably simple approach, usually with plenty of space around the object, makes it look very important.

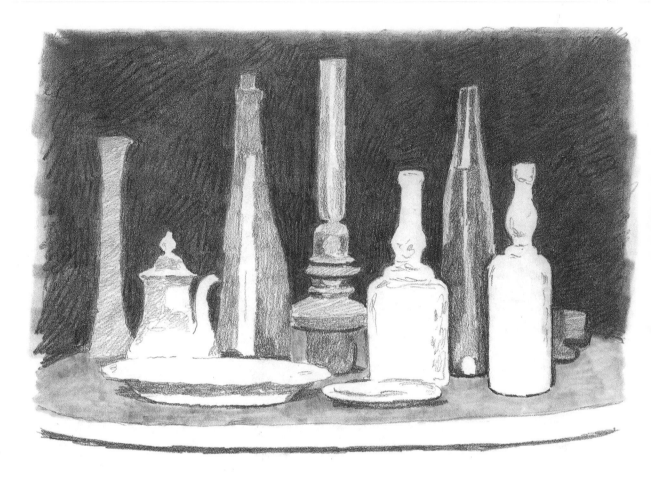

Here, after **Giorgio Morandi**, we have a large group of
bottles and pots against a dark background with a couple
of plates in the foreground. This monumental still life
suggests much bigger objects but still has the same
constituents that Morandi always used.

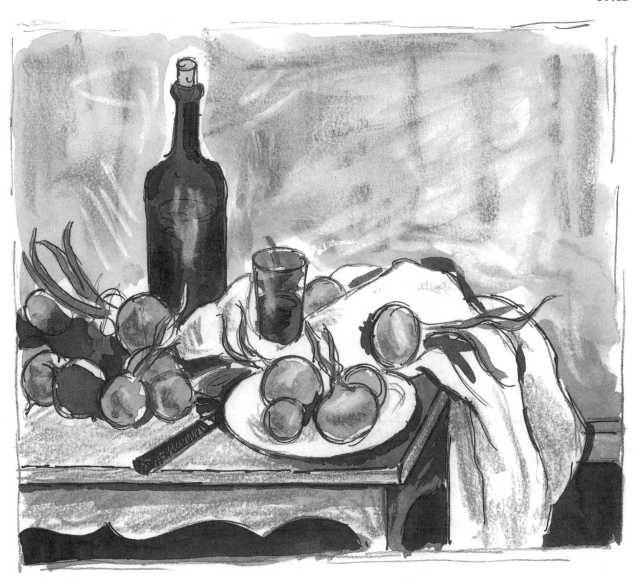

A still life based on a **Cézanne** picture was done rather
more finely in pen line, chalk texture and washes brushed
across some areas. In some places the chalk is on top of
the wash and in others the wash is over the chalk.

*Upper Deck*, painted in 1929 by **Charles Sheeler (1883–1965)**, is a still life with maritime connotations, though it could be any arrangement of machinery or industrial details that is the subject here. The drawing is of the upper deck of a 1920s steamship with its clutter of objects, which are all entirely functional in nature. This really is an enormous piece of still-life drawing that almost crosses over into the area of landscape. However, I think it can still be classified as still life because there is enough detail to make the objects the subject of the picture rather than the suggestion of larger spaces.

*Bridges* (after **James Doolin, b. 1932**) is very realistic in approach and quite a *tour-de-force*. The tonal values required a great deal of work. The more trouble you take with this aspect of a picture done in photo-realist style the better the final result will be. There is also an element of photo-distortion which serves to enhance the realistic effect yet further.

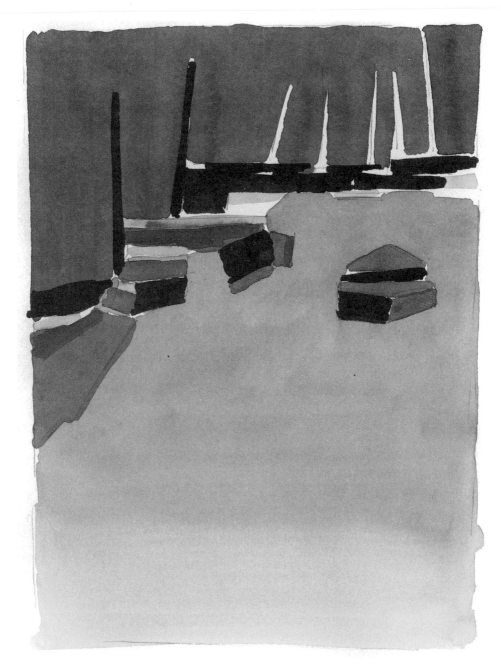

*Les Martigues* (after **Nicolas de Stael 1914–1955**) looks easy by comparison, but getting those large simple areas of tone down is harder than it looks. If you find they look less than smooth, don't worry – they might still work, so carry on regardless. The main difficulty for the beginner is lack of confidence. It is much better not to use pencil to put down the main shapes, but to go straight in with wash and brush. If you feel it is absolutely necessary to use pencil, keep it to a minimum.

The figures at the base of **Francis Bacon**'s **(1909–1992)** *Three Studies for a Crucifixion* seem to represent a raw, blind fury or perhaps even revenge. Bacon himself identified the figures as representations of the Furies who, in classical myth, torment evildoers before and after death. Although not classical studies, they seem to apply to classical myth.

The interesting thing about these drawings is that they don't represent anything real or familiar and consequently it is quite easy to get the shapes and proportions wrong. However, even if you do, it will not be too noticeable because there is nothing to compare them with except the originals.

Here is something distinctly odd: a Surrealist still life that is also partly a landscape. Although the objects are from everyday life they are given a new twist by the fact that they seem to be soft and melting instead of hard and rigid. **Salvador Dali's (1904–1985)** melting watches are famous and it is quite a feat to be able to paint such things in a way that makes them still recognizable while changing their shape so dramatically.

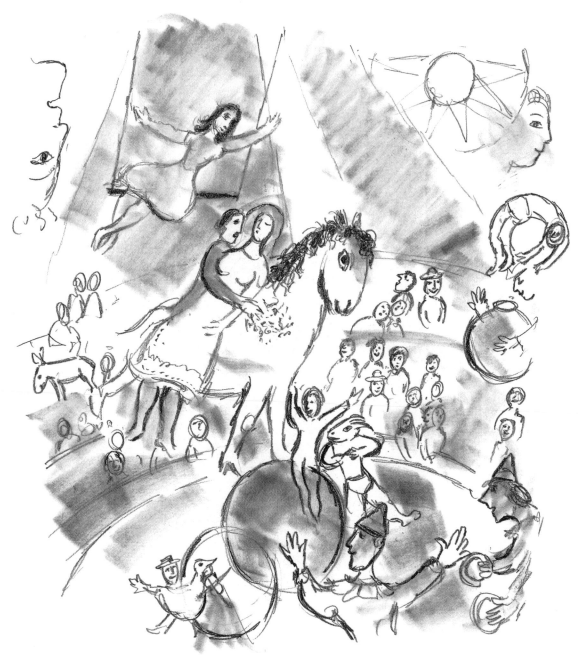

The gentle lyricism in **Marc Chagall's (1887–1984)** drawings could not be further from the feeling of unease, almost revulsion, that we met in Francis Bacon's work. Chagall used a charming, playful way of drawing in much of his work. Most of his paintings have either lyrical or joyful associations in their design, colour or the technique employed. He chose to portray the magical quality of life and touch our emotions in subtle ways.

207

*In this example of modern symbolism, the figures are very expressive and expressionistic, as many American works were at this time. The reduction in physical solidity emphasizes elegance and vibrancy.*

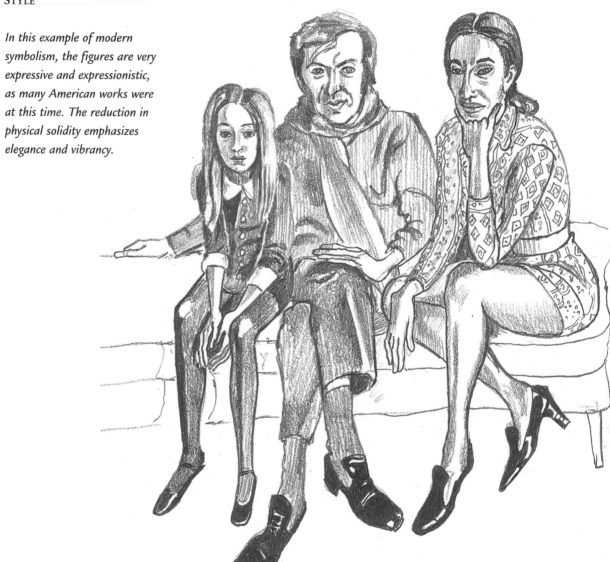

*The Family* by **Alice Neel (1900–1984)** can be read as a genuine exposition of the values of the New York artistic scene in 1970. The girl and the woman share many traits that set them in their milieu: long hair, long-sleeved short-skirted dresses, thin pared-down legs and elongated fingers. These point to a specific view of cutting edge fashion. Although less obviously trendy, the man is part of the same scene, with his casual scarf, longish hair and long hands with thin fingers. Posed close together, the three of them eye us unflinchingly and not favourably. Their look says, 'We are here, notice us.' Their slightly angular shapes heighten our awareness of their significance as representatives at the cutting edge, more so than their features or what they are actually wearing. One feels that after seeing this picture the sitters would probably grow to be more like Neel's depiction of them.

Drama in art can be conveyed through the action of figures. The quality of the composition depends on the way the figures move across the surface of the picture. In this example, dramatic action is conveyed by **Picasso** by means of the distortion of the women's bodies.

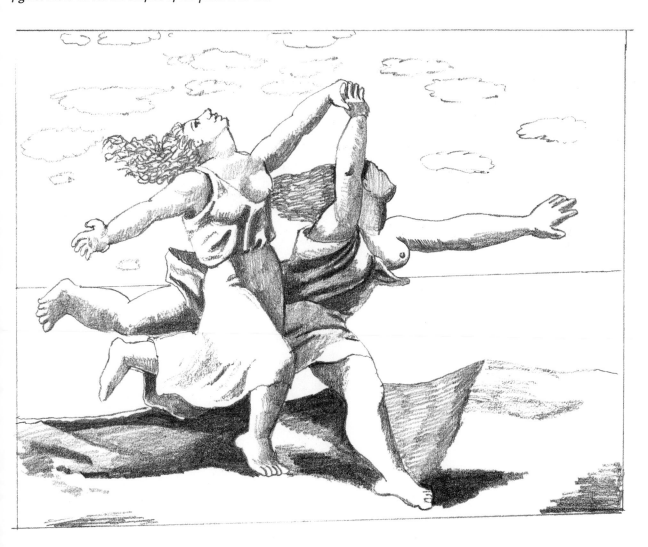

Picasso's figures on a beach are not naturalistically correct. They express the joy of running through the arrangement of the arms – outstretched and linked – and the disjointed leg of the leading figure, which stretches out distortedly to suggest the horizontal movement of running.

All of the images on this and the following spread try to convey to the viewer a feeling or idea that is not being expressed in words. Indeed, it may be difficult to express precisely or concisely the effect they have. One picture can be worth a thousand words. It is not easy to get across a concept by visual means, but with a bit of practice it is possible. Try to produce such an image yourself. You can use or adapt the approaches or methods we've been looking at. When you've produced something, show it to your friends and listen to their reactions. If your attempt is suggestive of the idea you wanted to convey, they will quickly be able to confirm it.

*The Kiss*, by Viennese artist **Gustav Klimt (1862–1918)**, shows the power of desire in a very graphic manner. The heavily ornamented clothing, while revealing very little of the flesh of the lovers, increases the tactile quality of the work. The firm grasp of the man's hands on the girl's face and head, her hands clinging to his neck and wrist, and her ecstatic expression tell us of the force and intensity of their sexual desire.

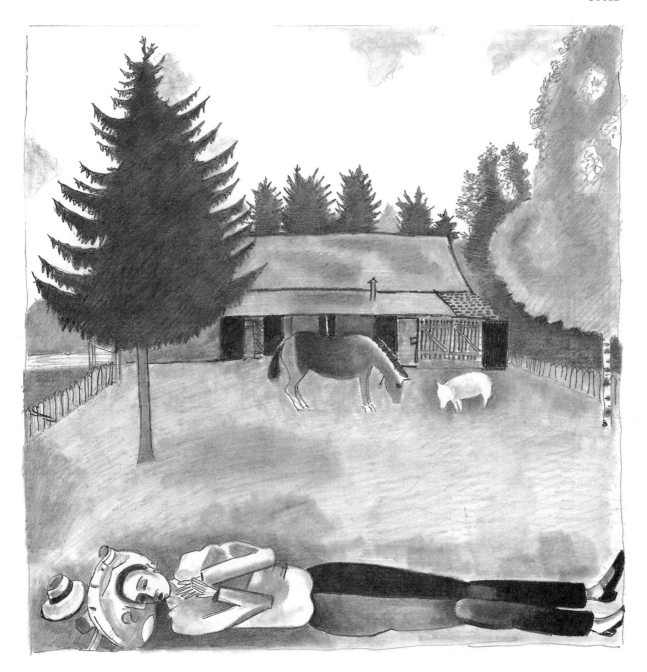

**Chagall**'s picture has an almost childlike sense of fun and enjoyment, emphasized by the rather naïve handling of the drawing. The picture of a poet reclining produces an air of gentle melancholy. This is partly due to the rather odd position of the figure, which is lying along the base of the picture, and partly due to the dark trees and almost ghostly toy-like animal shapes grazing in the fenced paddock behind the poet.

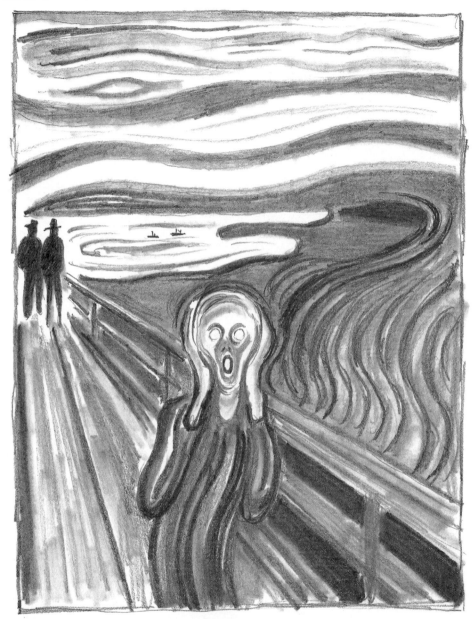

*The Scream* by **Edvard Munch (1862–1944)** is an expressive and subjective picture that is now read as a general statement about ourselves, particularly the angst and despair experienced by modern man.

The area depicted in the painting was favoured by suicides, and was close to slaughter-houses and a lunatic asylum where Munch's sister was incarcerated. The artist wrote of the setting: 'The clouds were turning blood red. I sensed a scream passing through nature.'

Munch's painting has a blood-red sunset in streaks of red and yellow, with dark blues and greens and blacks in the large dark areas to the right. The swirling lines and skull-like head with its unseeing eyes and open mouth produce a very strong effect.

In this drawing of a weeping woman by **Picasso** the extreme emotional power is brought out by the clever distortion of the physical shapes of the head without totally losing the effect of human grief. The face seems to be almost dissolving in tears while the hands and teeth create immense tension or anguish.

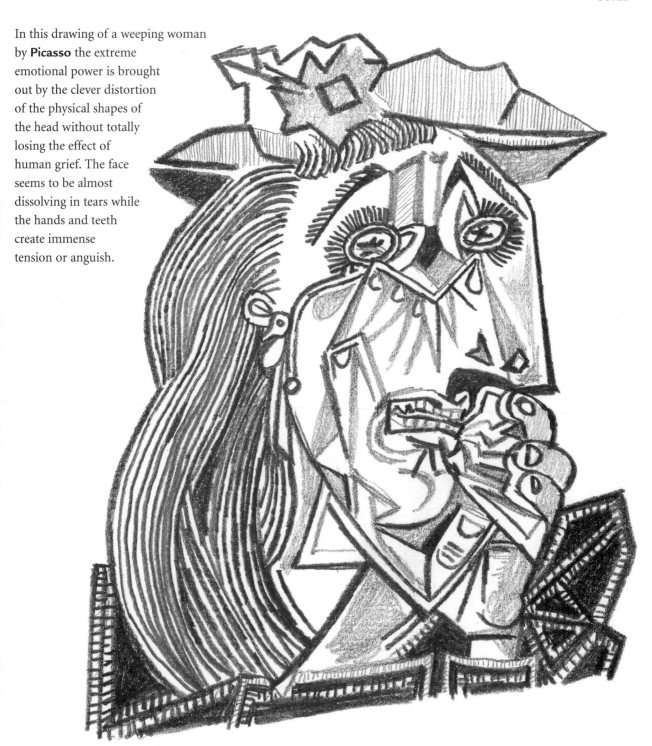

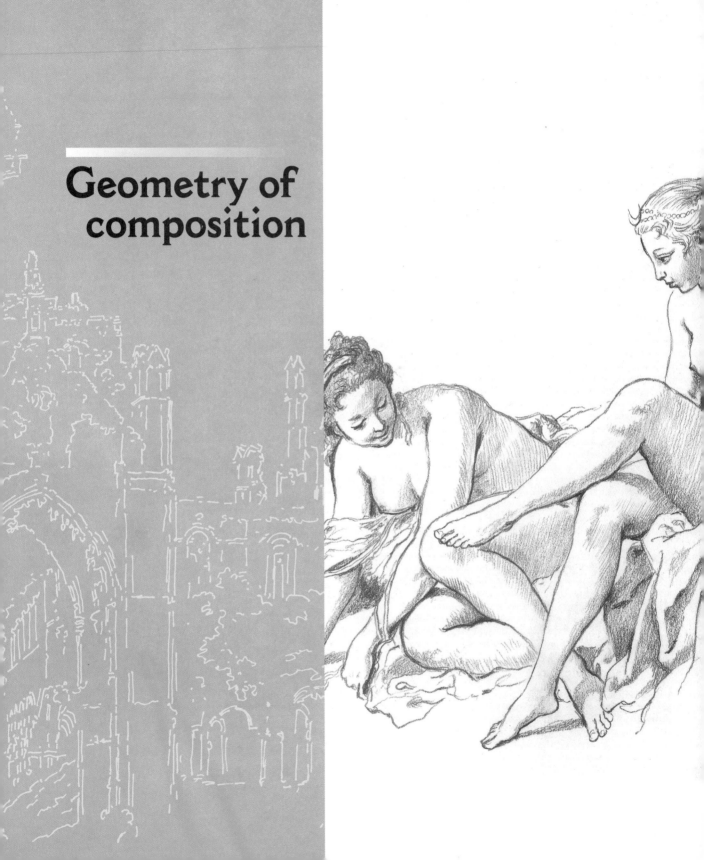

# Geometry of composition

In this section, I shall attempt to show how many artists rely not only on their natural ability but also use intellectual devices to produce more powerful works of art. One of the most common ways of achieving a satisfying picture construction is to employ the discipline of geometry, dividing the picture area into various fractions of the whole; taking thirds, quarters and other parts to help construct a balanced composition. Sometimes artists require a more dynamic system that uses sweeping angles and lines of movement through the composition, to draw in the attention of the onlooker. Most artists have some geometrical view of their work, either before they start, or they discover it as they proceed, through simplification. Even the basic decision to have your horizon line high or low in a landscape is a geometrical device in order to create a certain feeling within the final picture. So try this out when composing a drawing. As you will see, I suggest several options which you may find useful.

## Close Groupings

*When dealing with human subjects, all sorts of arrangements can make good compositions, and in the process tell us a great deal about the sitters. It used to be the case that a portrait would include clues as to the sitter's position in society or would show to what he (invariably) owed his good fortune. Most artists, however, are more interested in incorporating subtle hints about the nature of the relationships between the subjects in the groups they portray. You may choose to introduce an object into your arrangement as a device to link your subjects.*

*There are many ways of making a group cohere in the mind and eye of the viewer. In these two examples, both after realist painter* **Lucian Freud**, *the closeness of the arrangements is integral to the final result.*

When composing a picture, consideration of the geometry of the shapes involved is a good way to make a picture that not only holds together as a whole but also creates a dynamic within the composition that gives strength and power to the work.

■ *This arrangement makes a very obvious wedge shape leaning to the right. The shape is quite dynamic, but also very stable at the base. The slight lean gives the composition a more spontaneous feel.*

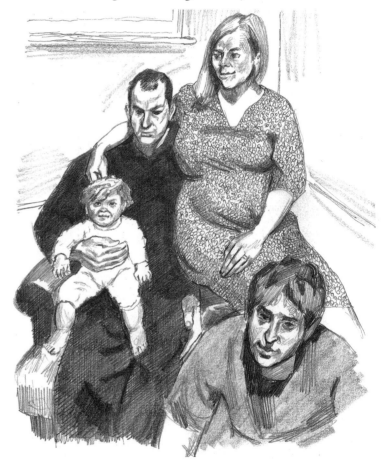

The central interest is shared between the baby and his parents. Our eye travels from the infant to the couple as they support him and each other on the armchair. In front, the elder son is slightly detached but still part of the group. The connection between the parents and the baby is beautifully caught, and the older boy's forward movement, as though he is getting ready to leave the nest, is a perceptive reading of the family dynamic.

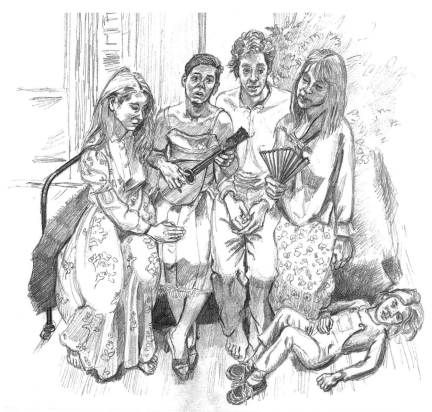

*Large Interior* – after **Watteau** is reminiscent of that artist's *fête champêtre* compositions in which young courtiers are depicted listening to music and enjoying each other's company. Freud transfers the outdoors to a well-lit indoor scene with three young women, a young man, and a child lying at their feet. As in many Watteau paintings the girls are wearing rather flowery, pretty dresses and the boy is garbed in a loose white ensemble, rather like a Pierrot. While the whole ensemble makes for a very friendly grouping, there is an element of a more formal mode of arrangement. In Freud's original the space around the figures produces a very posed, almost artificial effect. Here, even the child lying at the feet of the quartet seems very conscious of her position in the scene.

■ *This is a very solid, stable, composed group. The individuals are lined up along the same base with some squashing together of the upper bodies. The reclining figure is almost like an afterthought and contributes to the portrait's spontaneity.*

217

## Centrepieces

*For a group portrait it is very effective to include a focal point around which the sitters can gather. In bygone times an unwritten rule of portraiture was that the artist should incorporate devices pin-pointing the social standing and worthiness of the people he painted. Nowadays both artists and sitters are more interested in a presentation that is essentially revealing of character and individuality.*

■ *The two adult figures and the lifted top of the piano give a stable effect. The curved line that links the position of the heads pulls the eye smoothly across the composition.*

Like many 18th-century portraits, this one is carefully posed to include clues to the sitters' social position. The artist, **Carl Marcus Tuscher (1705–1751)**, wants to show us that these people are comfortably off – note the care that has gone into the clothing. The head of the family is Burkat Shudi, a well known harpsichord manufacturer and friend of the composer Handel. The piano is centrally positioned but set behind. If we were not sure that the family owes its good fortune to the instrument, Tuscher underlines the connection by posing Shudi at the keyboard with a tuning fork in his right hand, and has the eldest son indicating to the viewer what his father is doing. The arrangement is balanced but relaxed. It is as though we have dropped in on the family unexpectedly at home and found them at leisure.

The Duke of Marlborough's family portrait was done by **Sir Joshua Reynolds (1723–1792)** in his best classical manner. We see the father seated in the grandeur of the robes of the Order of the Garter, his hand resting on the shoulder of his eldest son. The mother stands at the back of the group under the triumphal arch, her fingers gently resting on her husband's cuff as she casts an amused glance at her children. They are grouped along the space in front of her, dogs weaving around their feet. One young girl is holding a mask, trying to frighten her sister, who is leaning back against an older girl's dress. Reynolds has lightened the formality with this humorous touch to bring out the characters of his sitters. This may be a great family, but there is a human dimension.

The drawing style for this copy is loose and tonally sparse. Areas of tone are either heavily scribbled lines, meandering lines following the form or smudged pencil to make the texture as unobtrusive as possible. The outlines are correct but not detailed. Simplification is a good rule here.

■ *Note the nicely balanced wedge shape with the wide curve of the heads of the family. The exception is the Duchess, who is centred under the tall arch in the background. Mobile, but restful at the same time.*

## Breaking with Convention

*Most of the arrangements we have looked at so far have been formal in terms of their composition and very obviously posed. The approach taken in this next drawing is remarkable. The English painter* **William Hogarth** **(1697– 1764)** *was notable for his progressive social attitudes, and these are very much to the fore in this powerful and humane piece of work, in which he presents his servants.*

The original Hogarth painting from which this copy was made is an extraordinary essay in characterization. Executed with great brilliance and obvious warmth and sincerity, it shows the artist's servants. The composition is exemplary. Each head, although obviously drawn separately, has been placed in a balanced design in which each face has its own emphasis. Hogarth's interest in his subjects is evident from the lively expressions, and we feel we are getting genuine insights from a man who knew these people well.

■ *A very straightforward fanning out of the six heads from the base, placed in close proximity. All slightly off-centre but still very symmetrical.*

## Double Portraits

*The double portrait can be used to produce interesting effects of juxtaposition by placing two similar, or two very dissimilar, people alongside each other in order to create contrast or repetition. There are some very famous examples*

*of this approach, but in the next series I have chosen particular illustrations that ring the changes visually and show how easily the device can be used to produce an unusual picture.*

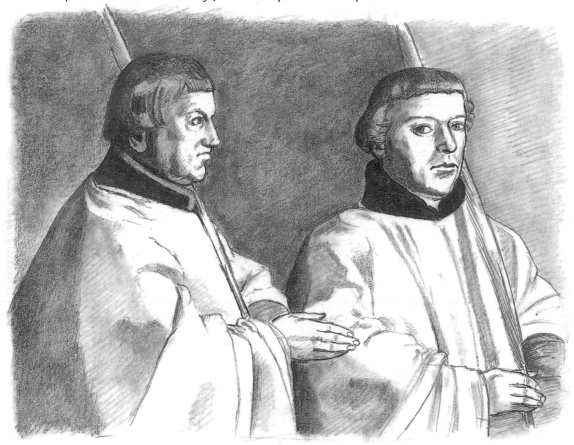

This rather stylized portrait of two canons, connected in religious orders and devotional intent, is made powerful by the simple repetition of shape and size. In Tudor times clerics were the most respected of the non-aristocratic community, and considerable attention was paid to their image for the public. These two are shown as formal and detached

from the viewer, but nevertheless wanting to show their status in the community. At this time the full-length portrait was reserved for rulers. Bust portraits such as this, like Roman classical busts, were a way of men from good families showing that they were solid citizens and of good intent. The inference is: 'We are not saints, but pious believers.'

■ *Very stable, very straightforward arrangement like two truncated triangles.*

In **Gainsborough**'s marvellous portrait of the Duke and Duchess of Cumberland, the arrangement does not attempt to disguise the fact that the young wife is much taller than her princely military husband. The full-length figures stop the picture being intimate. There is a definite 'swagger' effect, as the pair seem to be stepping out in public to show themselves off.

This sort of drawing needs a feathery, rather impressionistic touch with the pencil, using loose lines but observing the shapes as accurately as possible so that the lines don't become too arbitrary. A considered effort to draw in the soft, feathery lines works better than making swift, dashing strokes.

■ *The tall, elongated triangle of the Duchess makes a strong, vertical base shape for the rounder ellipse of her husband.*

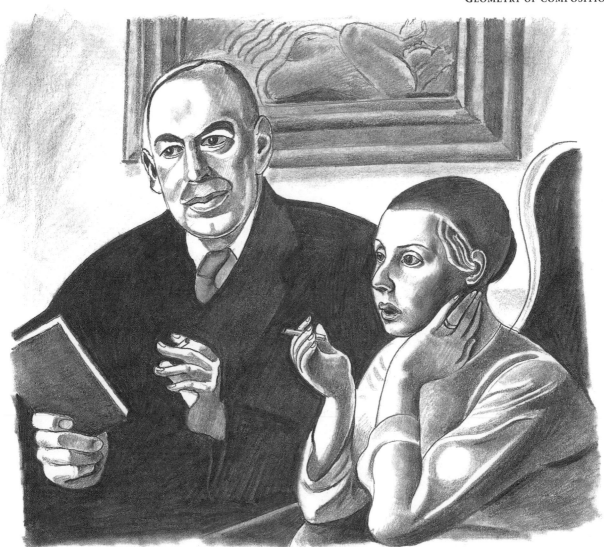

■ *The large amorphous shape of Keynes acts as a comfortable foil to the sharp equilateral triangle shape of his wife.*

The economist John Maynard Keynes commissioned a double portrait of himself and his wife from painter **William Roberts (1895–1980)**. The rather simple Cubist style was Roberts' normal way of working, and usually you could not recognize a human form in his paintings. The slightly mechanical look of reducing all the shapes to cylinders and ovoid forms tends to give a statuesque but rather inhuman look to his sitters, who could almost be dolls. Even so there is enough individuality in the two figures in this portrait to give an interesting, if unintentionally humorous, effect.

223

## Complex Geometry

*Make a practice of studying complex compositions to see where geometric shapes link to hold the figures together. Doing so will help you to think about incorporating such shapes into your own pictures as a matter of course and your compositions will benefit from this method of working.*

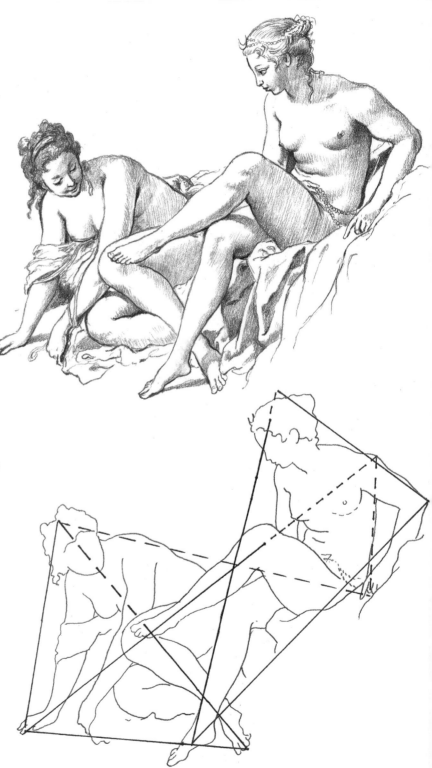

When it is analyzed, this simple enough composition by **François Boucher (1703–1770)** of two goddesses or nymphs at their toilet becomes a complex series of interlinking triangular shapes. The main thrust through the picture goes from the lowest hand on the left up through the knee and leg of the seated figure and on to her upper shoulder. From her head to elbow is an obvious side of a triangle from which two longer sides converge on her lowest foot. The line from the seated figure's upper leg along the back of the kneeling figure produces another possible set of triangles that go through the feet and hand of the lower figure. These interlinking triangles produce a neat, tightly formed composition that still looks totally natural and ideal.

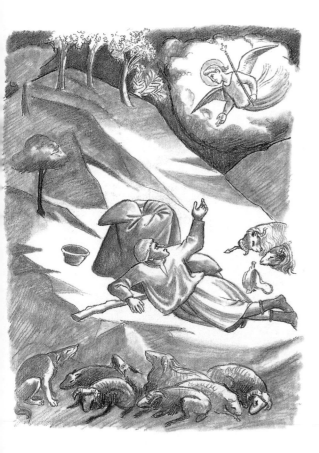

In this straightforward narrative (a copy of a mural by **Taddeo Gaddi (c. 1300–1366)** of the *Annunciation to the Shepherds*, in Santa Croce, Florence), we see the shepherds reacting to a bright light in the middle of the picture, on a steeply sloping hill with some trees at the top. In the top right-hand corner there's an area of dark sky and an angel floating out of a brightly lit cloud, indicating to the shepherds. Down at the bottom, there's a small flock of sheep with a dog looking on.

The position of the angel swooping downwards and the shepherds angled across the centre of the picture give an unambiguous, almost strip-cartoon version of the story. The brightness of the angel tells us of his importance, and the position and actions of the shepherds mark them out as central characters. Everything else in the picture is just a frame to convince you that this is outdoors and a fitting context for the shepherds.

This scene is taken from **Raphael**'s fresco in the Vatican of the *School of Athens*. Here are two loosely related groups of figures set on a staircase that are part of a much bigger composition. In order to make a crowd scene work so that it is not just a random dotting of figures over the setting, Raphael carefully produces closer groups of figures within the large crowd. He helps them to cohere as a composition by using the direction of the individuals' sightlines. For example, note how the uplifted face of the youth in the centre of the group at the bottom right of the picture starts the flow of movement as denoted by the arrowed line. Similarly, one figure by a gesture links one or two figures with another group – see how a double-handed gesture includes the slumped, reclining figure; sometimes figures face in towards each other to produce a centre to a composed set of figures. Raphael also uses the kneeling, sitting and reclining figures to set off the overall standing figures, to stop them becoming too vertically dominant. Raphael was a master of this sort of composition, and it is worth studying sections of large paintings by masters to spot these internal groupings within larger groups and discover how the whole dynamic of the composition works.

The Spaniard **Juan Sánchez Cotán (1560–1627)** found an effective, dramatic way to arrange and light quite ordinary objects in this still life. The dark background, the dangling fruit and cabbage, the cut melon and aubergine on the edge of the ledge produce an almost musical sweep of shapes, all highlighted dramatically. Would Cotán have seen fruit and vegetables arranged like this in late-16th/early-17th century Spain, or did he create this design himself specifically for his painting? Either way, the arrangement is very effective and a brilliant way of injecting drama into quite ordinary subject matter.

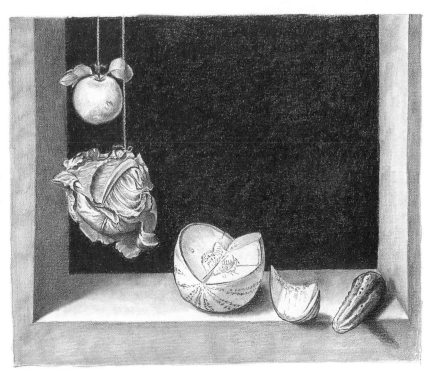

The American painter **Edward Hopper (1882–1967)** was keen to depict everyday life as he saw it. In this picture, there is no dramatic situation, and not one figure, although the open door suggests that someone may be nearby. The composition is very still, despite the waves on the near surface of the sea glimpsed through the door.

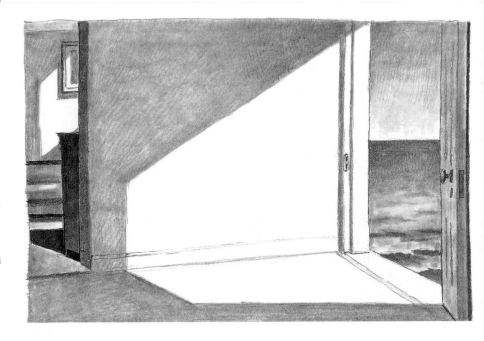

It seems we are looking at a depction of a timeless summer's day, as experienced in a house by the sea, bright, still, and balanced by the shadow and the light. Despite the simplicity, there is a touch of expectancy, as though someone will soon step into the space. The composition is attention-grabbing and oddly peaceful at one and the same time.

This is a copy of a landscape by the 19th-century American painter **John Kensett (1816–1872)**. Rocky, wooded banks curve into the picture at about centre-stage. To help the viewer Kensett has included a group of wildfowl just about to take off from the water. The viewer's attention is immediately caught by this movement, and by the detail of the foreground rocks. The inward curve of the water pulls your eyes to the distant mountain peak, rearing up above the surrounding hills. Even the cloudscape helps to frame the rather distinctive mountain, which is on the centreline. Kensett uses these very precise devices to get us to look at the whole landscape and appreciate the singularity of its features.

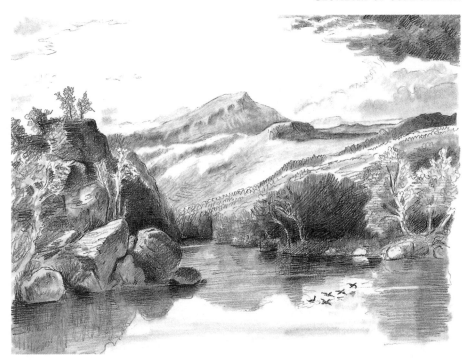

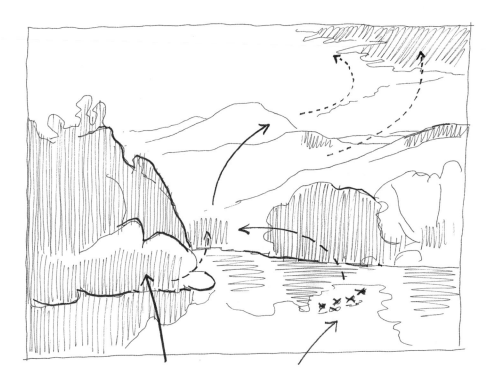

The view taken by **Degas** here is quite extraordinary. We see the upper part of the girl, upside-down as she bends to pick up a sponge. The tub acts as a large, stable base shape and the towel and chair on the floor lead us to the window indicated in the background. Just over half the picture is taken up with this unusual view of quite a simple action and gives an interesting dynamic to the composition. It looks almost as if we have caught sight of this intimate act through an open door. We are close, but somehow detached from the activity, which helps to give the picture a statuesque quality.

Degas has found a very effective way of creating interest just by the arrangement on the canvas. Ordinary, but extraordinary.

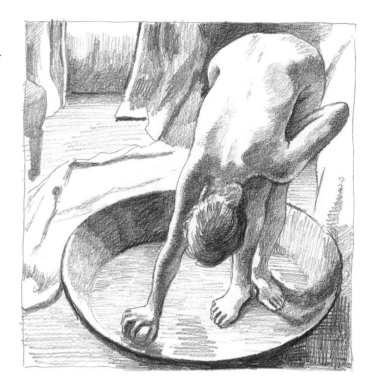

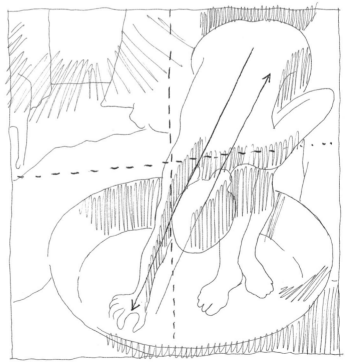

We stay with **Degas**. We are in a 19th-century dance studio, with a master continuing to instruct his pupils as they rest. All the attention is on the master with his stick, which he uses to beat out the rhythm. The perspective takes you towards him. The way the girls are arranged further underlines his importance. The beautiful casual grouping of the frothy dancers, starting with the nearest and swinging around the edge of the room to the other side, neatly frames the master's figure. He holds the stage.

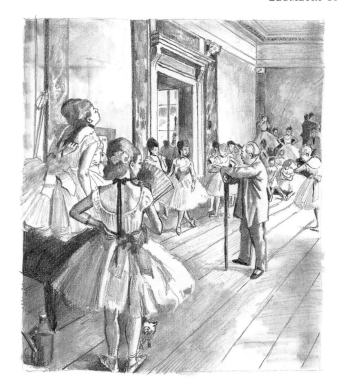

*The pictures shown here are classic examples of the use of geometry. Both* **Leonardo** *and* **Piero della Francesca (c. 1410–1492)** *were great mathematicians and their handling of geometry in their works reflects this facility.*

*If you want to test the effect of the systems they used, go and look at the originals of these drawings (you'll find the Leonardo in the Uffizi in Florence and the della Francesca in the National Gallery, London).*

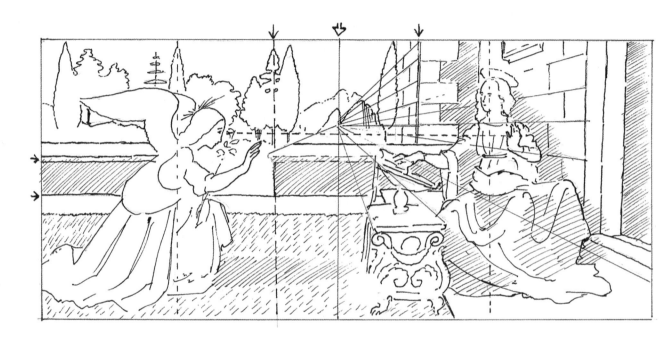

*The Annunciation* by Leonardo is centred on a 'cleft' (the mountain in the background) to which point all the perspective lines converge. (This symbol of the cleft earth is often used in paintings in conjunction with God's incarnation in human form.) The picture is divided vertically into two halves by this point and horizontally by a long, low wall dividing the foreground garden from the background landscape. The angel's head is about central to the left half of the picture and the Virgin's head is about central with the right half of the picture.

The scene seems to be divided vertically into eight units or areas of space: the angel takes up three of them, as does Mary, and two units separate them.

The angel's gaze is directed horizontally straight at the open palm of Mary's left hand, about one third horizontally down from the top of the picture.

All the area on the right behind Mary is man-made. All except the wall behind the angel is open landscape or the natural world.

In Piero della Francesca's *Baptism of Christ* the figure of Christ is placed centrally and his head comes just above the centre point of the picture. The figure is divided into thirds vertically by a tree trunk and the figure of St John the Baptist. The horizon hovers along the halfway line in the background. The dove of the Holy Spirit is about one third of the way down the picture, centrally over Christ. His navel is about one-third above the base of the picture. The shape of the bird echoes the shape of the clouds and because of this doesn't leap out at us. The angels looking on in the left foreground, and the people getting ready to be baptized in the right middle ground, act as a dynamic balance for each other.

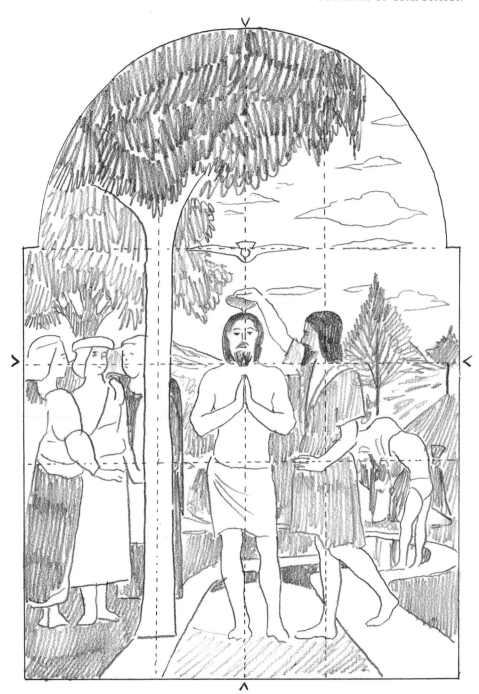

## Geometric connections

*The structural strength of your composition will depend on you making geometric connections between the various features you decide to include. These connections are vital if your picture is to make a satisfying whole. Look at any picture by a leading artist and you will find your eye being drawn to certain areas or being encouraged to survey the various parts in a particular order. Here are some examples where the connections have been made for you.*

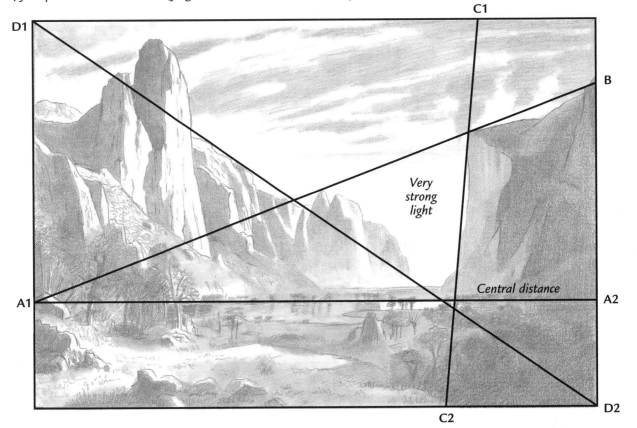

A very interesting geometric analysis can be made of this drawing of a valley in what is now Yellowstone National Park (after American wilderness painter **Albert Bierstadt**).

- A1–A2 follows the line of a stretch of water running through the valley and makes a very strong horizontal across the composition. Note that it is slightly below the natural horizon.

- D1–D2 traverses the composition diagonally from the top left corner to bottom right, cutting across the horizontal A where the sunlight shines brightly in reflection on the water. The line also gives a rough indication of the general slope of rocky cliffs on the left as they recede into the distant gap in the mountains.

- A1–B makes a sort of depressed diagonal from the top of the mountain on the right side.

- The near vertical C1–C2 describes the almost perpendicular cliff on the right side.

- The very brightest part of the picture, where the sun glows from behind the cliff (right), resides in the triangle described by the lines A1–B, the diagonal D1–D2 and the vertical C1–C2.

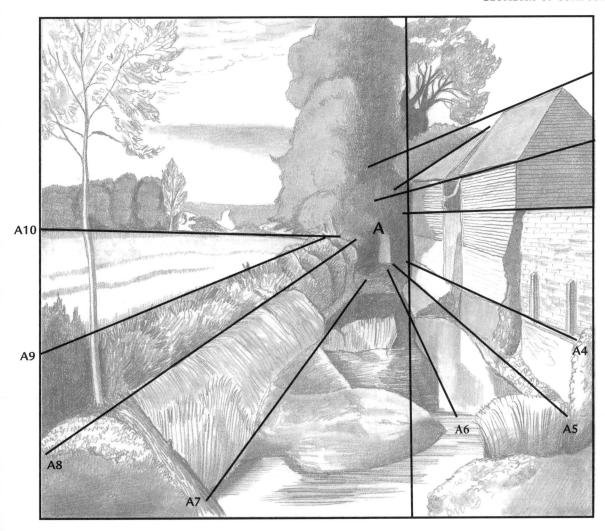

In this example (after **John Nash, 1893–1977**) the eye is taken from all directions (lines A1–A10) to the light shape in the dark area slightly off-centre, where the stream and the building converge onto an area of trees. This large, solid clump of trees is set about two-thirds from the left-hand side of the composition and just below the horizon level. The stream winds its way from the central foreground towards the deep dark shape in the central middle ground. Note also how the tree in the left foreground acts as a balance to the building and vegetation.

*The design of your composition can be based on a number of geometric configurations. Here we look at two contrasts: an almost centrally based design and one that relies for its movement on a dramatic thrust across the picture plane.*

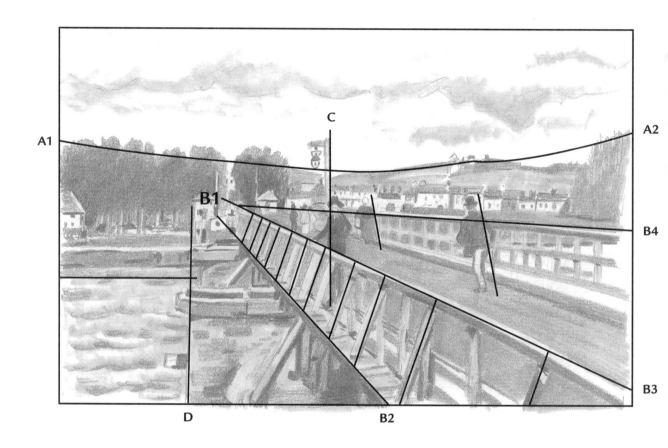

In this composition (after **Alfred Sisley, 1839–1899**) of a footbridge over the Seine at Argenteuil, we are immediately struck by its off-centre geometric construction and the dramatic movement across the picture, carried by the perspective lines which show the thrust of the bridge (at B1 raying out to B2, B3 and B4). The main line of the horizon makes a shallow saucer-like curve (A1–A2) broken in the centre by a vertical lamppost and continued by the central standing figure (C).

A simple vertical denoting the edge of the pier of the bridge, cutting the line of the river at right angles (D), defines the lower left-hand eighth of the picture.

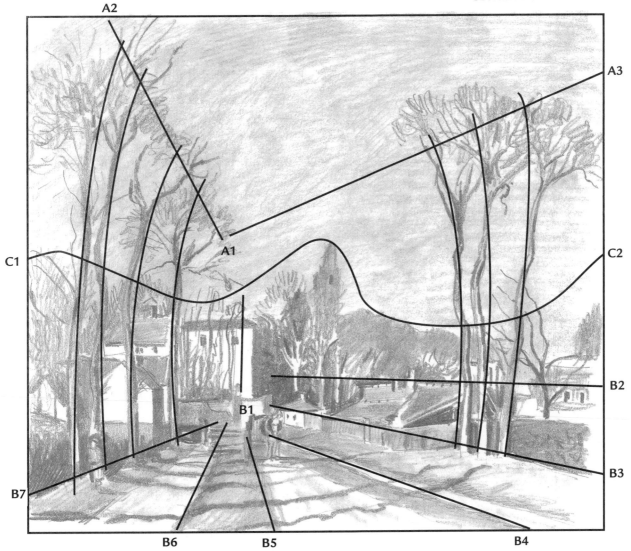

**Pissarro**'s composition of a lane seen along an avenue of slender trees gives an almost classic perspective view, where the main lines subtly emphasize movement into the distance.

The lines A1 radiating to A2 and A3 give the heights of the avenue of trees. Lines B1 to B7 similarly indicate the lower ends of the trees and the edges of the path and roadway. Everything radiates out or converges inwards to B1. At this point in the picture observe the strong line at the edge of the building behind the horse and cart.

Note too how the two rows of trees are linked by means of the curving shadows thrown across the roadway. The wavy horizon line C1–C2 denotes the various heights of trees in the distance.

# Simplifying composition

Here, I aim to demonstrate how you might approach your composition in a simplified way in order to get the most out of it. Reducing a picture to its basic shapes does encourage a more powerful result, and many works that particularly command your attention in art galleries do so as a result of such understanding by the artists who produced them. This section samples many masterpieces, revealed in their most simple outlines, in order to examine how they work on the viewer. You can try this for yourself when in a gallery, or when looking at art books, by reducing the compositions in your mind's eye to the very simplest surface areas. You will quickly get the hang of the exercise and it also serves to enhance your appreciation of the work of that particular artist. Then, of course, try it with regard to your own work, especially before you reach the final stages, and it could well have the effect of producing a more satisfactory piece of work.

This sort of still life, after **Samuel van Hoogstraten (1627–1678)**, was a great favourite in the 17th and 18th centuries, when it provided both a showcase for an artist's brilliance and a topic of conversation for the possessor's guests. Almost all the depth in the picture has been sacrificed to achieve a *trompe l'oeil* effect. The idea was to fix quite flat objects to a pinboard, draw them as precisely as possible and hope to fool people into believing them to be real.

Depth is required to make this kind of arrangement work (after **Osias Beert, c. 1580–1624**). Our eye is taken into the picture by the effect of the receding table-top, the setting of one plate behind another and the way some of the objects gleam out of the background.

In this copy of **Peter Paul Rubens**'s **(1577–1640)** painting of the rape of the daughters of Leucippus, the fidgeting of the horses gives context to the human action and lends amazing dynamism to the scene.

In the foreground we see two nubile young women being lifted up onto the horses in front of the powerful male riders. Although there are only two horses and four figures, the baroque movement of these beings creates a powerful dramatic action. This is a complex composition, and sketching the different elements will help you to break it down and make sense of it.

In **Titian**'s painting of Bacchus and Ariadne, there is just as much dynamism as in the Rubens but the effect of the energy is quite different because the scene is set further back in the landscape. The picture is much more open, with the airy space in the left half contrasting with the unruly procession of figures emerging from a grove of dark trees and moving across from the right. In this group are disporting maenads, satyrs and the drunken Silenus, all belonging to the boisterous entourage of Bacchus, god of wine and ecstatic liberation. Both aspects of this god's personality are represented here. Bacchus is centre stage, creating the major drama by flinging himself from his chariot, eyes fixed on the startled Ariadne, newly abandoned by Theseus on the island of Naxos, whom he has come to claim as his bride.

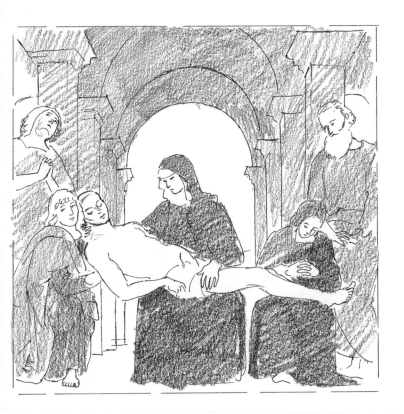

In this *Pietà* by **Pinturicchio (1454–1513)**, a colleague of Raphael, the dark shape of the mother of Christ supports her son's pale corpse, represented as a strong horizontal shape cutting across the arch which frames the scene. The dark shape of the Virgin and her central position serve to balance the picture. The dark areas above and to the sides contribute to the power of the composition. In the simplified version (below) you can see these relationships between the figures very clearly.

### Analysis

*Compositionally,* **Pierre Auguste Renoir's (1841–1919)** Boating Party *is a masterly grouping of figures in a small space. The scene looks so natural that the eye is almost deceived into believing that the way the figures are grouped is accidental. In fact, it is a very tightly organized piece of work. Notice how the groups are linked within the carefully defined setting — by the awning, the table of food, the balcony — and how one figure in each group links with another, through proximity, gesture or attitude.*

*Let's look at the various groups in detail.*

■ **Group A:** In the left foreground is a man standing, leaning against the balcony rail. Sitting by him is a girl talking to her dog and in front of her is a table of bottles, plates, fruit and glasses. It is obviously the end of lunch and people are just sitting around, talking.

■ **Group B:** In the right foreground is a trio of a girl, a man sitting and a man standing who is leaning over the girl, engaging her in conversation.

■ **Group C:** Just behind these two groupings are a girl, leaning on the balcony, and a man and woman, both seated.

■ **Group D:** Behind this trio, two men are talking earnestly, and to the right of them can be seen the heads and shoulders of two men and a young woman in conversation.

**Group A**

Group D

Group C

Group B

In **Georges Seurat**'s large, open-air painting *The Bathers*, the composition is effectively divided in two: the horizon line with factories along it comes about two-thirds above the base of the picture, and the diagonal of the bank runs almost from the top left of the picture down almost to the bottom right corner. The larger figures are grouped below this diagonal. The picture is drawn as though the viewer is sharing the quiet calm of the day with them, surveying the people sitting on the grass and in the boat on the river and the scene beyond. This is probably one of the most carefully thought-out pieces of picture-making of any painting made after the Impressionists. It is painted in Seurat's customary fashion from many preliminary drawings and colour sketches of all the figures and parts of the background. He would carefully orchestrate each part of his picture in the studio, painting systematically from his studies and placing each one so that the maximum feeling of balance and space was made evident in the finished picture. This is a brilliant piece of composition by any standards with its diagonal bank of the river, the horizon about two-thirds up, the still figures placed in the foreground and the expanse of water with trees either side holding the centre space.

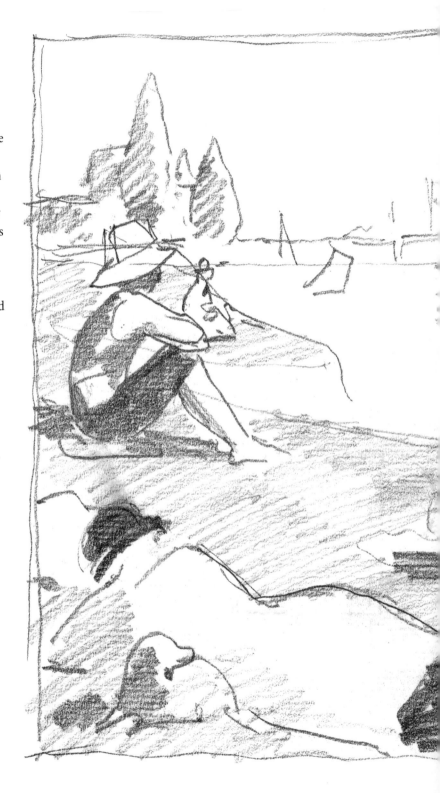

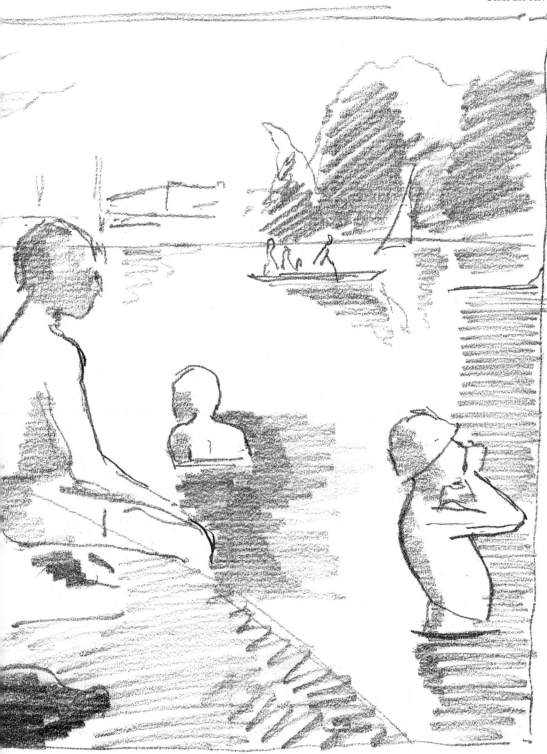

In the top picture after **Gustave Caillebotte (1848–1894)**, the light reflects off the wall in the background, and the bodies of the men are highlighted. In the second version the background wall appears dark and shadowed and the bodies of the men blend in with this. The change of viewpoint changes the whole dynamic of the picture, from one of calm and almost lazy activity to hard, intense industry. The darker tones in the bottom picture accentuate the pace of activity, and the fact that all three are stripped to the waist underlines the elemental feel. The space between the men isolates them within their labour. They do not share the easy companionship of the men in the top picture whose physical proximity emphasizes their 'at oneness' within the task.

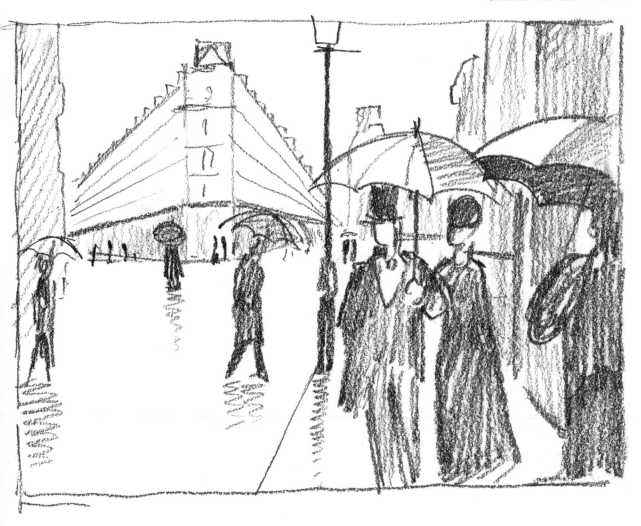

The left side of this picture (after **Caillebotte**) is mostly empty, with the distant wedge-shaped block of apartments thrusting towards us. The right half of the picture is packed with three figures under umbrellas, a couple coming towards us and a single figure who is entering the picture from the right edge. The two halves of the picture are neatly divided by the lamppost. The scene is played out between tall buildings which bleed off the side of the picture. The viewer is made to feel part of the scene.

**Abstract and naturalistic design in composition**

Some pictures, while appearing to be purely abstract in conception, are in fact naturalistic and portray actual things. *Street in Delft* by **Johannes Vermeer (1632–1675)** is a remarkable picture for its time. Cut diagonally in half from bottom left to top right, the lower half is filled with the façade of a building and most of the upper half is taken up with sky. The house is built out of a series of rectangles for the windows and door, enhancing the picture's geometric effect, even though other details suggest a real house with inhabitants.

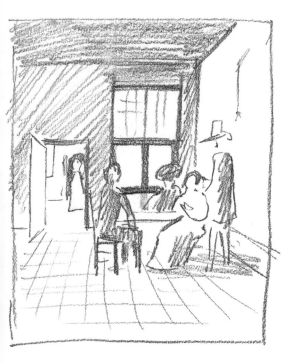

This copy of a **Pieter de Hooch** is less intimate than the von Menzel below by virtue of the fact that the viewer is kept at some distance from the group sitting in the room. The area above them is dark except for the light coming in through the window at the back. The doorway to the left allows us to see even further into the picture. If you ask a child or an adult unpractised in art to draw a scene, they tend to set the action in distant space, as here.

The advent of the camera and the influence of techniques evident in the work of Japanese printmakers encouraged Western artists to cut off large areas of foreground so as to increase dramatic effect and bring the viewer into the scene. This interior by **Adolphe von Menzel (1815–1905)**, *Living Room with the Artist's Sister*, is like a cinema still: the viewer is standing the other side of the lit open doorway, looking into the room where someone sits in front of a light. We are confronted by two contrasting images – of an inner world from which we are cut off by the door and the anonymity of that lone figure in the background, and of the girl who is looking expectantly out towards us. We wonder what this girl is waiting for and we wonder about her relationship with that other figure.

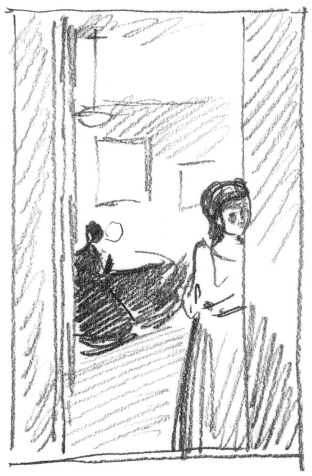

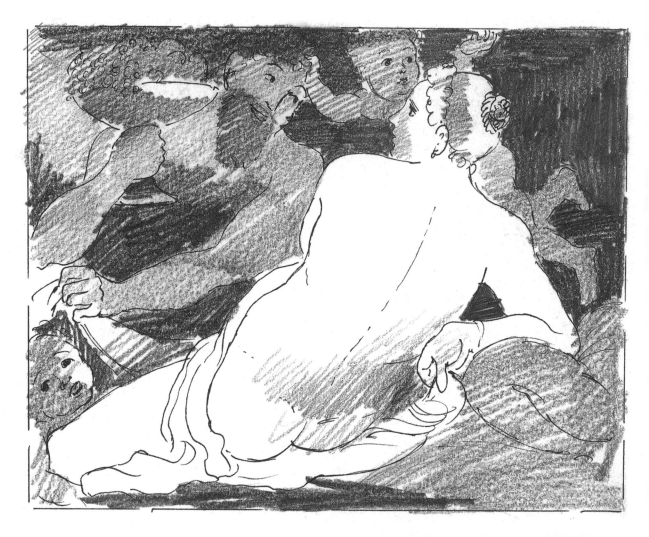

In these two sketches of **Paolo Veronese**'s **(1528–1588)** *Venus with Satyrs and Cupid*, a very simple compositional device has been used for added sensuality. The bare back of Venus is revealed to us as she stretches across the picture plane, sharply lit against the dark, chaotic space in front of her where the moving shapes of the satyrs and Cupid can just be made out.

252

The great **Leonardo da Vinci** pioneered several different approaches to figure composition which influenced all the artists of his generation and many years after. This strange composition of Mary sitting in the lap of her mother (St Anne) and leaning over to pick up the infant Jesus as he plays with a lamb creates a large triangular shape rather like the mountains in the background. The composition has great stability even though there is swooping movement curving across it and the two movements contrasting with each other create a very interesting design.

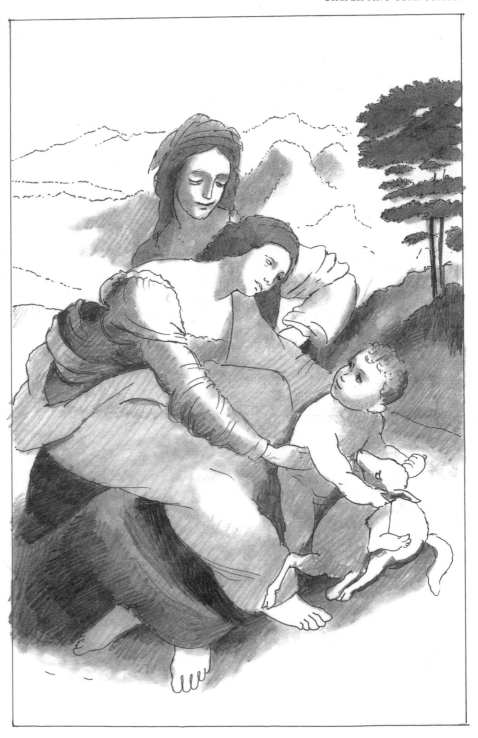

### The sky: expressive clouds

*The sky plays a very dramatic role in the following two examples of landscapes: copies of **Vincent Van Gogh's** (1853–1890) picture of a cornfield with cypress trees,* *and, overleaf, of **Jacob Van Ruisdael's** (1628–1682) Extensive Landscape. Although different in technique, both types of landscape are easier to do than they look.*

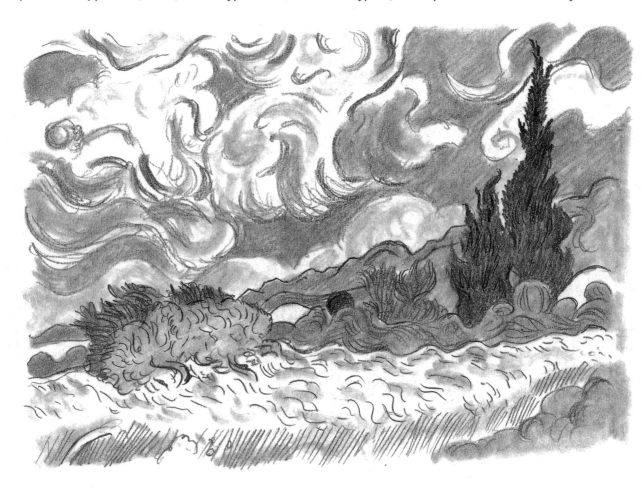

The Van Gogh copy is characterized by strange, swirling mark-making for the sky, trees and fields. The feeling of movement in the air is potently expressed by the cloud shapes which, like the plants, are reminiscent of tongues of fire. Somehow the shared swirling characteristic seems to harmonize the elements. The original painting was produced while the artist was a patient in the St-Remy mental asylum, near Arles.

To copy the composition, draw in the main parts of the curling trees and clouds and the lines of the grass and bushes (as above). Once you have established the basic areas of vegetation and cloud, it is just a case of filling in the gaps with either swirling lines of dark or medium tones or brushing in lighter tones with a stump. Build up slowly until you get the variety of tones required.

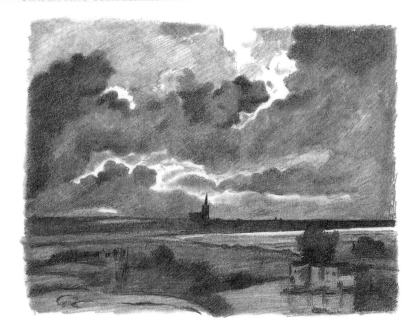

In **Ruisdael**'s *Extensive Landscape,* the land referred to in the title of the image only takes up a third of the space. The clouds, drawn in contrasting dark areas with a few light patches, create an enormous energetic sky area in which most of our interest is engaged. The land by comparison is rather muted and uneventful.

First, mark in with light outlines the main areas of cloud, showing where the dark cloud ends and the lighter sky begins. Draw in the main areas of the landscape, again marking the lines of greatest contrast only.

Next, take a thick soft pencil (2B–4B) and shade in all the darker and medium tones until the sky is more or less covered and the landscape appears in some definition. Finish off with a stump to smooth out some of the darker marks and soften the edges of clouds. The more you smear the pencil work the more subtle will be the tonal gradations between dark and light. Afterwards you may have to put in the very darkest bits again to increase their intensity.

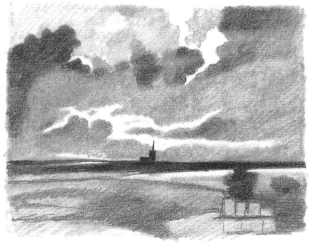

### The sky at night

*One difficulty of drawing at night is working in poor light. For this reason a townscape is an easier choice because you can position yourself under a lamppost and draw from there. In the first of our two examples, light provided by the moon* *is spread across the scene by the expedient device of the reflective qualities of a stretch of water. In the second, moonlight also comes into play, although less obviously. Night scenes are always about the lit and the unlit, the reflective and the non-reflective.*

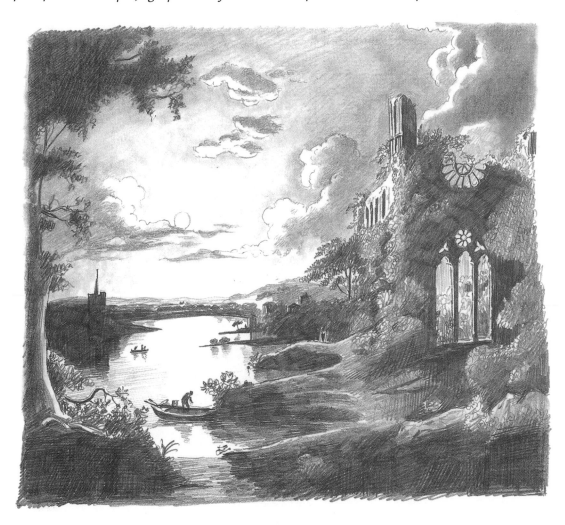

The classic picturesque scene was for many years the whole point of landscape painting. Artists would find a rugged, untamed spot that would appeal to Romantic sensibilities and draw it at a dramatic moment. In this copy of a **Henry Pether (1828–1862)** painting of Anglesey Abbey, a ruin in the best Gothic taste is shown against gleaming water and moonlit sky. The clouds are almost as carefully designed as the position of the ruins. All elements in the picture combine to create an atmosphere of delight in the airy qualities of the nocturnal scene.

The British artist **Atkinson Grimshaw (1836–1893)** was known for his depictions of the city after dark. This copy of *Piccadilly at Night* captures the effects of a dark, cloudy sky with the hint of moonlight and sombre, looming buildings lit by street lamps, windows and cab lights. A recent downpour helps to emphasize the brilliance of the light. Study the two stages opposite leading up to the final drawing.

As you draw in the main elements be aware of the perspective effects of the buildings along the street. Leave white paper to show where the lamps are and also their reflections on the wet street. Put in very strongly with dark lines the pillars, cornices, window ledges and so on of the buildings.

The light and dark areas in the sky should appear softer in contrast to the lines used for the buildings. The lighter areas can be smudged across with a stub to keep them looking lighter but not as bright as the lamps. The only white paper showing should be to denote the source of light and the reflections of it. The whole of the sky area should be softened with the application of the stub. When you have uniform greys and darks over the whole area, take a putty eraser and lighten up the clouds nearest the moon's glow.

# Analysis of
# ingredients

This is a similar exercise to that of the previous section, but this time we examine the actual content of a picture in order to produce something more significant ourselves. Many artists have created works of art in which small details encode meanings that increase the effectiveness of the overall picture; sometimes they are purely symbolic. But often they are more of a design feature, which lends authority to the subject matter of the whole composition.

Everything in a picture makes some contribution to the final result, and can be to your advantage or disadvantage. It is the mark of a good professional that nothing is really left to chance, even if a certain element looks as though it was an accidental touch rather than included on purpose. So here we analyze a selection of the details of great works, in order to understand how they can help us with our own, especially when we are contemplating a major piece of drawing. It is great fun to do all this, and even if at first it doesn't seem to work in your case, keep looking and analysing because eventually you will discover ways of using your observations.

## Portraits: active and passive partners

*Even the most unlikely pieces of furniture or most mundane objects can be used to create interest in a portrait. Props to produce a setting for a portrait are usually made to look as natural as possible in order to convince the viewer that this is how the artist found the subject when drawn. If they do their work well the result looks natural but provides information to help us connect with the subject. Of course, sometimes props are just incidental and act merely as aesthetic devices to round off the shape or colour of the portrait, but nevertheless do their job.*

*A useful rule is not to include anything that takes too much attention from the face. Having a prop as a focal point can be a good idea, but it should never be allowed to upstage the main participant. In these examples we find props playing a variety of roles to varying degrees, either as indications of narrative or as symbolic devices.*

This copy of a portrait of a Flemish banker (1530) by **Jan Gossaert (c. 1462–c. 1533)** shows him at his desk writing. Around him are quill pens, inkwell, penknife, paper and so on – all that he needs for writing bank drafts, account loans and bills, some of which are suspended on the wall behind him, tied up in bunches (right).

This detail is taken from a portrait of Lady Dacre by **Hans Eworth (1540–1573)**. Here the hands tell the viewer not just about the learning of the scholarly lady (note the thumb keeping her place in the book in her left hand), but about her creative ability as she moves to write in her journal. Literary and educational pursuits were becoming fashionable in the 16th century and so these compositional props are very obvious symbols of the sitter's status. If the book she holds is a scriptural work, this would also reflect on the lady's piety, in an age when religion was a serious part of the life of the ruling class.

The hands of the elderly Catholic prelate Cardinal Manning, after a painting by **G.F. Watts (1817–1904)**. The pose is appropriately peaceful and non-aggressive and is similar to one done much earlier by Raphael of the Pope.

Phillip II of Spain, by **Titian**, grasps the crest of a helmet while his left hand holds the scabbard of his sword just below the hilt. As he is also in half armour, the inference is clear that this king will not flinch from taking military action to defend and expand his kingdom.

263

## Symbols of power

*Symbolism has always been used as a vehicle for reinforcing the images of the powerful. Absolute monarchy became a hot topic in the 17th century, especially in England where it cost a king (Charles I) his head. Here we see two very different depictions of kingship, each reflecting political reality.*

■ *The double column of Roman design suggests stability and power.*

■ *The jewelled sword from a different age suggests continuity of the monarchy.*

**Hyacinth Rigaud (1659–1743)** depicts the Sun King, Louis XIV, as the personification of absolute monarchy. The haughty pose, flamboyant but with a distancing quality, declares the monarch's position of supremacy within the state. The showing of the king's legs was traditional in full-length portraits of monarchy in this period, and the hand on hip depicts aristocratic concern. The drapes hanging above and to his right allude, rather theatrically, to the monarchy's central role in the politics of France and Europe. The extraordinary gesture of holding the sceptre upside down, like a walking stick, shows that the king is above showing the respect that is normally paid to such an important badge of office. The ermine-lined robe trailing across the dais covered in fleur-de-lys – the emblem of French monarchy – further emphasizes his unequalled status. Every gesture, object and material in this portrait is a symbol of the regal power of the king of France. Finally, he is shown wearing a periwig of the latest design, implying that the French king creates the fashion that lesser monarchs copy later.

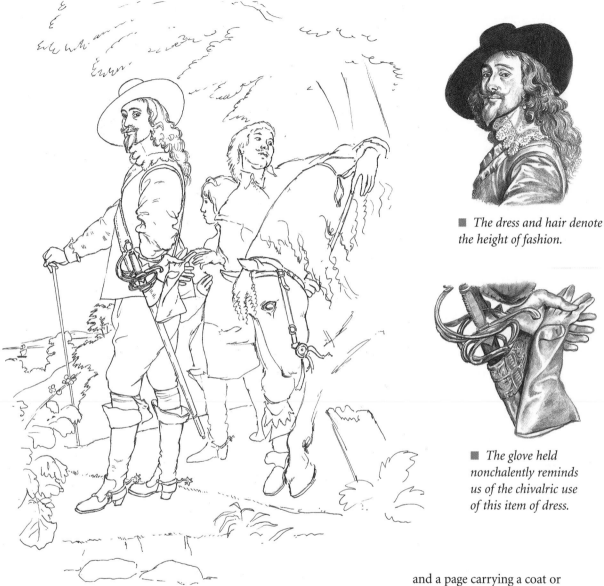

■ *The dress and hair denote the height of fashion.*

■ *The glove held nonchalently reminds us of the chivalric use of this item of dress.*

Typical English understatement has gone into this portrait of Charles I by **Anthony Van Dyck (1599–1641)**. The set-up is similar to that for Louis XIV but the symbolism is certainly more subdued, as you would expect from a monarchy under attack. The English king was not as powerful as his continental neighbour and here he is shown dressed as a cavalier, devoid of the paraphernalia of state. However, his royal status is underlined by the pose – hand on hip, walking stick held almost as a sceptre, the cool, haughty appraising look. The attendance of a groom and a page carrying a coat or blanket for the king's pleasure, and the horse's gesture almost of obeisance, suggest this is more than a portrayal of a country gentleman. Van Dyck was an expert at making the apparent casualness of the setting into a statement of symbolic power and elegance.

265

**Settings with a history**

*Historic characters have a built-in list of props that could be used to show their importance. The modern portraitist has to try to emulate this example by working out which objects will enhance the history of his subject. If your subject has done something celebrated, you need to show what this was. The achievements of sportsmen, scientists, artists and soldiers are relatively easy to convey visually. More difficult are those of politicians, local worthies and businessmen, and their portraits have to be approached with great imagination.*

Napoleon was said to have been very pleased with the original of this portrait of himself by **Jacques-Louis David (1748–1825)**, painted in 1812. The furniture and props have been carefully manipulated to convey the message of the Emperor's dedication. The hands of the clock are pointing to past four and the candles in the desk lamp have burnt down. Unrolled on the desk is the cause of his toiling through the night – the Code Napoleon. The Emperor's sword is shown nearby, implying that his role as defender of the French nation is not being neglected as a consequence. When shown the finished work, Napoleon said that 'the French people could see that their Emperor was labouring for their laws during the night and giving them "la gloire" by day.'

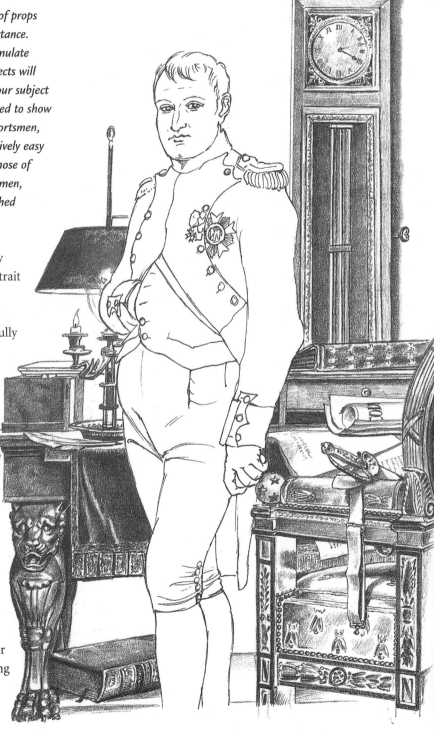

Doña Teresa Sureda was the wife of a
close friend of the artist **Francisco
Goya** and sat for the original of this
portrait after the two men had
enjoyed a night out on the town.
It is said that in posing her in an
uncomfortably large armchair, Goya
was getting his own back for her
complaint that he was a bad
influence on her husband. Certainly
she looks very stiff and reproachful,
but whether this was due to the
chair or her attitude to Goya it is
impossible to surmise.

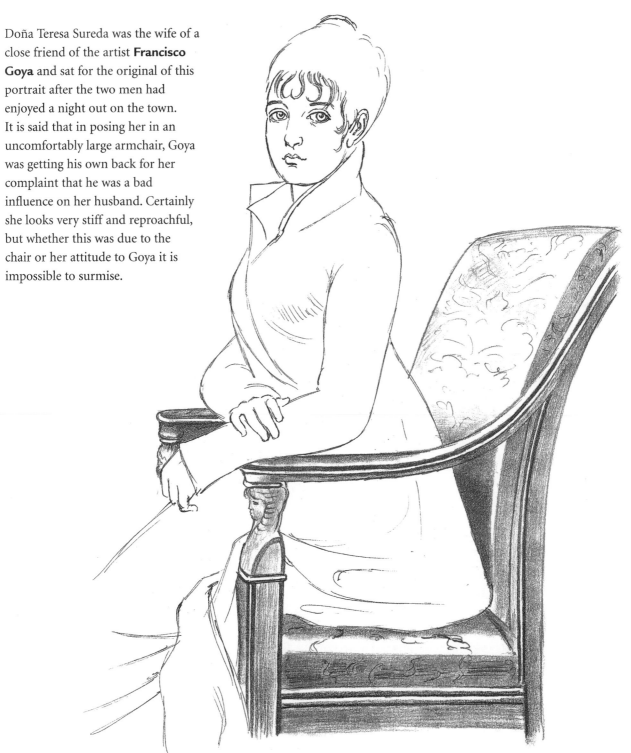

In the 16th century, when **François Clouet** painted the original of this portrait, a bathroom setting was very fashionable. The bath was not an ordinary daily ablution but a special event at which quite a few people would be present. The soft silk cloth draped inside the bath of this gentlewoman was to ensure that her skin would not be abraded by the rough wooden or woven surface of the tub. Remember, this is long before the introduction of smooth coatings for baths. The draped material to her left is a rather theatrical device, hinting perhaps that what is a private action has become public.

The sitter is thought to be Diane de Poitiers, mistress of Henri II, although there have been other attributions, including Mary, Queen of Scots.

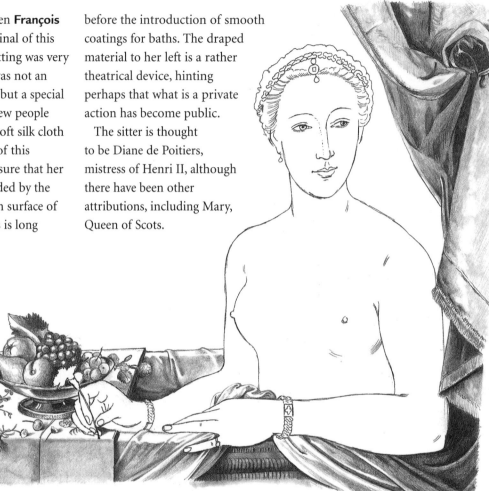

If a portrait lacks background detail it stands to reason that any furniture will take on more significance. The Neo-Classical painter **Jacques-Louis David** used the plain backdrop, with sharply defined lighting, to increase the focus on his sitters. The original of this portrait of a young girl is by a follower of David who has copied the master's approach. The sideways position on the chair increases the informality of the pose, as does the shawl casually thrown on the table behind her.

It says a great deal about **Velázquez**'s relationship with his patrons, the Spanish royal family, that they allowed the painter to pose their young daughter in his studio. A tiny figure in the huge space of the studio, she stands at the centre of a lovely informal composition. Around her are her maids (hence the title of the picture, *Las Meninas* – 'The Maids of Honour'), a dwarf, a large dog and, to the left, a self-portrait of the artist engaged on producing the picture. We see the reverse of a large canvas leaning on an easel. One of the maids is curtseying to figures directly in front of where the viewer stands. In the original, two figures are dimly reflected in the mirror on the wall behind Velázquez and the Infanta, possibly visual references to the child's parents, the king and queen. Hanging in the gloom of the upper walls, we can see paintings.

The scene seems accidental, as though it is not intended for our eyes. On the other hand it does offer a window onto the world of the artist, with the viewer becoming a witness to his act of creation and an insider in the artistic process.

Velázquez's brilliant scheme has been much copied by other artists, including Picasso, who based a whole series of works on it.

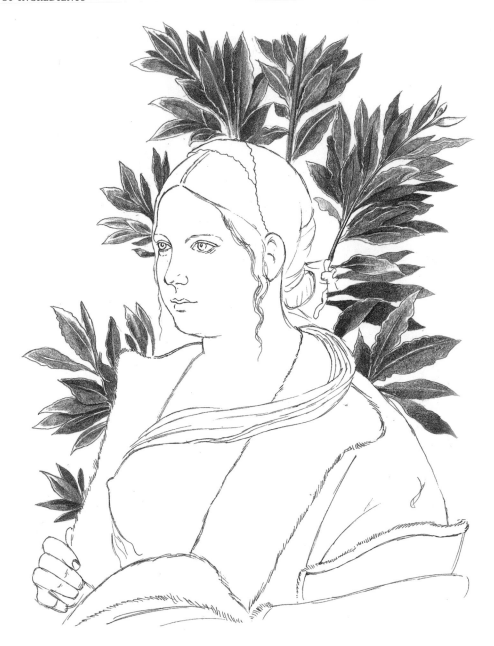

Laura was the beloved and muse of the Italian poet Petrarch. In this copy of **Giorgione**'s **(c. 1477–1510)** depiction of her in 1506, her identity is underlined by the laurel bush shown behind her head and shoulders. The laurel was given by Apollo and the Muses to crown the great poets of antiquity. The actual model for this portrait may have been a muse for Giorgione or a patron. The veil suggests a bridal portrait and the bared breast refers to Amazonian chastity.

## The genius of simplicity

This copy of a painting by **Matisse** is a tutorial in great draughtsmanship: keen observation, the simplification of shapes and the absolute supremacy of line over detail.

Copying any of the great masters teaches us that great art cannot be reduced to a formula and simply emulated. The observation of life and the attempt to draw honestly what you see, each time, freshly, is the way to produce good drawings.

For his portrait of Carmeline (1903), Matisse introduced an interesting variation on a theme he used several times in his work. The model's back is strongly reflected in the mirror and beside it we see the artist himself, painting his sitter. This device greatly increases the immediacy of the portrait.

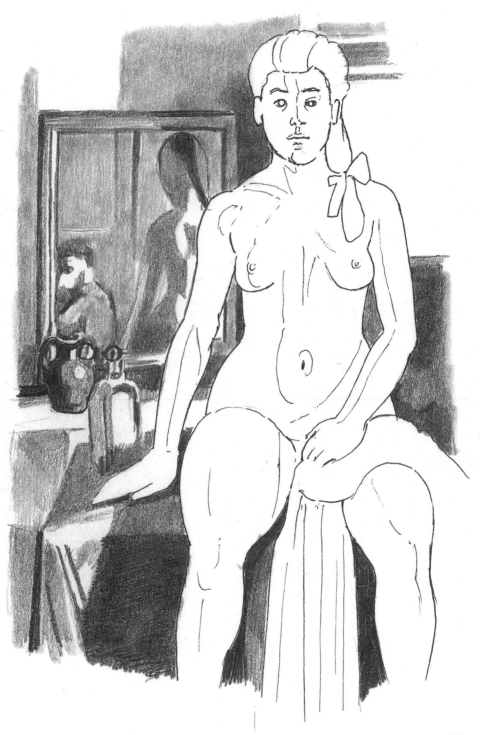

## Making the most of the mundane

*The symbolism in* **Jan Van Eyck's (1390–1441)** *Arnolfini Marriage (1434) is so complex that art historians are still unsure of the meaning attaching to some of the picture's content. It is quite certain, however, that the original represents both a blessing and a legal*

*affirmation of the union of the couple portrayed, thought to be Giovanni Arnolfini and Giovanna Cenami. Every movement, position and object in this room underlines the theme of marriage. It is, in effect, a marriage contract produced by an artist.*

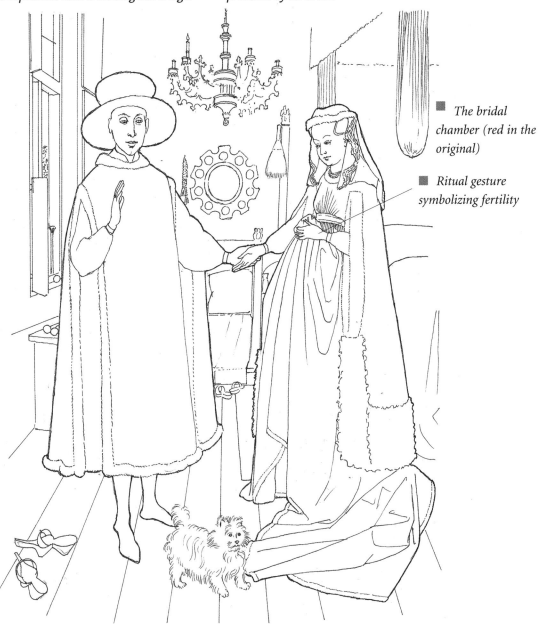

*The bridal chamber (red in the original)*

*Ritual gesture symbolizing fertility*

■ *The single wedding candle burning in the chandelier cites traditional Annunciation iconography.*

■ *The brush is a pun on Virgo/Virga to emphasize virgin purity, as well as an allusion to the 'rod of life', symbol of masculine fertility and strength; bridegrooms were ritually beaten with a switch to ensure couples were blessed with large numbers of children.*

■ *The 'immaculate mirror' (speculum sine macula) signifies the purity of the Virgin and the bride. In the mirror, which is surrounded by scenes from the Passion, you can see two figures, one the artist and a second witness to the marriage.*

■ *Van Eyck signed the painting as a witness, giving it the legitimacy of a legal document.*

■ *Promising marriage without the presence of a priest was customary in the 15th century by the joining of hands. The pledge was considered legally binding. The bridegroom holds his other hand up very deliberately. He may be about to place it over the bride's open palm or perhaps make the sign of the Cross.*

■ *Fruit alludes to the Fall and warns against sinful behaviour. The light coming through the window suggests that the ceremony is taking place under the eye of the Creator.*

■ *The dog is a symbol of devotion and conjugal fidelity.*

273

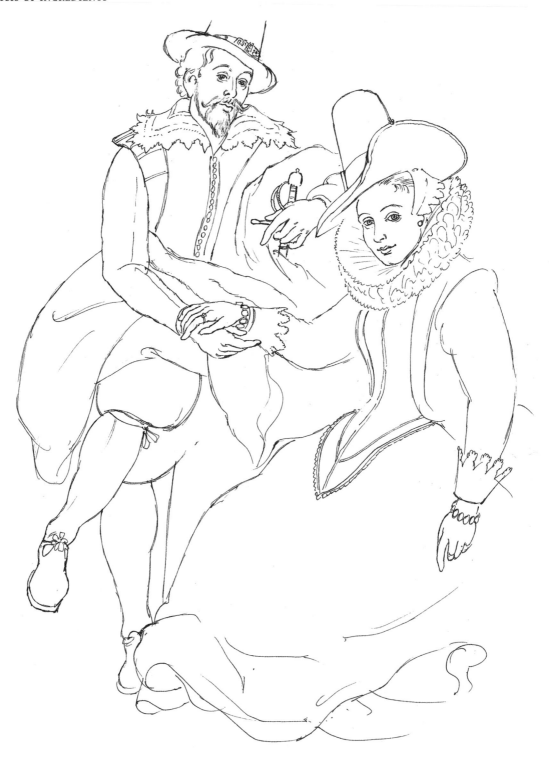

## Portrait of a marriage

*Like Van Eyck's double portrait of Arnolfini and his bride, this example is also a statement about marriage, although one that is perhaps more agreeable to our eyes. In **Peter Paul Rubens**' depiction of himself and his new wife Isabella Brant (1609), we see not so much a declaration of intent as one of fact. Isabella was the daughter of a rich aristocrat and probably came from a better family than her spouse. Rubens was not only a great painter with access to the courts of Europe but also a diplomat with very good connections.*

*The beautiful embroidery on her bodice and the extravagant ruff she wears, with the precious bracelets around her wrists, give a festive wedding appearance to the couple.*

*The tone of tender familiarity and equality is one we recognize. The pose is not so far away from how a modern couple might present themselves for a portrait celebrating their union. She kneels on the ground, her hand in his, but there is no hint of subservience, only of loving attention flowing between them.*

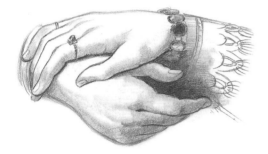

■ *The joining of the hands is, as we have already seen, a symbol of a pledge of marriage. Here the interpretation can be broadened, for these two are already man and wife. The way the hands are joined tells us that this is a contract based on love, not commerce. The couple's open, almost joyous, expressions support this idea.*

■ *The placement of Rubens' hand on the hilt of his sword implies that he has aristocratic credentials, if not by birth then certainly by achievement.*

■ *In the original the couple are seated outside in a garden with honeysuckle growing in the bushes around and behind them, giving us an intimation of the honeymoon. Plants are typically used in art to symbolize the pastoral idyll of the garden of paradise.*

## Creating a composition

*Most artists draw or paint the elements in their compositions piecemeal and then fit them together in the studio. Here I have deconstructed an* **Edouard Manet (1832–1883)** *by separating out the individual parts of his picture and then reassembling them as he did. Try this system yourself – you should not find it too difficult to do it effectively. Manet arranged the elements shown here to produce a rather intriguing picture. Let's discover why it works so well compositionally.*

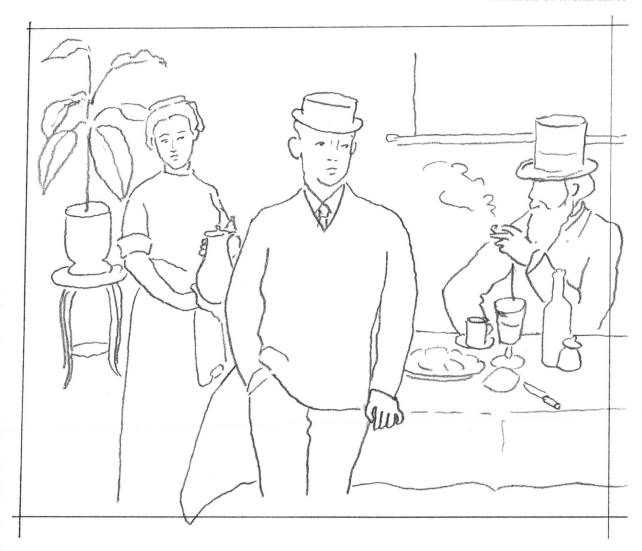

A cursory glance tells us that we are witnessing the end of a meal enjoyed by two men, whether alone or separately we are not sure. Neither is communicating with the other. The woman with the jug has been placed in the background with the potted plant to the left of her, thus acting as a frame and serving to make her part of the narrative. The older man looks in the direction of the woman, the woman looks questioningly at the younger man and he looks beyond, out of the picture.

When you create a composition have in mind the poses you want to put together, then draw them separately. Afterwards draw in the background, including still-life objects, to make the scene convincing. If you decide that you want an outdoor setting, draw the background first and then decide how you will fit the figures in before you draw them separately. Some artists look for backgrounds to suit the figures they want to draw. The important point is to match the shapes and sizes carefully so that the proportions work.

## Mixed media: a classical approach

*The term mixed media simply means that an artist has used several different types of materials. For example, he might have drawn the basic shapes in pencil, sharpened up the foreground details with pen and then used chalk or brush and wash to soften parts of the work. There are many other* *types of mixed media, including cutting out paper shapes and drawing or painting over them. The example shown here (after* **Claude Lorrain***) is straightforward and uses several common types of media in combination.*

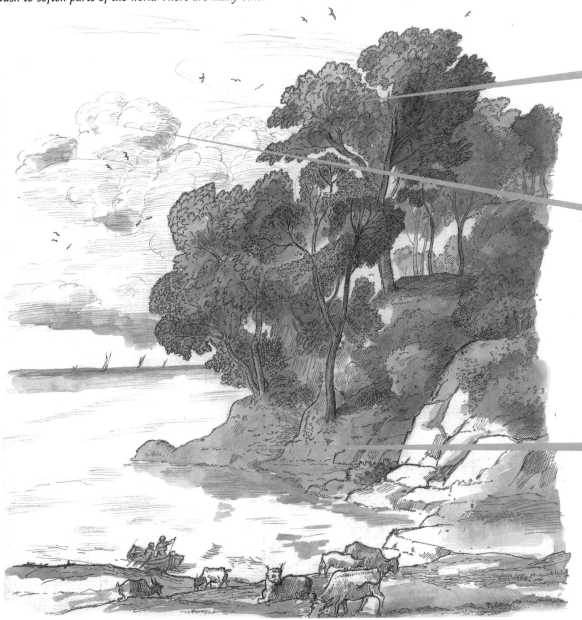

■ Although Claude's treatment is fairly formal, it is not difficult. These leaves, for example, are quite easy to draw. Pen and ink were used to capture the required definition and then a tonal wash was applied to strengthen the effect of each clump.

■ The mixture of mediums allowed Claude to gradate with great effect the softness of the clouds (here in graphite), which are sketched in very simply. They contrast with the wiry pen line used for the trees and the soft, sombre shadows, in wash.

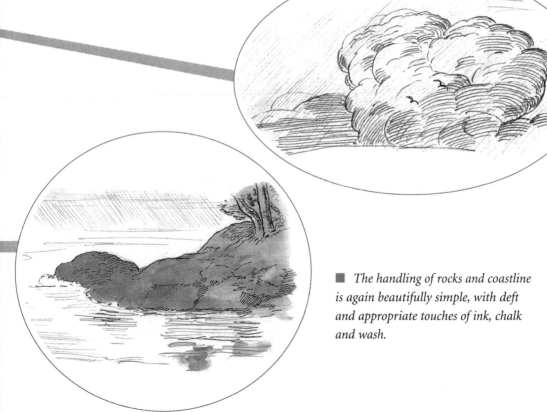

■ The handling of rocks and coastline is again beautifully simple, with deft and appropriate touches of ink, chalk and wash.

## Foliage: the classical approach

*Drawing trees can be quite daunting when first attempted. It a common misconception that every leaf has to be drawn. This is not the case. Over the next few pages you will find examples by Italian, French and Dutch masters which demonstrate how to solve the problem of showing* *masses of small shapes that build up to make larger, more generalized outlines.*

*In these examples a lively effect of plant growth is achieved, by the use of vigorous smudges, brushed lines and washes, and finely detailed penlines, often in combination.*

Notice the soft, almost cloud-like outline given to the groups of foliage in this example after **Titian** (drawn in pen, ink and chalk). No individual leaves are actually shown. Smudges and lines of tone make patches of light, which give an impression of thick bunches of leaves. The branches disappear into the bulging form, stopping where the foliage looks most dense.

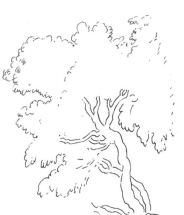

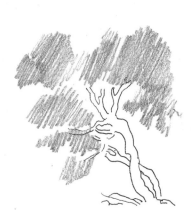

Despite the minimal drawing, this example after **Tiepolo** (in pen and ink) is very effective. The solidity of the wall has been achieved with a few lines of the pen. A similar technique has been used to capture the general effect of the longish groups of leaves. The splash of tone has been applied very freely. If you try this yourself, take time painting on the wash. Until you are sure of what you are doing, it is wise to proceed with care.

The approach in this drawing after **Boucher** (in black chalk) is to put in the sprays of branches and leaves with minimal fuss but great bravura. The technique of using squiggles to describe bunches of leaves evokes the right image, as does drawing in the branches more heavily but with no effort to join them up. The approach works because our eyes expect to see a flow of growth, and seen in context the leaves and branches would be easily recognizable.

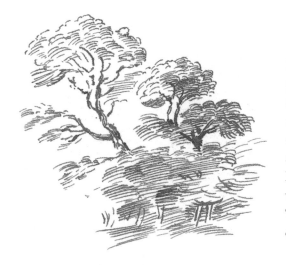

The emphasis here, in an example after **Guercino**, is on giving unity to the whole picture while producing an adequate representation of trees in leaf. The lines around the outside edges of the clumps of leaves give a good impression of tree-like shapes. Simple uni-directional hatching, smoothing out as the lines get further from the edge, give the leafy areas solidity without making them look like a solid wall. Darker, harder lines make up the branches and trunk. The suggestion of softer and harder tone, and the corresponding tonal contrasts, works very well.

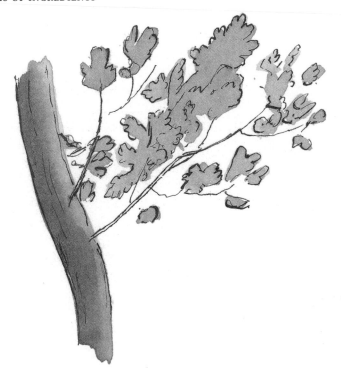

Very efficient methods have been used in this drawing of a branch (after **Lorrain**) to convince us of its reality. The combination of line and wash is very effective for branches seen against the light. If any depth is needed, just a few extra marks with the brush will supply it.

The two basic stages before the finished drawing are given below.

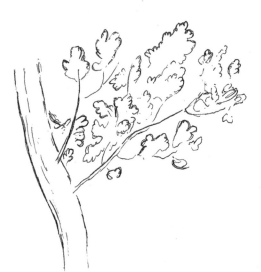

■ *First, the outline shapes of the branch and leaves are lightly drawn in pen.*

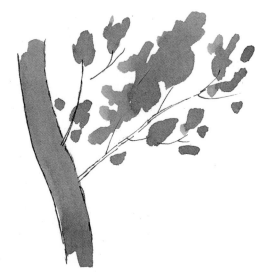

■ *Next, a tonal wash is applied over the whole area of the branch and each bunch of leaves.*

There is no hesitation in this pen, ink and wash drawing after **Rembrandt**. Minimal patches of tone are just enough to give solidity to the trunk and ground. Look at the quick scribble of lines, horizontally inscribed across the general growth of the branches, suggesting there are plenty of leaves in the middle of the tree.

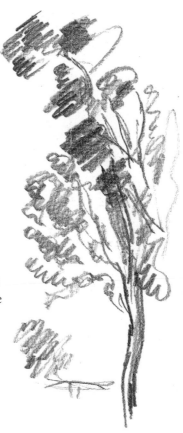

In this graphite drawing (also after Rembrandt) very firm, dark slashes of tone are accompanied by softer, more rounded scribbles to describe leaves at different distances from the eye. The growth pattern of the tree is rendered by a strong scrawl for the trunk and slighter lines for the branches.

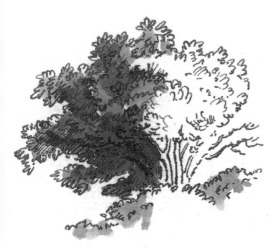

This neat little copse of trees (after **Philips Koninck (1619–1688)**), lit from one side with heavy shadows beneath, looks very substantial, even though the drawing is not very detailed. The carefully drawn clumps of leaves around the edges, and where some parts of the tree project towards us, help to give the impression of thick foliage. The closely grouped trunks growing out of the undergrowth are clearly drawn.

283

## The middle ground

*If a foreground has done its job well, it will lead your eye into a picture, and then you will almost certainly find yourself scanning the middle ground. This is, I suppose, the heart or main part of most landscape compositions and in many cases will take up the largest area or command the eye by virtue of its mass or central position. It is likely to include the features from which the artist took his inspiration, and which encouraged him to draw that particular view. Sometimes it is full of interesting details that will keep your eyes busy discovering new parts of the composition. Often the colour in a painting is strongest in harmony and intensity in this area. The story of the picture is usually to be found here, too, but not always.*

*The eye is irresistibly drawn to the centre and will invariably return there no matter how many times it travels to the foreground or on to the background. The only occasion when the middle ground can lose some of its impact is if the artist decides to reduce it to very minor proportions in order to show off a sky. If the proportion of the sky is not emphasized the eye will quite naturally return to the middle ground.*

*Let us now compare two sharply contrasting treatments of the middle ground. In order to emphasize the area of the middle ground, I have shaded the foreground with vertical lines and the extent of the background is indicated by dotted lines.*

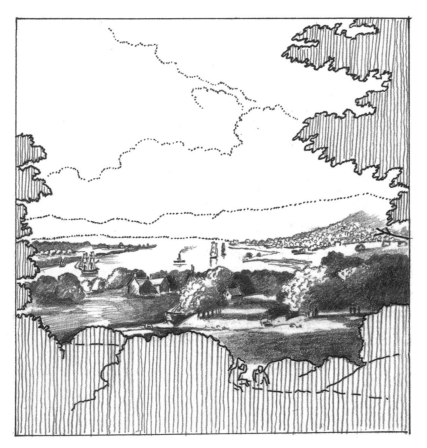

The centre of this picture (after **John Knox, 1778–1845**) contains all the points of interest. We see a beautiful valley of trees and parkland, with a few buildings that help to lead our eyes towards the river estuary.

There, bang in the centre, is a tiny funnelled steamship, the first to ply back and forth along Scotland's River Clyde, its plume of smoke showing clearly against the bright water. Either side of it on the water, and making a nice contrast, are tall sailing ships. Although the middle ground accounts for less than half the area taken up by the picture, its interesting layout and activity take our attention.

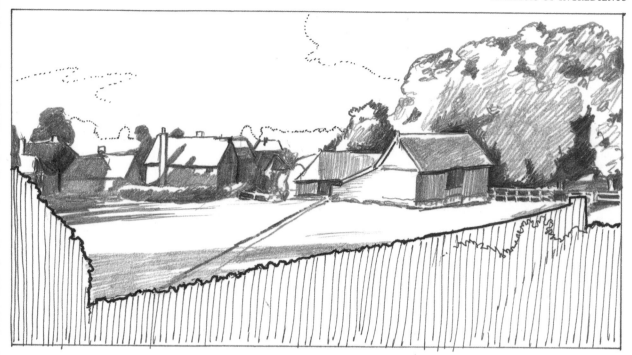

No attempt has been made here (after **Constable**'s picture of his uncle's house at East Bergholt) to centralize or classicize the arrangement of buildings. Constable believed in sticking to the actuality of the view rather than recomposing it according to time-honoured methods. The result is a very direct way of using the middle ground, a sort of new classicism. Our eye is led in to the picture by the device of the diagonal length of new wall dividing the simple dark foreground from the middle ground. The sky and a few treetops are all there is of the background; note how some of the sky is obscured by trees in the middle ground. Everything ensures that the attention is firmly anchored on the middle ground, where the main interest of the buildings is emphasized by the small space of the garden in the front. The composition is more accidental-looking – and therefore more daring – than was generally the case at that time.

## Significant skies

*These next examples bring into the equation the basic background of most landscapes, which is, of course, the sky. As with the sea in a landscape, the sky can take up all or much of a scene or very little. Remember, you control the viewpoint. The choice is always yours as to whether you want more or less sky, a more enclosed or a more open view.*

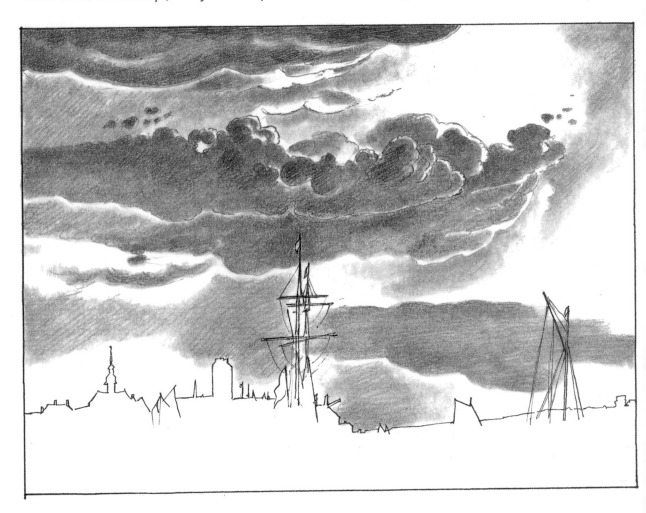

Our first example (after **Aelbert Cuyp (1620–1691)**) is of a dramatic sky with a chiaroscuro of tones. Very low down on the horizon we can see the tops of houses, ships and some land. The land accounts for about one-fifth of the total area, and the sky about four-fifths. The sky is the really important effect for the artist. The land tucked away at the bottom of the picture just gives us an excuse for admiring the spaciousness of the heavens.

Simmer Lake (after **J.M.W. Turner**) is a good example of that great artist's interest in the elemental parts of nature. The background of sky and mountains does not have the restlessness we associate with much of his work but is nevertheless fairly dramatic. The great burst of sunlight coming through swirling clouds and partly obscuring the mountains gives a foretaste of the scenes Turner would become renowned for, where the elements of sunlight, clouds, rain and storms vie for mastery in the picture.

# Now draw this...

This is the last section, and is in fact an extended drawing exercise designed to test your progress. All the given examples are deliberately chosen to be difficult, and just trying to copy them will serve to improve your own technique. Don't worry if your initial attempts are a little unresolved because, as I must point out, these are great master drawings. The main thing is to make the attempt and, if you have any success at all, you may compliment yourself on an excellent piece of practice. When you have done these, there is another little exercise that you might want to try as well. Get a large print or photocopy of a drawing that really impresses you and make a careful tracing of the main shapes in the composition. Re-trace those outlines onto some good-quality drawing paper and then, with the print set up in front of you, try to copy it as exactly as you can. This will give you considerable insight into the expertise of the original artist and will be a great exercise for refinement of your own style. Work on it for as long as you think is necessary, until you have achieved a satisfactory version of the original. As a drawing exercise, it can be very revealing.

**Rembrandt** drew himself repeatedly throughout his life, from early adulthood until just before his death, and has left us an amazing record of his ageing countenance. In this copy of a self-portrait done when he was about sixty years old, a smudgy technique with a soft 2B pencil was used in imitation of the chalk in the original.

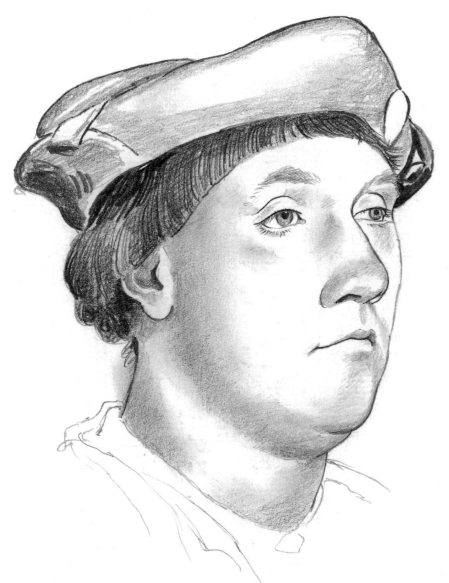

**Hans Holbein the Younger (1497/8–1543)** left behind some extraordinarily subtle portrait drawings of various courtiers whom he painted during his time as court painter to Henry VIII. These works are now in the Queen's Collection (most of them at Windsor, but some are in the Queen's Gallery at Buckingham Palace), and are worth studying for their brilliant subtle modelling. These subjects have no wrinkles to hang their character on, and their portraits are like those of children, with very little to show other than the shape of the head, the eyes, nostrils, mouth and hair. Holbein has achieved this quality by drastically reducing the modelling of the form and putting in just enough information to make the eye accept his untouched areas as the surfaces of the face. We tend to see what we expect to see. A good artist uses this to his advantage. So, less is more.

**Paul Gauguin (1848–1903)** gave the original of this chalk copy (1888) to Van Gogh as a gift. He called it *Les Miserables*, a reference not only to the traditional poverty of artists but also to their bondage to the quest for perfection.

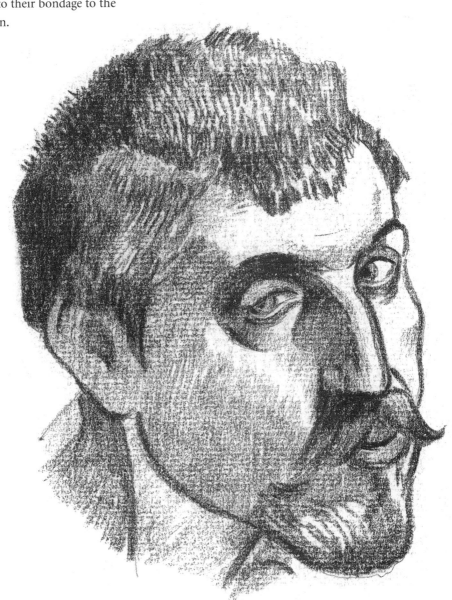

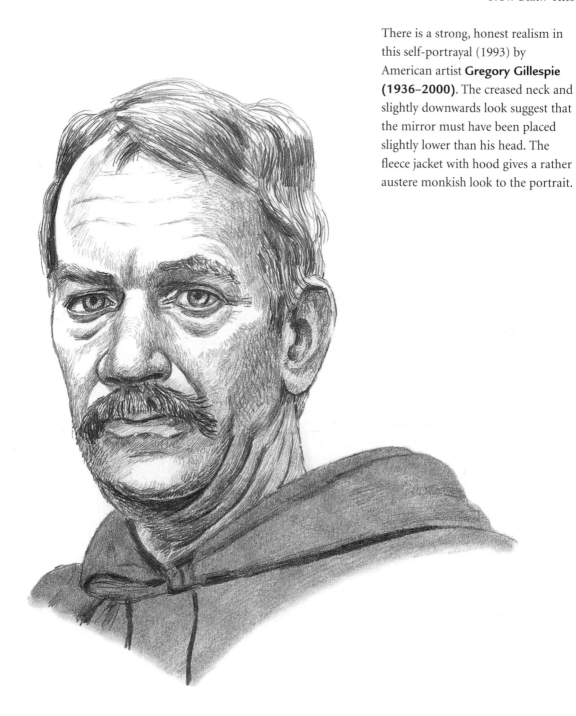

There is a strong, honest realism in this self-portrayal (1993) by American artist **Gregory Gillespie (1936–2000)**. The creased neck and slightly downwards look suggest that the mirror must have been placed slightly lower than his head. The fleece jacket with hood gives a rather austere monkish look to the portrait.

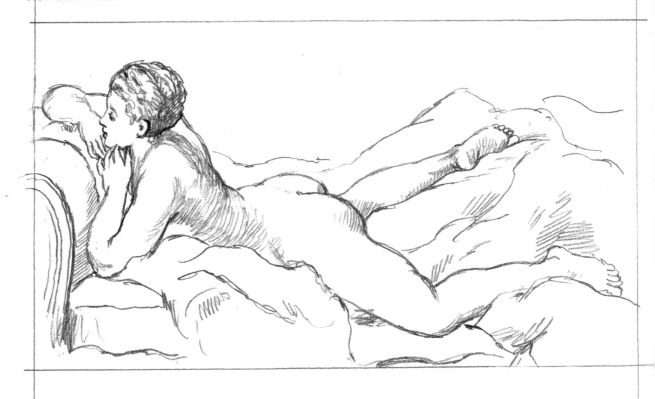

In this drawing, based on a work by the French 18th-century painter **François Boucher**, a nude girl is reclining on a couch, posing for the artist. Although her head is erect, supported by her hands, and her back is hollowed, she is in a pose that doesn't suggest action on her part at all. The side view of a reclining pose is always the most calm and peaceful in effect.

Drawing nude figures is always difficult but these examples have been made a little easier because the artist has confined the amount of detail to the essentials, so there is not too much to draw. Just make sure that the proportions and shapes come out well and you are halfway there.

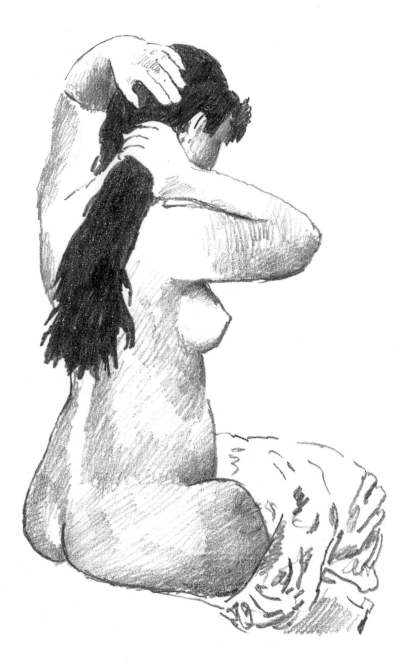

## Pierre Auguste Renoir

Renoir could be called the artist who loved women. His pictures of young women, dressed or undressed, are some of the sweetest drawings of the female form ever produced. He always has the painter's eye and sacrifices any detail to the main effect of the picture. When he does produce a detail, it is extremely telling and sets the tone for the rest of the picture. His drawings and paintings of late-19th century Paris are imbued with an extremely happy atmosphere which has captured the imagination of artists ever since.

295

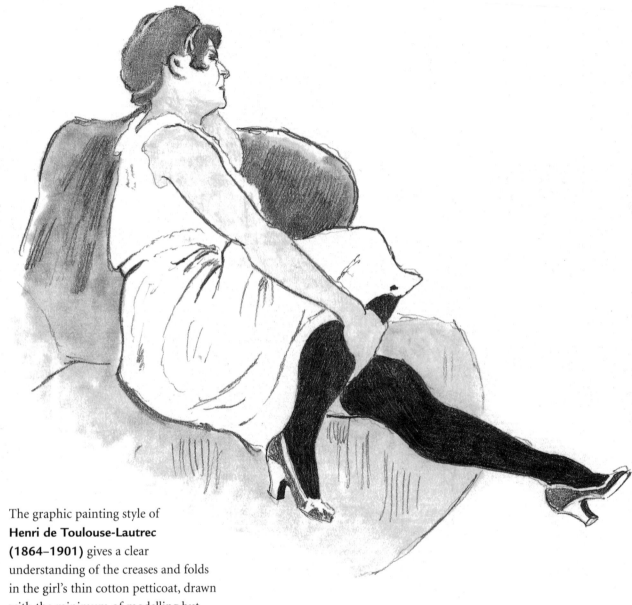

The graphic painting style of **Henri de Toulouse-Lautrec (1864–1901)** gives a clear understanding of the creases and folds in the girl's thin cotton petticoat, drawn with the minimum of modelling but expressing very clearly the solidity of the body under the garment. Mireille, a prostitute from the Salon in the Rue des Moulins, was a favourite model of Lautrec. Here she lounges in the Salon waiting for customers, casually holding one sturdy black-stockinged leg while stretching out the other.

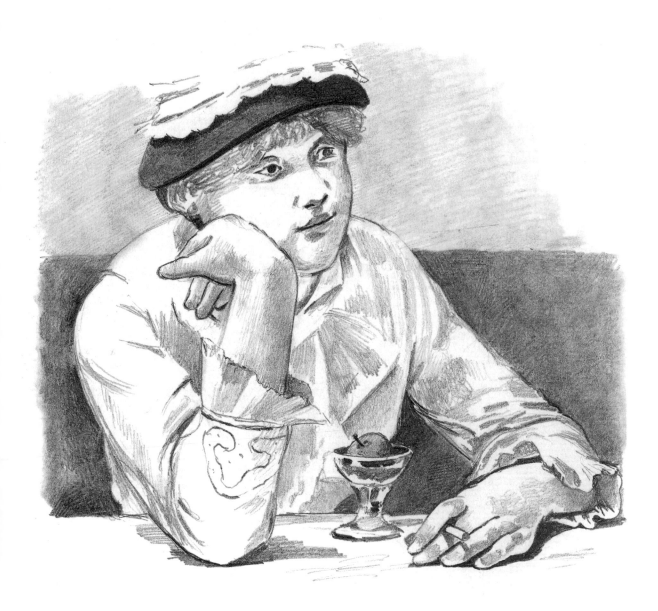

In this copy of a **Manet**, a young woman is sitting draped
around her plum dessert, a cigarette in her left hand while
her right hand supports her cheek. The naturalistic pose
gives a gentle, relaxed air to the portrait.

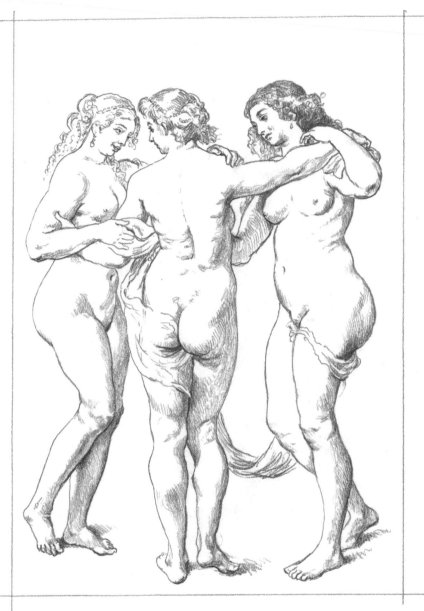

For an example of a three-figure composition I have drawn *The Three Graces* by **Peter Paul Rubens**, the great master painter of Flanders. He chose as his models three well-built Flemish girls, posed in the traditional dance of the graces, hands intertwined. Their formation creates a definite depth of space, with a rhythm across the picture helped by the flimsy piece of drapery used as a connecting device. The flow of their arms as they embrace one another also acts as a lateral movement, so although these are three upright figures, the linkage is very evident. The spaces between the women seem well articulated, partly due to their sturdy limbs.

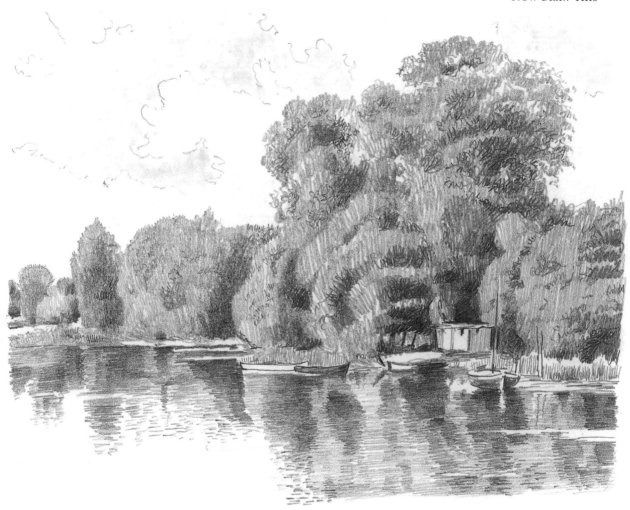

The River Oise in summer looks inviting in this depiction
by **Emilio Sanchez Perrier (1855–1907)**. The leafy trees
are presented as a solid mass, bulking up above the ripples
of the river, where the shadowed areas of the trees are
strongly reflected. The many horizontal strokes used to
draw these reflections help to define the rippling surface
of the calmly flowing river.

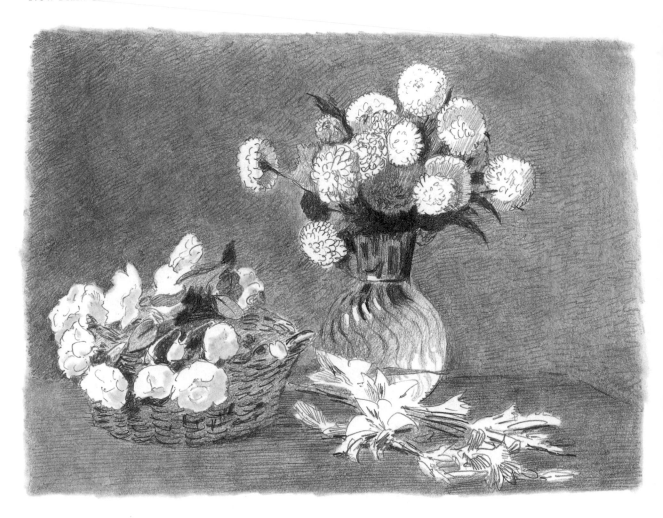

The rich bunches of dahlias in this picture after **Henri Fantin-Latour (1836–1904)** have an almost tactile quality to the creamy plush blossoms. They are lit with a soft light against a shadowy background that helps to produce a strong impression of depth and texture. Fantin-Latour's flower paintings are some of the most admired in the genre.

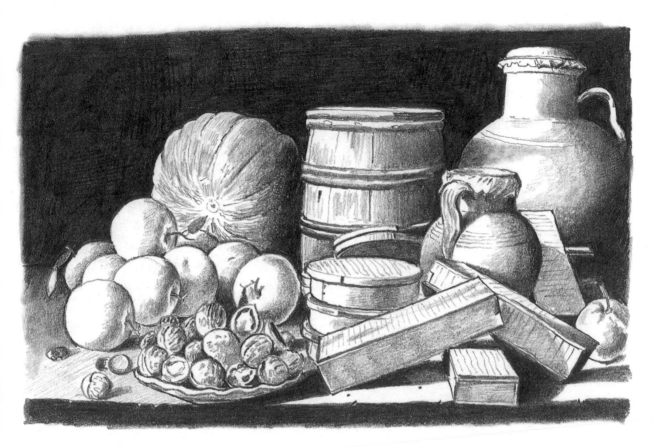

This beautiful piece by the famous Spanish artist **Luiz Meléndez (1716–80)** is a full and even crowded arrangement, but because of its simple workaday subject matter gives a very solid and complete-looking group of objects. The pots, packets and loose fruits and nuts both contrast and harmonize with each other at the same time.

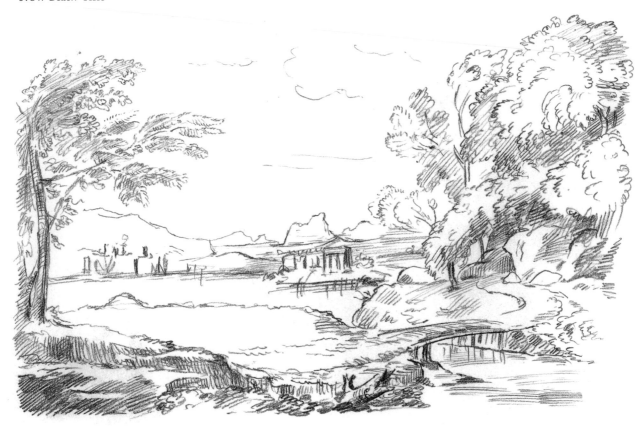

This landscape after **Claude Lorrain** looks entirely natural at first glance; there are not even any odd-shaped mountains to give the game away. Everything looks just as a part of the Roman campagna might have looked at this time. But Claude hardly ever produced a simple study picture, and certainly not on this scale; his direct studies were invariably of small details of landscape. The great French artist was renowned for beautiful scenes of unspoiled countryside, with some Roman remains, magnificent trees, water and a focal point (such as the bridge included here). No doubt every part of this picture is based in reality, but not in this particular arrangement. Claude would not have wanted to disappoint his aristocratic public by leaving anything to chance. On the other hand he would not have been satisfied if any aspect of a landscape of his had looked less than totally natural.

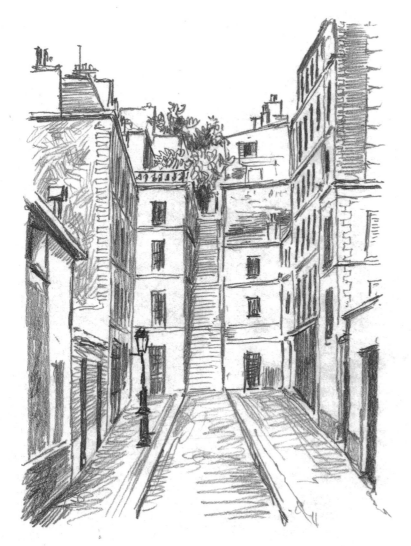

**Maurice Utrillo (1883–1955)** was famous for his deadpan representations of urban Paris and its suburbs. Mostly he left out figures and the buildings are unremarkable. These are depictions of an ordinary, work-a-day world where Utrillo and many others lived.

*All these drawings are here for your use as starting points for working after master artists. I hope that all this material is significant enough for the development of your abilities. I know that I had great fun and learned much from copying these masterworks. So good luck in your efforts.*

*Barrington Barber*

# Index